CLAUDE
THE POETIC LANDSCAPE

D1003217

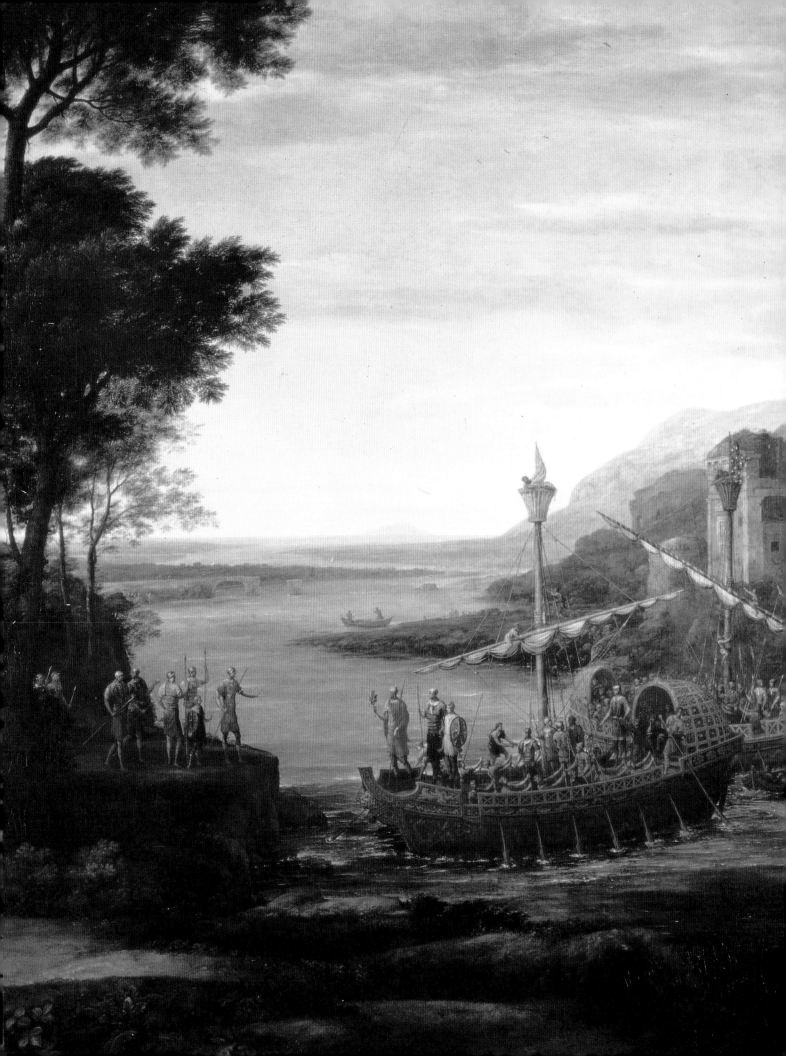

CLAUDE
THE POETIC LANDSCAPE

Humphrey Wine

NATIONAL GALLERY PUBLICATIONS, LONDON

This book was published to accompany an exhibition at
The National Gallery, London
26 January–10 April 1994

© National Gallery Publications Limited 1994

All rights reserved. No part of this publication may be transmitted in
any form or by any means, electronic or mechanical, including
photocopy, recording, or any storage and retrieval system, without
the prior permission in writing from the publisher.

First published in Great Britain in 1994 by
National Gallery Publications Limited
5/6 Pall Mall East, London SW1Y 5BA

ISBN 1 85709 045 4 hardback
525178
ISBN 1 85709 046 2 paperback
525179

British Library Cataloguing-in-Publication Data.
A catalogue record is available from the British Library.

Library of Congress Catalog Card Number: 93–85800

Editors: Felicity Luard and Diana Davies
Designed by Tim Harvey

Printed and bound in Great Britain by
Butler and Tanner, Frome and London

Front cover
Landscape with the Marriage of Isaac and Rebekah, detail (No. 21).

Back cover
Seaport with the Embarkation of Saint Ursula (No. 15).

Frontispiece
Plate 1 *Landscape with the Arrival of Aeneas before the City of
Pallanteum*, detail (No. 56).

Author's Acknowledgements

My first thanks must go to my colleagues in the National Gallery without whose efforts neither the exhibition nor this catalogue would have been possible. Of those outside the Gallery to whom I am indebted I wish to record special thanks to both Michael Kitson and Marcel Roethlisberger for their willingness to discuss this project with me; it owes a great deal to their respective researches on Claude Lorrain. I wish also to thank the following who helped in many different ways: Jane K. Brown, Emmanuelle Brugerolles, Michael Clarke, Tim Egan, Judy Egerton, Antony Griffiths, Olaf Koester, Alastair Laing, Helen Langdon, Sir Michael Levey, Gay Naughton, Lynn Federle Orr, Claire Pace, J.P. Roche, Nicholas Turner and Patricia Waddy.

I am grateful to Rosemary MacLean for her contribution to the catalogue, particularly for drafting the synopses of the stories on which Claude's paintings are based, and for generously sharing the results of her investigation into the hanging of Claude's pictures in seventeenth-century Italy.

Finally, I wish to thank my wife, Carol, for her support and encouragement. These have been, as always, invaluable.

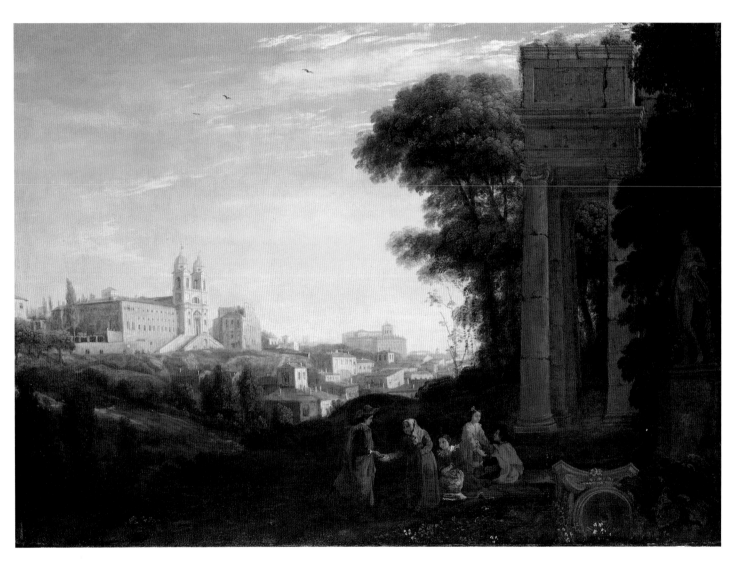

Plate 2 *A View of Rome* (No. 4).

Contents

Foreword

The pictures in this exhibition were painted by a subject of the German emperor who spoke French, lived in Italy and sold his works to the rich and powerful in Rome and Paris, Bohemia and Spain. Yet in no country has this supra-national artist been so highly and consistently esteemed as in Britain, where admiration for his work is quite simply one of the key facts of our cultural history.

Claude has shaped our painting in the works of Richard Wilson and Turner, as he has shaped our countryside through the gardens made in emulation of his landscapes. It is a tribute to his continuing hold over the British imagination that all but one of the pictures shown here come from collections in the United Kingdom – and the exception comes from that most Anglophile of German cities, Hamburg.

The National Gallery itself is an aspect of this phenomenon, for Claude lies at the very heart of the Trafalgar Square Collection: when the Gallery opened to the public in 1824, he was by far the best-represented artist, and the particular favourite of the Gallery's first great benefactor, Sir George Beaumont, who so loved his small *Hagar and the Angel* that, after giving it to the Gallery, he found existence without it intolerable and borrowed it back for the rest of his life.

There could then be no more appropriate subject for a National Gallery exhibition. Our aim has been both to celebrate Claude's art and to examine one particular aspect of its magic. We hope visitors will be transported by the sheer visual beauty of the paintings and drawings, as have kings, cardinals and magnates from the moment they were made. But if this exhibition has a purpose beyond pleasure of the eye, it is the proposition that these pictures are worth considering not just as landscapes but very seriously as stories, as

Claude himself clearly intended. Alone among the great painters of Europe, Claude frequently wrote on to his paintings the subjects they represented. There the inscriptions stand, like irremovable labels, telling spectators that they are looking at the Queen of Sheba setting out to find Solomon, or Aeneas talking to the high priest of Apollo.

He could have given no clearer indication that he believed knowledge of the subject to be a central part of full enjoyment of the pictures. In this exhibition, we have taken him at his word, and examined the relationship between the landscapes and the stories.

Of course, like all the best stories, they mean different things to different people. But without exception, they stimulate us to become part of a narrative that deals with the great passions of life, moral and emotional dilemmas, the death and birth of empires. I believe that if the pictures are looked at in this way, it becomes clear that Claude was a great story-teller, as well as a great painter: the stories are built up of hints rather than statements, because we know them already, and he can rely on us to tell the tale to the end. And it is in part because we know how the story must end – that Dido will be abandoned, that Rome will be founded and will be great – that we are so moved by the episodes we see.

It would not have been possible for us to tell this tale of Claude without the great generosity of those who have lent their paintings and drawings. We are extremely grateful to them for their kindness and for their trust.

Neil MacGregor
Director

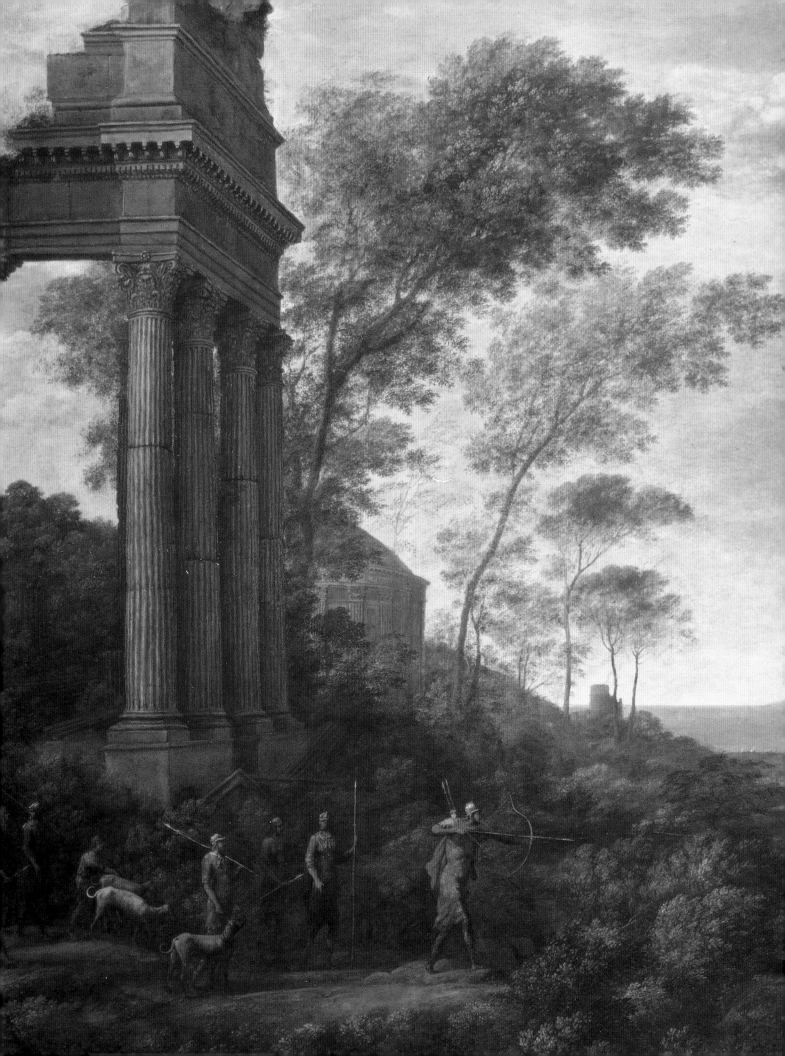

Claude: The Poetic Landscape

'Claude Lorrain...had shown more discretion, if he had never meddled with [mythological] subjects.'[1] Sir Joshua Reynolds's dismissive view would be easy to adopt in respect of the stories in Claude's landscapes, based as they often are on unfamiliar passages from ancient authors and represented by small, sometimes oddly proportioned figures. Indeed it is only in recent years that serious consideration has been given to the stories in his paintings and their possible meanings.[2] Claude as a painter of landscape, however, and as a painter of the effects of light, has been consistently praised since his own day.

For Reynolds, as for Claude's contemporaries, the difference between being a landscape painter and a painter of stories – whether mythological, religious or historical – went beyond a matter of vocational description. It was fundamental to the status of the individual painter and his work. This was because the painting of stories, or histories as they were called, was seen to require an effort of the imagination and a mastery of painting the human form, action and expression. Landscape painting, on the other hand, was associated not with creativity but with the mere copying from nature of (mainly) inanimate objects, and so was regarded as inferior not just to history painting, but also to portraiture and to genre scenes. Therefore, to praise Claude's paintings for their truthfulness to nature, as did his contemporaries, was two-edged: his very mastery of nature's effects bound him to the lesser ranks. Furthermore, whereas the function of landscape painting was to be merely pleasing, history painting was also required to move the spectator emotionally and/or to express some moral or didactic point. These

Opposite: Plate 3 *Landscape with Ascanius shooting the Stag of Silvia*, detail (No. 60).

distinctions were based on the application to painting of the distinctions made by Aristotle in relation to different kinds of poetry. That there was a parallel between the arts of painting and poetry was a commonplace of the period, the saying attributed to the ancient Greek poet Simonides that 'painting is mute poetry, poetry a speaking picture' being frequently cited.[3]

In this context Claude's painting of stories – to which this catalogue is largely devoted – takes on a particular importance. They were certainly not history paintings in any conventional sense – the figures were too small for that. Were they therefore seen by his contemporaries, as Reynolds would later see them, essentially as landscapes in which the stories had no emotional or didactic significance? Or were Claude's paintings experienced as mute poetry in which both landscape and figures combined to express meaning? That is to say, even if they were not true history paintings, could they have had the same function as history painting, namely to move and to please? These questions are considered on the following pages.

Contemporary perceptions of Claude

In the world of painting, Claude was a star. As Filippo Baldinucci (1624?–96), one of his biographers, relates, by the time Claude was thirty 'cardinals, and finally princes of all ranks, began to frequent his studio: and from that moment on, the way to the acquisition of his pictures was closed forever to anyone who was not either a great prince or a great prelate or who could not procure them through the agency of one of these, at great expense, or with diligence and long patience.'[4]

Baldinucci's assessment was scarcely an exaggeration. Claude, working in Rome where he had lived since 1627, undertook commissions for a clutch of

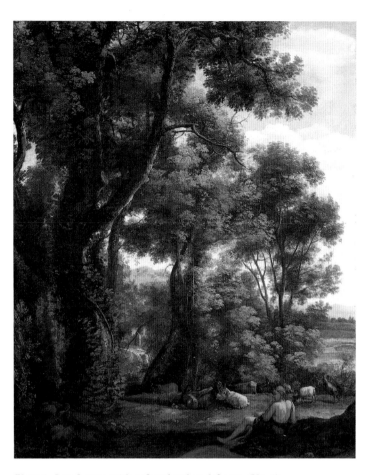

Plate 4 *Landscape with a Goatherd and Goats* (No. 9).

cardinals belonging to, or associated with, the families of the various popes reigning during his lifetime,[5] for Roman and French nobles, as well as for Philip IV of Spain. Among his other patrons were residents of England, Flanders, Holland and Denmark. The inventory which shows that on his death Claude possessed only four of his own paintings suggests that his production could not keep up with demand. This was a problem which the artist himself recognised as early as the mid-1630s when, allegedly as a safeguard against forgery, he began to draw records of his compositions in a bound volume called the *Liber Veritatis*.[6]

Yet if Claude's commercial success was complete, his critical success was qualified by a seeming inability to paint the human figure, at least not by the generally accepted standards of his day. This was first expressed by Joachim von Sandrart (1606–88), a German artist

who knew Claude around 1630 but published his biography only in 1675: '...however happy [Claude] is in representing well the naturalness of landscapes, so unhappy is he in [painting human] figures and animals, be they only half a finger long, that they remain unpleasant in spite of the fact that he takes great pains and works hard on them, and drew for many years in Rome in the academies from life and from statues, and even applied himself more to the figures than to the landscapes.'[7] Baldinucci, who knew Claude at the end of his career, echoed this criticism: 'He adorned his landscapes with figures made with incomparable care, but since he could never overcome in them his obvious fault of drawing them too slender, he used to say that he sold the landscapes and gave away the figures.'[8] That this perception of Claude's figures was almost as widespread as admiration for his landscapes is attested by the comment of a French contemporary, the writer and adviser on art Roger de Piles (1635–1709), that Claude was never able to create figures in good taste to accompany his landscapes.[9]

There is a double paradox here. Firstly, virtually all of Claude's landscapes included the human figure, and it is evident that this did not inhibit his success.[10] Secondly, even though landscape scenes based on a particular literary source were dependent on the recognisable depiction of particular figures, Claude painted more such scenes as his career progressed. The bulk of his production until around 1640 was of seaports or pastoral landscapes with no discernible story. Typical of Claude's paintings in the 1630s are *Landscape with a Goatherd and Goats* of 1636–7 and *A Seaport* of 1639, both in the National Gallery (Plates 4 and 5). It was with paintings such as these that Claude established his career, so there was no apparent commercial need for him to switch increasingly to text-based landscapes from the 1640s.

It can be argued that Claude's figures (and their alleged shortcomings) were simply insignificant compared with the beauty of his overall light effects. There is certainly evidence to support such a view. Claude's

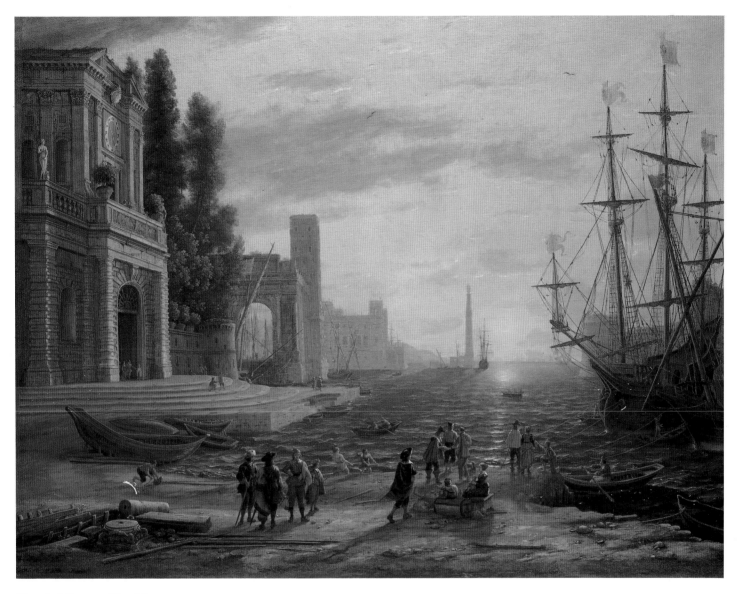

Plate 5 *A Seaport* (No. 13).

paintings were praised for their likeness to nature, Sandrart referring to their 'naturalness', and Baldinucci to Claude's 'still-unsurpassed imitation of nature in those of its various aspects which condition the views of the sun, particularly on the seas and rivers at dawn and evening', and to the artist's 'various and most beautiful observations which he had made of nature, of the changing and varying of air and light'.[11] In other words, the beauty of Claude's landscapes overcame, indeed in the case of his sunrise and sunset scenes outshone, the defects in his figures, rendering the latter forgivable.

This view is reinforced by descriptions of Claude's paintings by others during and soon after the artist's lifetime, and indeed in one case by Claude himself. For example, most references to paintings by Claude in seventeenth- and early eighteenth-century Dutch inventories call them landscapes, or morning or evening scenes, without specifying any subject.[12] In Italian inventories of the period Claude's subjects are often not described, or misdescribed, or his subjects are reduced in significance. For example, Claude's depiction of an episode from Virgil's *Aeneid*, *Landscape with Ascanius shooting the Stag of Silvia* (see Plate 33),

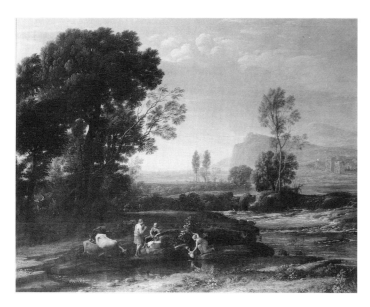

Fig. 1 *Landscape with the Flight into Egypt*, 1647. Oil on canvas, 102 x 134 cm. Dresden, Gemäldegalerie Alte Meister.

Fig. 2 *Aeneas and the Cumaean Sibyl* (No. 34).

was, in 1714, simply listed as a 'landscape [with] a deer hunt'. More remarkable is the misdescription within only three or four years of its execution of a painting owned by Vincenzo Giustiniani, *Landscape with Cephalus and Procris reunited by Diana* (destroyed in Berlin during World War II). In the 1638 inventory of Giustiniani's effects it was called 'an overdoor with a landscape and three figures of nymphs'.[13]

Claude himself seems to have encouraged, or at least colluded with, the lack of significance accorded to his figures. It is not surprising, given the slight size and the marginalisation of the Holy Family at the left of the Dresden *Landscape with the Flight into Egypt* of 1647 (Fig. 1), that it should have been described in the 1653 inventory of Cardinal Mazarin as 'a landscape showing a River and some shepherds playing the flute with some cows'.[14] More significant is Claude's own description of two paintings executed for Count Johann Friedrich von Waldstein in 1668. He wrote that year to his patron that the painting of 'Abraham and Hagar which is the rising sun is finished and the other which is the Angel showing the well to Hagar which represents the afternoon [needs] seven or eight more days...'[15] (Munich, Alte Pinakothek; see Fig. 7). The

moral significance of the biblical episodes of Abraham's expulsion of Hagar and Ishmael and the latter's rescue by an angel of the Lord is thus apparently considered by Claude as secondary to the decorative effects of light and atmosphere.

Claude's part in demoting the significance of his own subject matter seems to be borne out by some of his preparatory drawings, which show that the same landscape background could be used for wholly unrelated subjects. Probably the most telling example is a drawing of 1677 (Fig. 2). The composition of the landscape is close to that of *Landscape with Saint Philip baptising the Eunuch* (Plates 6 and 15) and shares with that painting the motifs of the carriage and horses. The two figures on the right of the drawing, however, have nothing to do with the biblical episode and may represent Aeneas and the Cumaean sibyl, a subject from Virgil's *Aeneid* and Ovid's *Metamorphoses*. It is possible that when the drawing was made the patron, Cardinal Spada, was undecided between the two subjects, and Claude was indicating how either could be incorporated into a particular landscape type.[16] What seems clear, in this case, is that the landscape was in no sense determined by the subject, but that quite different figures could be dropped in at will.

Related to the question of the importance in Claude's paintings of his figures is that of how his paintings were hung by their owners. Most of the avail-

Plate 6 *Landscape with Saint Philip baptising the Eunuch* (No. 33).

able evidence suggests that they were not hung in a way to highlight the significance of their subject matter. For example, seven years after Cardinal Giori's death in 1662 four of the six paintings he had ordered from Claude, including the biblical subject picture *Landscape with Samuel anointing David* (Paris, Louvre), hung together in his Roman palace in a room next to the garden. All told a quarter of the paintings in this room were landscapes, including pictures by Francesco Albani and Jan Both, but it does not appear that Claude's paintings were privileged in their hanging.[17] Similarly, of the twenty-three paintings recorded in an inventory of 1666 as hanging in a garden room of the Pamphili villa, over half were landscapes. They included two paintings by Claude: *The Mill*, a rural dance scene, and *View of Delphi with a Procession* (see Fig. 12).[18] Neither is based on a literary text and, save that they both allude to antiquity, the subjects have no connection.

The records of the Giori and Pamphili paintings suggest that landscape paintings, including those by Claude, were hung to complement views over owners' gardens, rather than to focus attention on the episode shown within the picture frame.

Whether Agostino Chigi's pairing of Claude's *Landscape with David at the Cave of Adullam* (Plates 7 and 12), a biblical episode with a serious moral point, with Salvator Rosa's *Mercury, Argus and Io* (Fig. 3), a typically lustful story from Ovid's *Metamorphoses*, was a matter of just balancing two pictures of similar size or was a deliberate contrast between pictures of virtue and vice is unclear.[19] On the other hand, that the learned Cardinal Camillo Massimi chose to hang two large paintings by Claude on either side of the door to his library may well have been a decision informed by their subjects. One of the paintings was *Coast View with Perseus and the Origin of Coral* (Plate 8), the other

Plate 7 *Landscape with David at the Cave of Adullam* (No. 27).

Fig. 4 *Apollo and the Cumaean Sibyl*, 1646/7. Oil on canvas, 96.6 x 136.5 cm. St Petersburg, Hermitage.

Fig. 3 Salvator Rosa, *Mercury, Argus and Io*, *c.*1653–4. Oil on canvas, 112.7 x 143 cm. Kansas City, Nelson-Atkins Museum of Art.

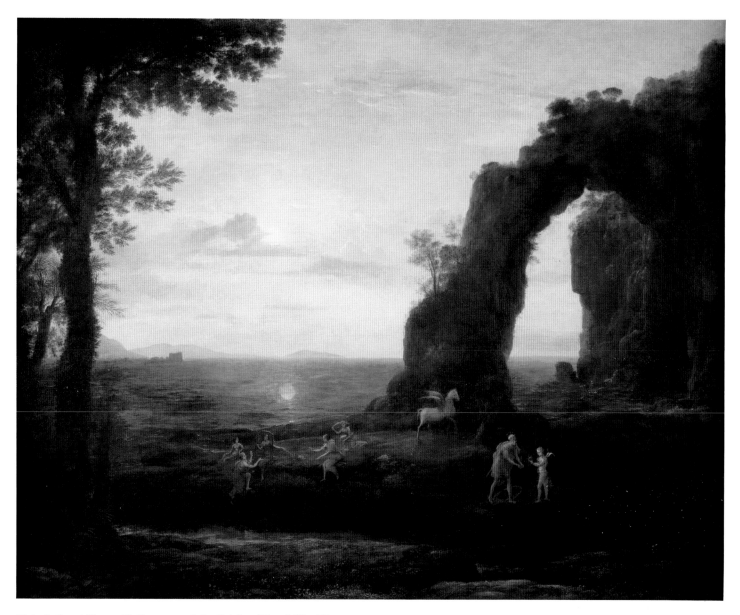

Plate 8 *Coast View with Perseus and the Origin of Coral* (No. 79).

was not its pair, *View of Delphi with a Procession* (Chicago, Art Institute), but another coast view, probably *Apollo and the Cumaean Sibyl* (Fig. 4). This last painting would thus have been separated from its pair, *Landscape with Argus guarding Io* (Norfolk, Holkham Hall).[20] If this is the case, Massimi created a new pairing by hanging near to each other in a prominent position two subjects from Ovid's *Metamorphoses*, linked by the concept of metamorphosis itself: the blood of Medusa's head changing into coral (see page 113) and the continual ageing and ultimate shrinking

'to a feather's weight' of the Cumaean sibyl.[21] On the limited evidence available, however, Massimi's approach to hanging seems to have been exceptional.

This indifference to content, and to investing Claude's paintings with individual significance is perhaps more apparent than real. The fact that Claude used a painter's description in his letter to von Waldstein by referring to his paintings' visual effects did not exclude the possibility that they carried other messages for the viewer. As for the inventory evidence discussed above, the function of an inventory was to

identify succinctly the individual objects in it and to distinguish them from each other. In that context to call the *Ascanius* a landscape with a deer hunt is more than adequate. The fact that in terms of square inches the landscape was dominant was entirely relevant in preparing an inventory. But it may nevertheless have been possible that the figures carried resonances more penetrating than their relatively small size would suggest.

A more concrete piece of evidence for the importance of the subject matter in Claude's paintings is his inscription on a preparatory drawing for *Landscape with the Arrival of Aeneas before the City of Pallanteum* (see Plate 31): 'Prince Don Gasparo [Altieri] has told me that he desires the subject of Aeneas showing the olive branch to Pallas as a sign of peace.'[22] It is inconceivable that the subject would have been unimportant to a patron who bothered to specify it, and in this case other surviving preparatory drawings for the *Arrival of Aeneas*, of which No. 58 is one, indicate the thought which Claude invested in the relative placing, poses, gestures and costumes of the principal figures – all matters which would have concerned a conventional painter of stories.[23] As both his principal biographers relate, Claude took considerable pains over his figures, an inevitable procedure for any artist who recognised that the figures represented the primary means by which a spectator would identify the specific story. Further, although no other similar inscriptions by Claude survive, nor written commissions, it is reasonable to assume from the fact that many of Claude's subjects were unusual that they were specified by the patron.

Developments in Claude's art

In so far as surviving drawings are a guide, broadly speaking more drawings in which the figures predominate are to be found after about 1650 than before (although compared with landscape studies they remain a minority). This trend cannot be assumed to have been entirely created by patrons' requests for unusual subjects since figure studies also survive for common subjects, such as the Journey to Emmaus and the Rest on the Flight to Egypt.[24] Claude's interest in the human figure, its pose and grouping, was therefore self-generated to a degree, and accords with a generally more considered approach by the artist to his art. He had ceased to include figures in modern dress after the early 1640s, so eliminating from his paintings the more mundane figures of everyday experience.[25] From about 1650 he tended to became more consistent in his use of antique buildings for antique subjects. For example, whereas some of the earlier seaports, including the *Embarkation of the Queen of Sheba* of 1648 (see Plate 14), combined buildings of Renaissance and antique styles, the principal buildings in *View of Carthage with Dido and Aeneas* of 1676 (see Plate 34), are all in antique style.[26] It is from the 1650s also that Claude's pictures more often accorded with their literary sources, which he later began to note on related drawings.[27] Gesture and expression, those hallmarks of the history painter, became more demonstrative for a period around 1650, for example in *David at the Cave of Adullam* of 1658 (see Plate 12). Additionally, whereas throughout his career Claude used buildings to allude to subject matter, as in the *Embarkation of Saint Ursula* (No. 15) and *Aeneas at Delos* (No. 53), in his later paintings the composition of the landscape itself seems designed to reinforce the story. In the Petworth version of *Jacob, Laban and his Daughters* of 1654 (Fig. 5), for example, the group of trees at the right competes with the principal figures on the left, who are thereby reduced in significance. However, in the Dulwich version of the subject, painted in 1676 (Plate 9), the principal figures have been moved to the centre of the composition and relatively higher within the picture space. Visually the trees still dominate, but their trunks now lead the eye towards the figures, so giving more emphasis to the competition for Jacob between Rachel and Leah. A similar comparison may be made between the National Gallery's *Landscape with Hagar and the Angel* (Plate 10) and another version of the subject painted ten years later (Fig. 6). In the first, the

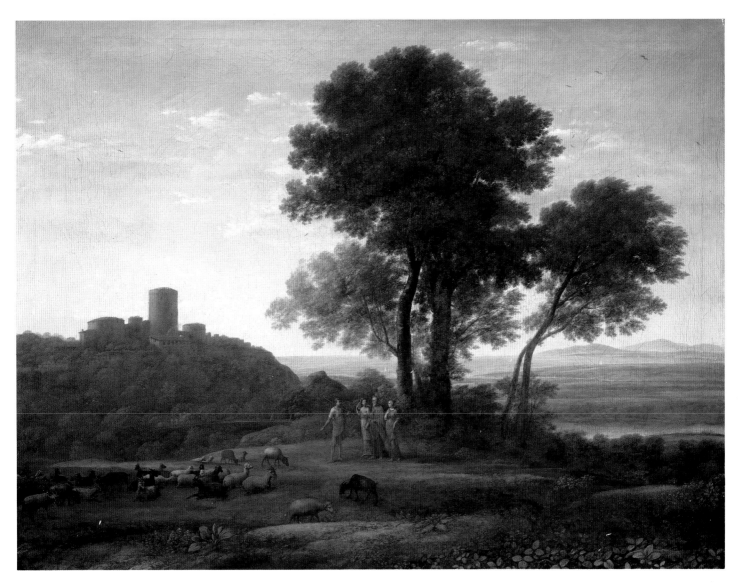

Plate 9 *Landscape with Jacob, Laban and his Daughters* (No. 31).

Fig. 5 *Landscape with Jacob, Laban and his Daughters*, 1654. Oil on canvas, 143.5 x 251.5 cm. West Sussex, Petworth House, National Trust.

figures lead the eye to the landscape, whereas in the second there is a greater balance between figures and landscape, and the connection between Hagar and the place to which she is ordered to return is more direct. This kind of development can be noted also by comparing the Dresden *Flight into Egypt* of 1647 (see Fig. 1) and a version of the same subject painted in 1663 (Madrid, Thyssen-Bornemisza Collection; MRP 158). In the latter the visibility of the Holy Family is assisted by the angles both of the dominant tree trunk and of the gazes of the foreground figures. Similarly, in the later and reduced-size repetition of *Landscape with the Adoration of the Golden Calf*, the column with the idol,

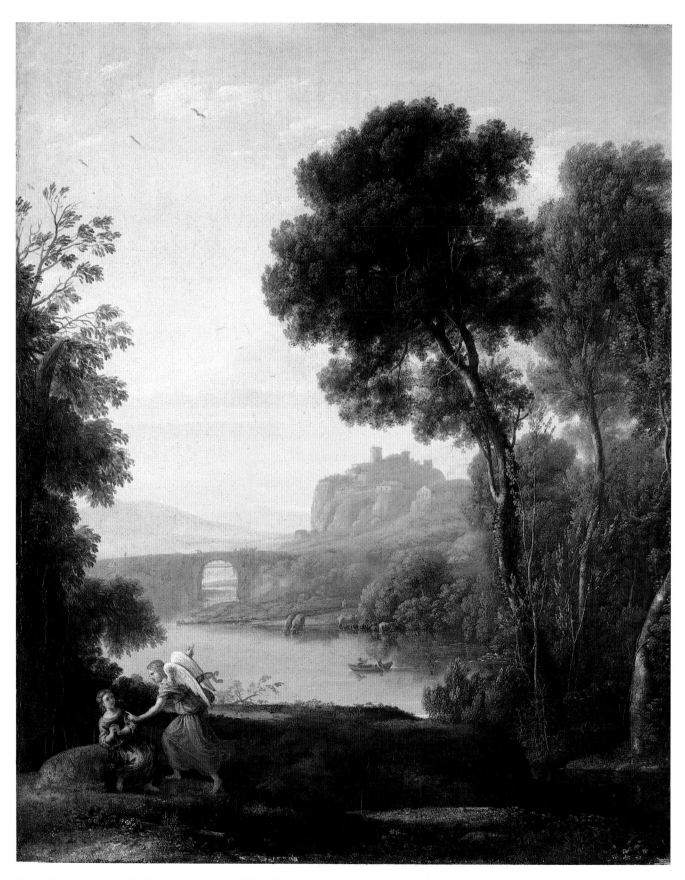

Plate 10 *Landscape with Hagar and the Angel* (No. 19).

Fig. 6 *Landscape with Hagar and the Angel*, 1656. Oil on canvas, 101.5 x 87.5 cm. Private Collection.

Fig. 7 *Landscape with Hagar, Ishmael and the Angel*, 1668. Oil on canvas, 106 x 140 cm. Munich, Alte Pinakothek.

which is the key motif of this particular story, is more prominent in the overall composition (Plate 11) than it is in the Karlsruhe version (see No. 29).

There was nothing original about such compositional devices, but it is worth pointing out that they were devices for stressing narrative, rather like underlining in a written text, and that they were well understood by history painters who were occasional landscapists, such as Annibale Carracci (1560–1609) and Domenichino (1581–1641). A parallel development in Claude's art was the use of landscape motifs or composition as metaphor. This too had been understood by Annibale in the celebrated Aldobrandini lunettes (Rome, Galleria Doria-Pamphili), in which the serene landscape of the *Flight into Egypt* (see Fig. 16) can be contrasted with the jarring divisions of space in the *Entombment*. Of necessity, this kind of picture analysis is conjectural and depends on some prior knowledge of the narrative concerned as well as a degree of imagination. Nevertheless, some suggestions can be ventured: the twisted trees in the Munich *Landscape with Hagar, Ishmael and the Angel* seem expressive of Hagar's grief (Fig. 7);[28] in *Landscape with David at the Cave of Adullam* King David stands on the (moral) high ground (see Plates 6 and 12); the idea of difference between the Arcadians and Trojans is expressed by one wooded and one unwooded bank of the Tiber in *Landscape with the Arrival of Aeneas before the City of Pallanteum* (see Plate 31). Perhaps the most striking use of landscape composition as metaphor is the gulf that divides the destructive Ascanius and the innocent stag in Claude's last painting (see Plate 33). As preliminary drawings indicate (Nos. 63 and 64), it was a solution which Claude arrived at after rejecting other possibilities.

Taken together these examples suggest an artist who wanted his art to be taken seriously, who in his maturity at least carefully considered the subject matter of his paintings, and who believed that the organisation of landscape could enhance effective story-telling. This was not a belief confined to Claude. It was alluded to by Giulio Mancini in his *Alcune ConsideratX appartenenti alla pittura come di diletto di un gentilhuomo nobile e come introduttione a quello si deve dire* (Rome c.1620), in which he graded landscape from the simplest showing

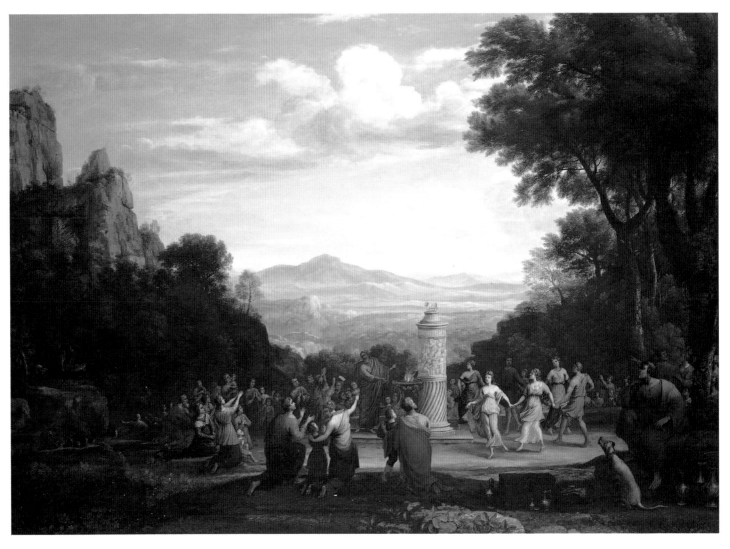

Plate 11 *Landscape with the Adoration of the Golden Calf* (No. 28).

Opposite: Plate 12 *Landscape with David at the Cave of Adullam,* detail (No. 27).

only inanimate objects to the 'most perfect' showing human beings 'with expression and action'.[29] For painters the depiction of human expression and action were the mechanics of story-telling, so Mancini recognised that narrative could occur in a picture dominated by landscape.

The concept that landscape might go beyond the decorative had already been privately expressed in Rome in 1602 by G.B. Agucchi (1570–1632), who wrote a programme which he gave to the artist Lodovico Carracci, setting out how to depict with small figures in a landscape the episode of Erminia and the Shepherds from Tasso's *Gerusalemme Liberata*. Agucchi explained

that 'the forms [of the figures] could not be other than small because of the breadth of the view and should be executed with that much more diligence and care as is needed in small things *to show the action and effects that such a delightful story requires*' (my italics).[30] For Agucchi therefore there was no inconsistency between small figures in a landscape and effective story-telling. On the contrary, in choosing this episode from Tasso he doubtless recognised that the pastoral landscape in Tasso's poem was an integral part of the story. Although Agucchi gave his programme to Lodovico Carracci, its spirit is best shown in the small landscapes of Domenichino, Agucchi's protégé and an acknowledged

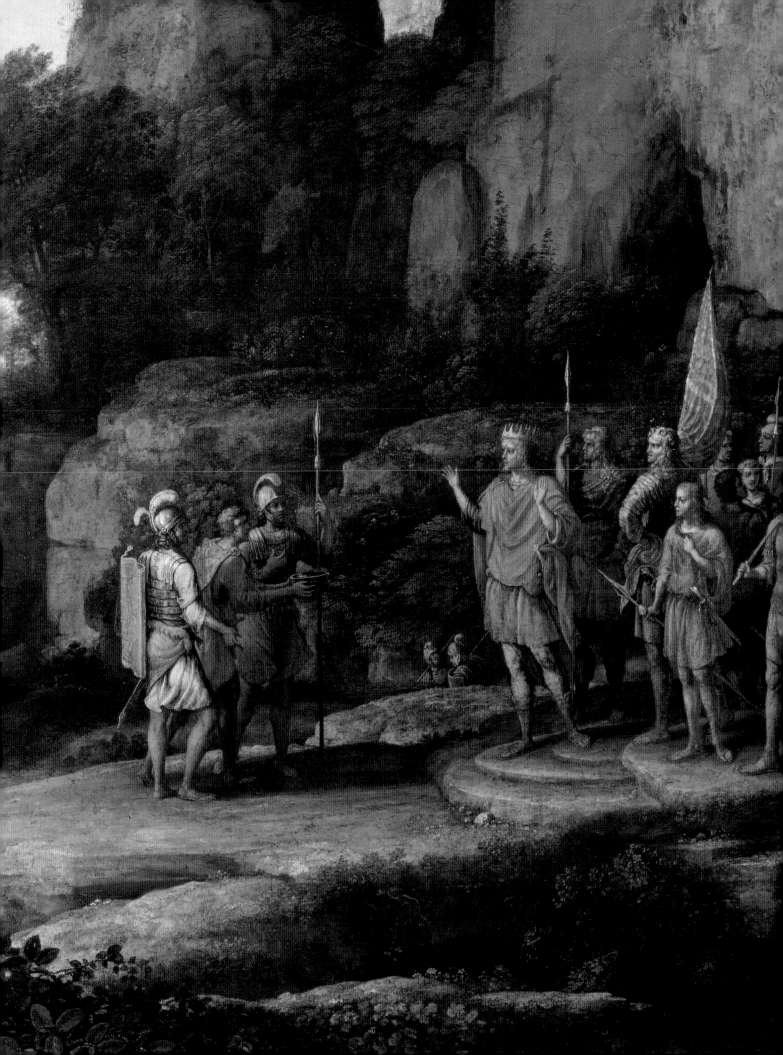

Fig. 8 Domenichino, *Saint George killing the Dragon*, *c.*1610–11.
Oil on wood, 52.5 x 62 cm. London, National Gallery.

Fig. 9 *Landscape with Saint George killing the Dragon*, *c.*1643.
Oil on canvas, 112 x 149.5 cm. Hartford, Wadsworth Atheneum.

Fig. 10 *Landscape with the Marriage of Isaac and Rebekah*, detail
showing a man accepting a drink.

history painter whose landscapes, only a small part of his total output, came to influence Claude in the 1640s (Figs. 8 and 9).

Claude's inscriptions

That both Claude and his patrons considered the stories in his paintings to be significant is suggested by the number of times that he identified his subjects by inscriptions – on the paintings themselves (see Nos. 33 and 60), on related drawings or on the record of the painting in the *Liber Veritatis*. It was mainly unusual subjects which were identified in this way, although not invariably so. Claude followed this practice intermittently, from a painting of the burial of the early Christian saint, Saint Serapia, made in the late 1630s (Madrid, Prado), to his final painting, *Ascanius shooting the Stag of Silvia*, of 1682 (No. 60)

Particularly revealing of the function of Claude's inscriptions is that on a painting of 1648, *Landscape with the Marriage of Isaac and Rebekah* (Plate 13), 'MARI[AGE] DISAC AVEC REBECA'. As recounted in Genesis 24: 67, the marriage was a rather private affair: 'And Isaac brought her into his mother Sarah's tent and took Rebekah, and she became his wife.' Clearly the

painting is not of this episode, which would in any event not have appealed to Claude who, as Baldinucci says, 'never soiled his brush with any lascivious or in any other way indiscreet representation.'[31] The only episode in the Bible that could justify the painting's title occurs a little earlier: Rebekah's family agrees to the proposal delivered by Abraham's servant Eliezer, that Rebekah should marry Isaac, who was not present. Eliezer then gave presents to Rebekah, her brother and

Plate 13 *Landscape with the Marriage of Isaac and Rebekah* (No. 21).

mother, 'and they did eat and drink, he and the men that were with him and tarried all night' (Genesis 24: 54). At the extreme right of the painting a man accepts a drink (Fig. 10). As this is the only correspondence between the painting and the biblical text, the excuse for its title is thin.

That, however, is not the end of the story. A slightly earlier drawing in the Musée Bonnat, Bayonne (MRD 645), showing a social gathering with the central figures dancing is inscribed 'nozze di rachel giacob' (marriage of Rachel [and] Jacob). This was another biblical marriage short on ceremony: 'Then [Laban] gave [Jacob] Rachel his daughter to wife also... And he

went in also unto Rachel...' (Genesis 29: 28–30). The drawing is essentially a rural dance scene, the religious significance of which lies only in the inscription.[32] No painting resulted from this drawing, but what is clear is that Claude was trying to dress up a genre subject – the rural dance scene (Fig. 11) – in the clothes of history. The point is reinforced by a near identical version of the National Gallery's *Isaac and Rebekah* in the Galleria Doria-Pamphili, Rome. The latter painting is not inscribed as being a painting of Isaac and Rebekah or of any other subject, and is called *Landscape with Dancing Figures*, or alternatively, *The Mill*, after the building in the background. The National Gallery

Fig. 11 *Dancing Shepherds near a Wood*, c.1637. Oil on canvas, 96.5 x 132 cm. Duke of Westminster Collection.

Fig. 12 *View of Delphi with a Procession*, 1650. Oil on canvas, 150 x 200 cm. Rome, Galleria Doria-Pamphili.

painting has as its pair *Seaport with the Embarkation of the Queen of Sheba* (Plate 14), another quasi-biblical subject identified by Claude's inscription on the painting. The pair to the Doria-Pamphili version is the *View of Delphi with a Procession* of 1650 (Fig. 12), the title of which is also based on Claude's inscription on it: 'HAC ITUR AD DELPHES' (This is the way to Delphi). While in both the *Embarkation of the Queen of Sheba* and the *View of Delphi* the figures and setting are consistent with a (loose) reading of the paintings' subjects, it is the inscriptions alone which give them specificity.

The National Gallery pair were bought by the Duc de Bouillon (1605–52), the general of the Papal army from 1644 to 1647. The pair in the Galleria Doria-Pamphili were bought by Prince Camillo Pamphili (1622–65), nephew of Pope Innocent X. The history of the two commissions is unclear, save that the *Isaac and Rebekah* was originally destined for Pamphili and probably the *Queen of Sheba* also.[33] Pamphili may have originally commissioned the paintings (inscribed with suitable subjects) in anticipation of his renunciation of his cardinalship and his marriage in 1647 to Olimpia Aldobrandini, though he failed to anticipate that this love match, solemnised against the wishes of his mother, would force his immediate exile from Rome.[34] Claude completed the commission the following year, perhaps sharing Pamphili's hope that the exile would be brief. When that proved not to be the case, Bouillon, who had himself left Rome in 1647, may have offered to buy the completed paintings via an agent, at which point Claude inscribed Bouillon's name on the *Queen of Sheba*. Pamphili then ordered a replica of the *Isaac and Rebekah* but, perhaps in view of the sensitivity of the subject of marriage, did not have the inscription on the first version repeated, nor did he have a replica made of the *Queen of Sheba*. As if to underline that the new version of the *Isaac and Rebekah* was only a rural dance scene based loosely on the antique, Pamphili ordered as its pair a painting of a 'safe' subject, which by its inscription was evidently connected to Delphi where Apollo had an oracle.

Of necessity this is speculation, but the conclusion seems nonetheless inescapable that at this stage of Claude's career he, and presumably his patrons also, felt it possible to determine the perception of the contents of a painting in part by its presentation. If the figures in themselves did not identify the story, then the inscriptions on the paintings – irremovable labels as it were – did. The purpose of some of Claude's inscriptions on paintings of the embarkation of saints – for example that on *Seaport with the Embarkation of Saint Paula* (Madrid, Prado) – may therefore have been not

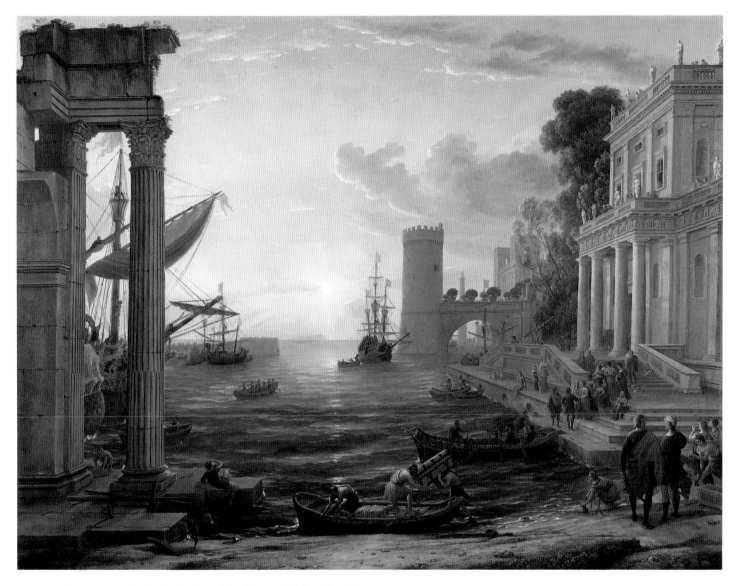

Plate 14 *Seaport with the Embarkation of the Queen of Sheba* (No. 26).

just to identify the subject but also to announce that the scene in question was not a run-of-the-mill port scene.

Paintings inscribed by Claude with their subjects are, however, relatively unusual overall. *Landscape with Aeneas at Delos* (No. 53) has inscribed on it the names of the principal figures (Anius, Achises and Aeneas) in a story related by Ovid and Virgil. *Landscape with Saint Philip baptising the Eunuch* (No. 33) has its New Testament subject inscribed on it even though it was commissioned by a cardinal who may be assumed to have been able to recognise it. *Landscape with Ascanius shooting the Stag of Silvia* (No. 60) was

inscribed both with its subject and its source. The inscriptions on these and other paintings were in French, Italian or Latin, and sometimes a mixture, for example *Aeneas at Delos*, and generally were in the language of the patron.[35] Patrons possibly requested these identifying inscriptions to inform other viewers of the paintings' subjects and perhaps to alert them that they were more than landscapes. In the later paintings, the inscriptions have more of the character of legends to book illustrations than suggestive titles, and it is possible that they served as a display of learning by both painter and patron. How easy it was to overlook an

inscription, however, is shown by the case of the *Ascanius*, which was inventoried as a deer hunt in spite of an elaborate inscription on it identifying the subject and its literary source.

The pastoral world

It would be wrong to assume that because a painting by Claude had no subject derived from an identifiable literary source, it was therefore without meaning.[36] More likely it had meanings which were elusive and open, resonances of an antique world beyond precise analysis, an apparently ideal world of shepherds and nymphs which was sufficiently distanced from the viewer for him to project on to the painting meanings associated, perhaps, with nostalgia or melancholy. *Landscape with a Goatherd and Goats* (see Plate 4) may represent a painting of this type (as indeed would *Landscape with the Marriage of Isaac and Rebekah* were it possible to ignore the inscription). Although such paintings have their own visual tradition in, for example, sixteenth-century Venetian paintings (Fig. 13), they, like their Venetian predecessors, depended for their resonances on a literary tradition – that of the pastoral poem. The literary progenitors of sixteenth- and seventeenth-century pastoral poetry were the *Eclogues* of Virgil, a series of verses which open with the lines: 'You, Tityrus, lie under your spreading beech's covert, wooing the woodland Muse on a slender reed.' Renaissance and later poets saw in the *Eclogues* an ideal outdoor world far from the cares of court and city life, peopled not by gross labourers but by shepherds, poets and musicians.

The shepherd's life was seen as 'a perfect image of the state of Innocence, of that golden Age, that blessed time, when Sincerity and Innocence, Peace, Ease, and Plenty inhabited the Plains.'[37] The ideal occupation had, however, to be joined to the ideal landscape, 'pleasing Meadows, shady Groves, green Banks, stately Trees, flowing Springs, and the wanton windings of a River, fit

Opposite: Plate 15 *Landscape with Saint Philip baptising the Eunuch*, detail (No. 33).

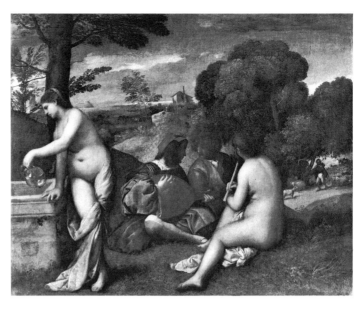

Fig. 13 Titian, *Le Concert Champêtre*, 1510/11. Oil on canvas, 110 x 138 cm. Paris, Musée du Louvre.

objects for quiet innocence...'[38] Numerous poets of the Renaissance and Baroque periods expressed similar sentiments. The comparison between poetry and painting was a well-established commonplace, and while Claude's pastoral paintings do not illustrate specific texts, it seems highly probable that they evoked reminiscences of the *Eclogues* and of Renaissance pastoral poetry. They are brought to mind, for example, by the enjoyment of the seventeenth-century French poet Le Digne at imaginary shepherds leading their flocks to the sound of flutes: 'Fortunate good folk to be thus far from town, far from ambition, far from useless manners, far from the tricks of the Court replete with infidelity.'[39] Essential to this imagined world was its self-containedness.

Often, as in Claude's paintings, the cities are present but far distant, providing the reassurance of choice between town and country without the squalid reality. Sometimes the rustic solitude is complete and then it is associated, as it was by Jacques Davy Du Perron, Archbishop of Sens (1556–1618), with melancholy: 'On the sadly sweet banks of the waters I rest, and see flowing together both the waters and my days. There I see myself gaunt and pale, and if I still love their

Plate 16 *Landscape with the Flaying of Marsyas* (No. 71).

dreamy softness where my sorrow finds its reflection, in the most secret of woods I tell of my martyrdom.'[40] The lines recall Ovid's story of Narcissus and Echo, a subject painted by Claude (see Plate 28), but they are not a paraphrase of it, any more than Claude's pastoral paintings are illustrations of specific poems. It is necessary to know the story of Narcissus and Echo to understand its particular moral message, but not to see that Claude's painting and Du Perron's sonnet tap into similar sentiments.

The sentiments themselves were not those of rustic folk but of courtiers and city dwellers. Virgil was appreciated through more recent poems such as Sannazaro's *Arcadia* (Venice 1502), an often reprinted poem in which a nobleman, Sincero, becomes a shepherd while he dwells in Arcadia, a poetic land of melancholy.[41] What was appealing was the unreality. It was this that permitted the cultivated reader or viewer to identify with such scenes. Writing shortly after Claude's death, although not about his paintings, the French writer Fontenelle (1657–1757) said: 'When someone represents to me the calm that reigns in the country, the simplicity and tenderness with which love is there experienced, my imagination, touched and affected, transforms me into the shepherd's condition, I am a shepherd: but when someone represents to me,

Fig. 14 Nicolas Poussin, *Et in Arcadia Ego, c.*1630. Oil on canvas, 101 x 82 cm. Derbyshire, Chatsworth, Devonshire Collection.

Fig. 15 Nicolas Poussin, *The Finding of Moses*, 1651. Oil on canvas, 116 x 177.5 cm. London, National Gallery.

Plate 17 *Study of Trees in the Vigna Madama* (No. 10).

though with all possible accuracy and justice, the wretched tasks that shepherds do, I cannot envy them, and my imagination remains stone cold. The chief advantage of poetry consists in painting for us vivid pictures of what affects us.'[42]

Poussin's and Claude's views of Arcadia differ, that of Poussin (Fig. 14) lacking the tranquillity of Claude's, and being more assertive in its confrontation with death and in its demand on the viewer to participate. Both artists projected a distancing from reality that was essential to the contemplative enjoyment of their paintings, but they used different means to do so. Poussin's method may be characterised as investigative. His *Finding of Moses* in the National Gallery (Fig. 15), for example, includes architectural elements based on research into what was believed to have existed in

Plate 18 *Landscape with Apollo and the Muses* (No. 72).

Fig. 16 Annibale Carracci, *Landscape with the Flight into Egypt*, *c.*1604. Oil on canvas, 122.5 x 230 cm. Rome, Galleria Doria-Pamphili.

ancient Egypt. Claude's method by contrast was imaginative – imagined buildings alluding to actual ones, for example the variation of the Pantheon in *Aeneas at Delos* (see Plate 30), actual ones in imagined settings,

such as the Arch of Titus shown partially reconstructed in Plate 25 – but there was rarely any attempt to paint a scene or its details with archaeological correctness.[43]

The distancing of the painted scene from the viewer's perception of everyday reality, common to both Poussin and Claude, was deliberate. It was in response to the view widely held in the seventeenth century that both poetry and painting should represent things not as they were but as ideally they should be, that is to say that nature should not simply be imitated but should be improved upon by a selection from its most beautiful parts.[44] The example was frequently given of how the ancient Greek painter Zeuxis, faced with having to make an image of Helen of Troy, amalgamated the most beautiful parts from each of five female models. The concept of idealisation, although formulated in

connection with the depiction of the human form, was applicable to the depiction of landscape also, both in the choice of the individual landscape elements – hills, trees, water, etc. – and in their harmonious arrangement. This was first exemplified by Annibale Carracci in his *Landscape with the Flight into Egypt* (Fig. 16), and later adopted by Claude in serene compositions in which elements of land and sky, open and closed space were carefully calculated as, for example, in his *Landscape with the Flaying of Marsyas* (Plate 16).

Idealisation did not mean the abandonment of natural forms. On the contrary, the extraction of the ideal from the natural was dependent on an intimate knowledge of nature. Claude's studies of trees are exemplary in this respect (Plate 17), as are his observations of plants at the front of the Edinburgh *Apollo and the Muses* (Plate 18). Hence Sandrart's praise for Claude's trying 'by every means to penetrate nature, lying in the fields before the break of day and until night in order to learn to represent very exactly the red morning sky, sunrise and sunset and the evening hours',[45] and hence Claude's practice of not copying his drawings from nature in paint, but instead inventing landscapes based on his understanding of nature as recorded in his drawings. Among Claude's numerous studies of artists drawing (Plate 19) there is none showing an artist inside his studio. This absence is as personal a statement by the artist of the artistic role he adopted for himself as any written credo might have been (of which there is none).

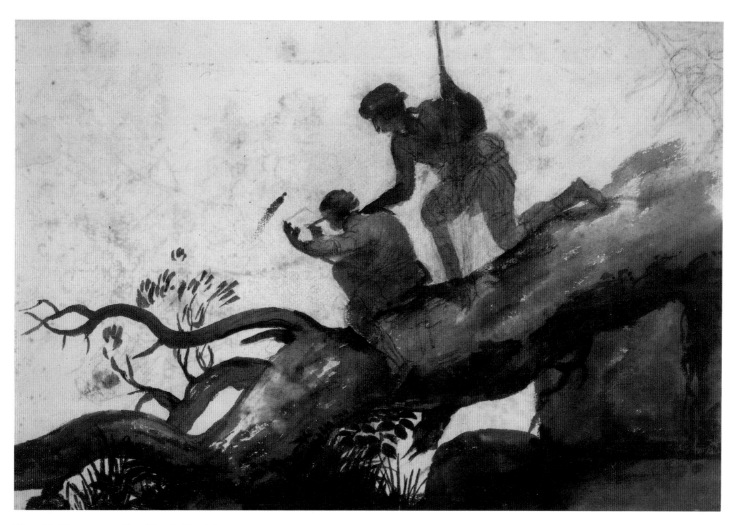

Plate 19 *Figures on a Tree Trunk* (No. 14).

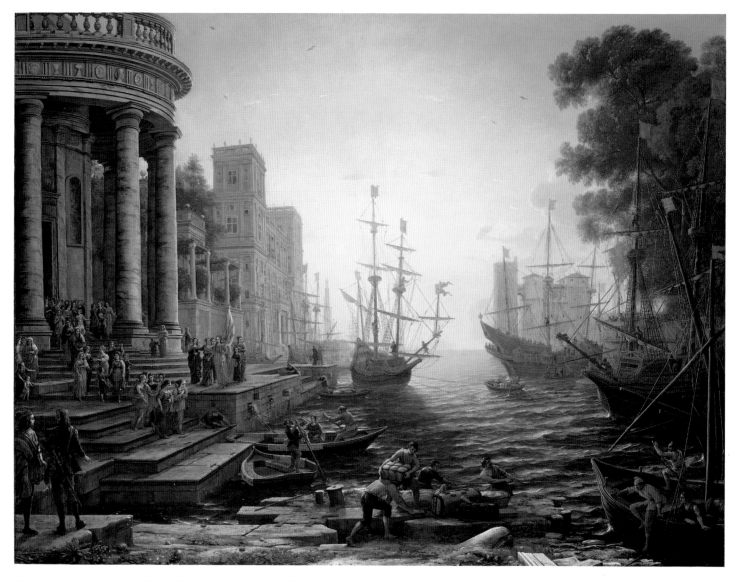

Plate 20 *Seaport with the Embarkation of Saint Ursula* (No. 15).

Opposite: Plate 21 *Seaport with the Embarkation of Saint Ursula*, detail.

Claude employed other means than idealisation to induce the kind of reverie which might have allowed Fontenelle to 'become' a shepherd while looking at a Claude painting. His religious subjects as well as his pastorals are replete with themes of journeying, or rising or setting suns, and sometimes both. The allusive nature of these motifs is reflected in contemporary poetry, for example that of Du Bois in *La Nuict des Nuicts* (Paris 1641), where the poet consciously confuses God and the sun: 'This sweet Creator of beauties/In greeting us good evening hides itself in the waters/And the lengthening shadows/Warn Heaven to light its flares.'[46] The idea of a relationship between light and the divine was an established one,[47] and in *Seaport with the Embarkation of Saint Ursula* (Plates 20 and 21) there may have been seen an allusion to the saint travelling towards the sun/divine via her impending martyrdom. The other aspect of Claude's art which encouraged reverie was its numerous references to the passing of time. This is particularly the case in those pictures which incorporated journeying and/or the sunrise or sunset, as well as pastoral subjects which alluded to antique time.[48]

The spiritual associations evoked by Claude's

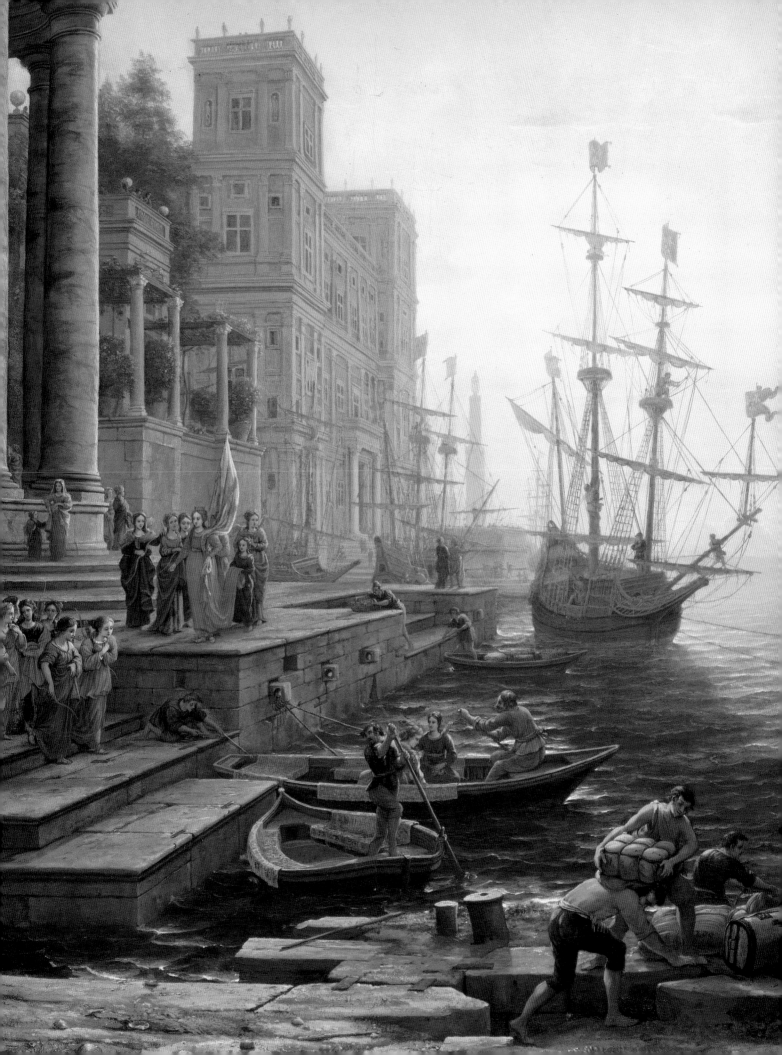

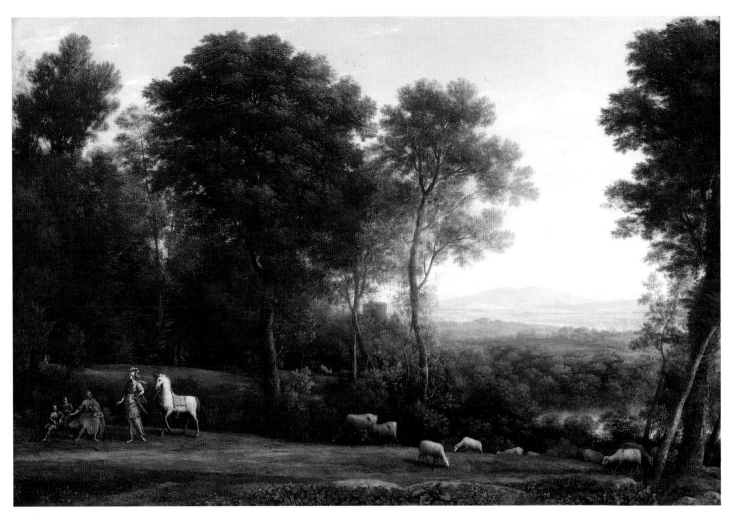

Plate 22 *Landscape with Erminia and the Shepherd* (No. 43).

paintings of religious subjects may also have been evoked by his pastorals. The relationship between the contemplation of nature and the contemplation of God was expressed by the Milanese prelate Cardinal Federico Borromeo (1564–1631), who owned landscapes and still lifes by, among others, Jan Breughel the Elder and Paul Bril. In his devotional treatise of 1625, *I Tre piaceri della menta christiana*, Borromeo wrote that the contemplation of nature was a means of being close to the Creator because his presence was to be found in all things. Later he wrote that 'paintings enclose in narrow places, the space of earth and the heavens, and we go wandering, and making long [spiritual] journeys standing still in our room...' (*Pro suis studiis*, 1628).[49] This was not an attitude restricted to Italy. Jean Baudoin in 1638 likened the whole world to a painting 'in which the things painted make us admire the Worker who made them'.[50] For Arnaud d'Andilly, writing in 1671, the soul could be led to contemplate and adore the Creator in listening to 'the murmuring so sweet of the clear water streams, the harmonious sound of birds in concert...'[51] More specifically relevant to Claude, who was particularly celebrated for his renderings of the rising and setting sun, are the numerous associations made by his contemporaries between the sun and divinity. The poet Saint-Amant (1594–1661) saw the sun as a reflection of the Creator, giving life to the universe and nature, and maintaining its order; Antoine Godeau (1605–72), Bishop of Grasse and Vence, likened God to the sun which disperses the

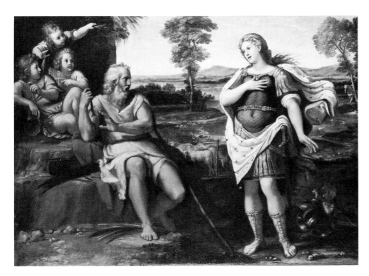

Fig. 17 Circle of Annibale Carracci, *Erminia takes Refuge with the Shepherds*, c.1605. Oil on canvas, 147.5 x 214.5 cm. London, National Gallery.

shadows of the soul just as the actual sun disperses the shadows of the night (*Poésies chrestiennes*, 1654); and the Jesuit Jean de Bussières (1607–78) wrote that the sinner should love God with the constancy and regularity of the sun's course (*Descriptions poétiques*, 1649).[52]

This is not to say that anyone looking at a sunrise by Claude would necessarily at once think of God. Even the pious Borromeo admitted that when he ordered a *Winter Landscape with a Glory of Angels* from Brueghel and Rottenhammer he was not thinking at all of symbols or mysteries, and only later came to see in the painting 'earthly misery...represented by the face of winter, and the joy of Heaven by spring'.[53] The point is rather that there were available multiple associations which were not mutually exclusive. The error would be, in any discussion of Claude's subject paintings, not to take account of the non-subject paintings, both for the associations with which they might themselves have been invested, and for the associations which they carried over to, or shared with, the subject paintings. The converse is true: although Claude's paintings of subjects based on specific texts may have carried specific meanings, in some cases relevant to the individual patron, they may have carried other messages as well. Among many paintings by Claude which are both episodic and evocative is *Landscape with Erminia and*

the Shepherd (Plate 22). This shows an episode from Tasso's popular *Gerusalemme Liberata* (see page 89), but at the same time goes to the heart of its pastoral nature. It may thus have exploited two quite different types of reaction by the viewer: the pleasure of recognition of the particular part of the story and the afterglow of the pastoral associations with which Claude invested it. That this was far from being a painter's automatic response to the text can be seen by comparing Claude's rendering with that by a member of the circle of Annibale Carracci, *Erminia takes Refuge with the Shepherds* (Fig. 17).

Unmatched pairs

If it is correct that Claude's paintings operated at different levels, this may provide a solution to a long-standing problem in his work – the question of his 'unmatched' pairs. That is to say, although the nominal subject matter in each of two paired paintings may be unconnected, their underlying or secondary meanings may be related. Nearly half of Claude's total output of paintings, including many of his most important works, have been identified as pairs.[54] Typically a landscape would be matched with a port scene or a seascape, a morning scene with an evening scene. The visual balance was often further reinforced by the composition. *Landscape with the Marriage of Isaac and Rebekah* and *Seaport with the Embarkation of the Queen of Sheba* (see Plates 13 and 14) illustrate this. The first is a late-afternoon landscape framed by trees on the right, the second is a morning port scene framed by columns on the left. In the first light falls from the right, in the second from the left. These are principles to which Claude held, as is shown by his final pair, *View of Carthage with Dido and Aeneas* and *Landscape with Ascanius shooting the Stag of Silvia* (see Plates 34 and 33), in which, again, a port scene lit from the right is contrasted with a landscape lit from the left, and in which the columns on the right of the *Dido and Aeneas* are answered by those on the left of the *Ascanius*.

While Claude's visual matching of pairs was con-

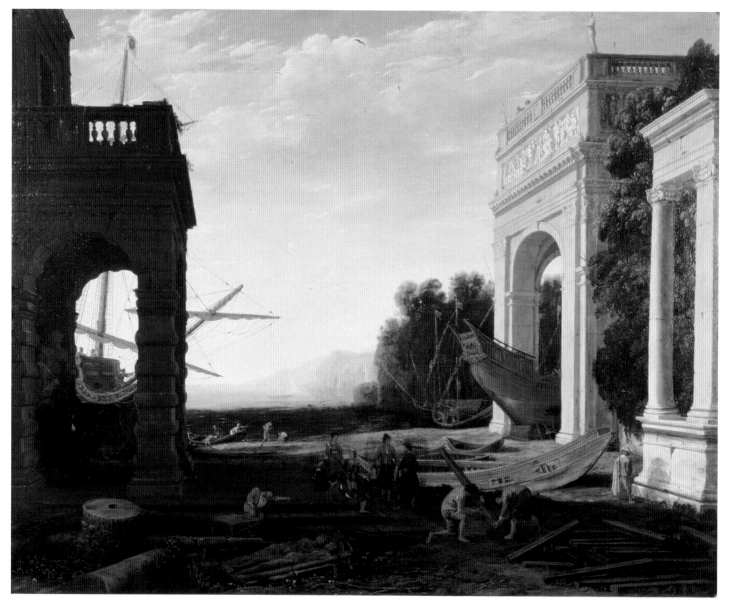

Plate 23 *Coast View* (No. 65).

sistent, there was less consistency in matching the sources from which the subject matter of each pendant was derived. Three examples of such 'unmatched' pairs are illustrated here. They are, in chronological order: *Coast View* and *Landscape with the Judgement of Paris*, both of 1633 (Plates 23 and 24), *Pastoral Landscape with the Arch of Titus*, 1644, and *Coast Scene with the Landing of Aeneas*, 1650 (Plates 25 and 26), and *Landscape with the Father of Psyche sacrificing at the Temple of Apollo*, 1662, and *Landscape with the Arrival of Aeneas before the City of Pallanteum*, 1675 (Plates 32

and 31). In the first two pairs, a subject based on a literary source is paired with one that is not. In the third case a subject based on the *Golden Ass* of Apuleius is paired with a subject based on Virgil's *Aeneid*. The significant differences in the dates between each painting of the second and third pairs cannot alone account for the apparent mismatches, since other such cases occur in Claude's work in which each part of the pair was painted within a year or so of the other.[55]

Coast View and *Landscape with the Judgement of Paris* (Plates 23 and 24) have been identified as

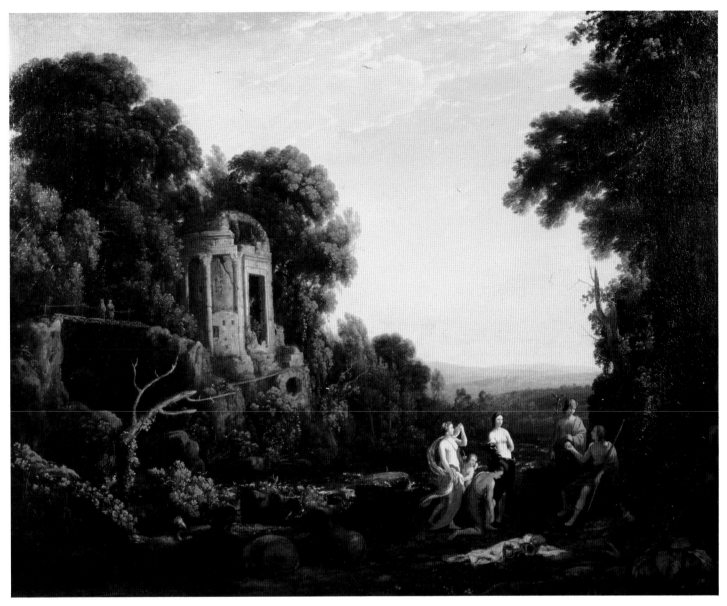

Plate 24 *Landscape with the Judgement of Paris* (No. 66).

Fig. 18 *Landscape with the Judgement of Paris*, 1645/6. Oil on canvas, 112.3 x 149.5 cm. Washington, National Gallery of Art.

Claude's earliest pair on canvas.[56] Their patron is unknown. In the latter, Paris is shown presenting the golden apple to Venus who is accompanied by Cupid, while Minerva kneels and Juno stands facing the viewer. The significance of Paris' choice of Venus had long been a matter of interpretation. For example, the sixth-century historian Fulgentius, whose *Mythologies* were in print from 1498, claimed: 'Paris...did a dull and stupid thing and, as is the way of wild beasts and cattle, turned his snail's eyes towards lust [Venus] rather than selected [sic] virtue [Minerva] or riches [Juno].'[57] Later

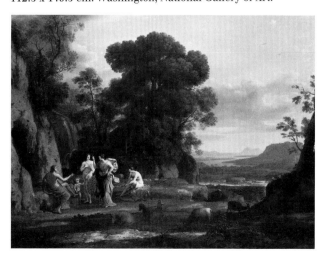

Plate 25 *Pastoral Landscape with the Arch of Titus* (No. 52).

interpretative literature saw the goddesses as repre-
senting the contemplative life (Minerva), the active life
(Juno), and the sensual life (Venus). However, in con-
trast to Claude's later version of the subject (Fig. 18) in
which Paris has yet to make his choice and Juno's ges-
ture of exhortation points some moral, in this earlier
version the 'dull and stupid' Paris, looking every bit the
part, has already decided.[58] Claude therefore shows not
the moral conflict that preceded Paris' decision but the
fateful moment of the decision itself, the tragic conse-
quences of which (the Trojan War) are possibly alluded
to by the prominently placed ruined temple. Paris' ulti-

mately destructive action can be contrasted with the
scene of construction and trading and the rich build-
ings in *Coast View*. The paintings may, therefore,
represent a contrast between reasoned discussion and
constructive activity on the one hand, and destructive
impulse on the other.

Making an interpretative connection between
Pastoral Landscape with the Arch of Titus (Plate 25) and
Coast Scene with the Landing of Aeneas (Plate 26) is
more problematic. As with the first unmatched pair
discussed, the patron (in this case probably French)
is unknown. Six years separate the two paintings,

Plate 26 *Coast Scene with the Landing of Aeneas* (No. 48).

Plate 27 *Landing at a Classical Seaport* (No. 49).

although the drawing of a *Landing at a Classical Seaport* (Plate 27) signed and dated 1643, suggests that this was Claude's original idea for a pendant, later abandoned for the present painting.[59] Further, the subject of *Coast Scene* has not been identified, although it is probably one of the landings of Aeneas, the ancestral hero of the Romans, of which several are recounted by both Virgil and Ovid. The *Pastoral Landscape* on the other hand is not connected to any text, although the ruined Arch of Titus is prominent in the painting. Titus was Emperor of Rome (AD 79–81), and other ruins with which he may have been associated by educated

seventeenth-century Romans are depicted in imagined locations: the superimposed arches of the Colosseum, finished during his reign, and an aqueduct, of which he ordered a number to be repaired. If *Coast Scene* indeed shows Aeneas it can be connected with the origins of ancient Rome, while the ruined Arch of Titus evokes the end of Roman power. It was, therefore, both reasonable and imaginative that from the late eighteenth century *Coast Scene* and *Pastoral Landscape* should have been called respectively the Rise and the Decline of the Roman Empire, although as with *Coast View* and *The Judgement of Paris* there is no evidence external to the paintings to support such an interpretation.

Hidden meanings

In the latter part of Claude's career he painted a preponderance of subjects derived from identifiable texts. Where this is the case, and where the patron can also be identified, it is possible to propose that the painting(s) in question had some meaning particular to the patron. This task is both helped and hindered by the abundant literature available in Claude's time which purported to interpret the texts of the ancient authors – helped because such interpretative literature existed at all, and hindered because the same incident in the ancient source might be subject to different interpretations. Furthermore, this interpretative literature needs to be treated with caution because it is not always clear how far artists or their patrons were aware of it, or wished to allude to it, and because even men of acknowledged learning could be impatient of it. As Sir Francis Bacon observed early in the seventeenth century: 'It is true fables, in general, are composed of ductile matter, that may be drawn into great variety by a witty talent or an inventive genius, and be delivered of plausible meanings which they never contained. But this procedure has already been carried to excess; and great numbers, to procure the sanction of antiquity to their own notions and inventions, have miserably wrested and abused the fables of the ancients.'[60]

Given its revelatory nature, sacred text offered

more limited opportunities in seventeenth-century Rome for multiple interpretation, although episodes in the Old Testament were traditionally interpreted as prefigurations of episodes in the New. Even so particular biblical episodes might have seemed appropriate to particular patrons. Interpretations specific to the patrons have been proposed, for example, for *Landscape with David at the Cave of Adullam* and *Landscape with Saint Philip baptising the Eunuch* (see Plates 7 and 6; Nos. 27 and 33).[61] Profane poetry, however, was open to multiple interpretations and it was specifically in relation to Ovid's *Metamorphoses* – the most celebrated poem of the best known of the ancient Roman authors in the seventeenth century – that the French writer Richer echoed Bacon's warning. Richer scorned 'our mythologists who devote all their study to seeking a moral sense in the most chimerical [of Ovid's] thoughts'.[62] Nevertheless, the idea that the ancient poets, and Ovid in particular, used poetry as an entertaining disguise for moral truths was commonplace in the sixteenth and seventeenth centuries.[63] Further it was frequently stated that ancient poetry did not veil a single meaning, but multiple meanings. As another commentator, Barptolomy Aneau, wrote: 'It is of the very nature of poetry, as distinct from other forms of discourse, that it is able to carry the greatest number of simultaneous meanings and so satisfy the reader's human search for plentitude and significance' (*Trois premiers livres de la Metamorphose d'Ovide*, Lyon 1556).[64] The game of interpretation was one which the educated were flattered into joining: 'It requires a critical mind, trained in literary judgement, history, and the sciences to uncover [multiple meanings in fables]'.[65] And just as in poetry, so in painting: in the Jesuit colleges of France and in Lorraine, Claude's country of birth, a young man's education in rhetoric included working out the riddle which his teacher considered a particular painting might contain.[66] This would have inevitably involved careful looking at the painting in question and imaginatively interpreting it. Between the pleasure of recognition of a

Fig. 19 'La Fontaine du Miroir Perilleux. Amour de Soy Mesme.' Barptolemy Aneau, *Imagination Poetique*, Lyon 1552, page 66. London, British Library.

particular episode, and the afterglow derived from its pastoral associations, Claude's paintings perhaps more than most permitted to the learned a further, cryptic thrill of intellectual satisfaction.

The tradition of interpreting the ancient texts was particularly rich in relation to Ovid's *Metamorphoses*, which was a standard school text and immensely popular in the seventeenth century.[67] These interpretations had two main strands. One was religious, whereby objects and events in the *Metamorphoses* were given divine significance. The best known of the religious interpretations was the *Ovidius moralisatus* by Pierre Bersuire (d. 1362), translated into French and printed in Bruges in 1484,[68] in which, for example, the spear given by Procris to Cephalus was seen as symbolic of 'the divine word which penetrates where it wishes and when it is so pleased to the very heart of his human creatures'.[69]

From the mid-sixteenth century, however, religious interpretation of the *Metamorphoses* was superseded by moral interpretation, largely because of Counter-Reformation clerical objections to Ovid's poetry being treated like a religious text.[70] For writers around 1600 the licentious stories in the *Metamorphoses* were 'set down that we viewing their incontinence, should fly the

like impudencie, nor follow the like excesse' (1578).[71] The story of Narcissus (see page 106), the youth so wrapped up in admiring himself that he had neither eyes nor ears for anyone else, was an especially popular spur to such moralising.[72] 'O YOUNG people, step back and never admire yourselves in such water. THIS well is SELF-LOVE', counselled Barptolomy Aneau in a book of illustrated morals based on the *Metamorphoses* (Fig. 19).[73] The legend to the accompanying illustration translates as: 'The well of the perilous mirror. Love of oneself.' An especially well-known book of often moralising interpretation was Natali Conti's *Mythologiae* of 1551, first translated from Latin into French in 1597 and republished in French in 1627. For Conti the lesson of Narcissus' fate was a warning against glorification of one's own beauty, wealth, nobility, or power, without recognising that such things derived from God's generosity.[74] To judge from the poet Thomas Howell's (fl. 1568–81) marginal notes to his version of the fable, sentiments of this kind seem to have been widespread: 'Pryde is the destroyer of many good gyftes' and 'The transitory thinges of this world are not to be trustyd.'[75]

Claude's *Narcissus and Echo* (Plate 28) was painted for an unidentified English patron in 1644.[76] It cannot be assumed, however, that the patron's purpose in commissioning the painting was as a moral exemplar. Even if it was so commissioned, different morals could be drawn from the story. Jean Baudoin, for example, saw Narcissus less as an example of self-love and more as the type of man who retires to the country to lead a solitary life, so failing to work for the public benefit or to become involved in political affairs.[77] Yet such retirement was the pastoral dream evoked by many of Claude's paintings, including, through its setting, his *Narcissus and Echo*. For Baudoin, therefore, Claude's treatment of the subject would inevitably have denied the story's moral purpose. Another contemporary author took a wholly different line on the story, identifying with the nymph Echo: 'This fable teaches us that after many cares, anxieties and troubles which accompany the services one renders to [great lords], and the

Plate 28 *Landscape with Narcissus and Echo* (No. 67).

affection one has for them, like the unfortunate Echo all that we are often left with is just a voice with which to complain.'[78]

The position is complicated in the case of Claude's painting by the prominent inclusion of the nymph (who was originally draped) in the bottom corner. No such figure is included in Ovid's story, so that her inclusion in the painting (draped or not) seems to be a diversion from any intended moral. The Greek author Pausanius, writing towards the end of the second century AD, recounts that: '...there is another story about Narcissus,

less popular indeed than the other, but not without some support. It is said that Narcissus had a twin sister; they were exactly alike in appearance, their hair was the same, they wore similar clothes, and went hunting together. The story goes on that Narcissus fell in love with his sister, and when the girl died, would go to the spring, knowing that it was his reflection that he saw, but in spite of this knowledge finding some relief for his love in imagining that he saw, not his own reflection, but the likeness of his sister.'[79] It would be tempting to conclude that the nymph represents

Narcissus' sister were it not for the fact that she looks more asleep than dead. Instead it is possible that Claude included the figure of the reclining nymph to stress the 'blindness' of Narcissus' self-regard. This would accord with an allegorical interpretation of Ovid's story probably current in Claude's time. The sixteenth-century Italian writer Alessandro Farra saw in the myth of Narcissus and Echo an allegory of the man who neither listens to the voice of God nor sees the true nature of the world, instead turning away from contact with intellectual beauty.[80] Farra made a specific analogy between God's voice and Echo, so a

seventeenth-century mythologist may have been tempted to see in Claude's sleeping nymph the intellectual beauty shunned by man, who turns his back on the true nature of the world as represented by Claude's extensive landscape.

The moral of the story of Cephalus and Procris (see page 107) of which Claude painted a number of versions (Plate 29) was no more straightforward than that of Narcissus. One writer's interpretation was that suspicion of one's spouse often resulted in great misfortune.[81] For another, who concluded that 'jealousy is a mortal poison', the moral need not be limited to

Plate 29 *Landscape with Cephalus and Procris reunited by Diana* (No. 69).

Plate 30 *Landscape with Aeneas at Delos* (No. 53).

matrimonial situations, although when it was the appropriate behaviour was to be like Augustus' wife, Livia, who turned a blind eye to her husband's infidelities and so retained her power.[82] In the matrimonial context French writers reached opposite conclusions. For Renouard, Cephalus was to be blamed for his addiction to hunting at the expense of spending time with his wife, with the result that he would return exhausted from the hunt, desiring rest rather than Procris.[83] For Du Ryer, however, Cephalus was a great hunter used to getting up at the crack of dawn. When he married Procris, whom he loved passionately, he became lazy and spent more time in bed: he refused Aurora the goddess of the Dawn to stay with Procris.[84]

The episode of Cephalus and Procris reunited in the presence of Diana is not to be found in Ovid.[85] It has been suggested recently that Claude's painting may show Diana as virgin goddess in her role as saviour, so giving it a Christian interpretation.[86] Just as possible, however, is that the patron, familiar with the view that hunting was inimical to marriage,[87] ordered the painting to represent the contrary opinion and with a more secular purpose: it is Diana, goddess of hunting, who joins the couple in a shared activity.

The interpretative method applied to the *Metamorphoses* was applied also to Virgil's *Aeneid*. Consequently, texts were available to explain its 'real' meaning. The *Aeneid* is the story of Aeneas who flees the burning city of Troy and, after many trials and much journeying, reaches Italy where he established the beginnings of the Roman state. It was written during the period 29–19 BC and remained known during the Middle Ages. It appeared in Italian translation by 1476 and French translation in 1509,[88] and was among the best-known and most often reprinted works of the ancient authors.

The fifteenth-century Florentine Cristoforo Landino wrote a moral interpretation of the *Aeneid*, describing the poem as an allegory of the soul in search of divine wisdom. This moral and allegorising interpretation was echoed in the edition of Virgil's work annotated by Giovanni Fabrini, first published in 1576 and reprinted several times in the seventeenth century.[89] Fabrini saw Troy as the body which had to be destroyed and abandoned so that the ideal man could profit from a higher life.[90] As with the *Metamorphoses*, however, other interpretations were available. The German Achilles Bocchius, writing in 1574, saw Aeneas as a symbol of constancy and good moral conduct,[91] a view echoed by Sir Philip Sydney's dictum: 'No philosopher's precepts can sooner make you an honest man than the reading of Virgil' (*An Apologie for poetrie*, London 1595).[92] René Rapin, however, writing in the reign of Louis XIV, was at pains to stress the king-like qualities of Aeneas: devoutness, glory, valour.[93] The comparison between Aeneas and Louis XIV was made explicit by Michel de Marolles, who dedicated to the king *Les Oeuvres de Virgile traduites en prose* (Paris 1655): 'Aeneas who is of the blood of the Gods, well represents in my opinion the greatness of your line, which takes its origin from the most glorious Blood of the Universe.'[94] Five years after this was written, Charles II was welcomed back to England as a new Aeneas come to Italy, so demonstrating the versatility of Virgil's hero in the hands of professional flatterers.[95] On a wholly different tack, one

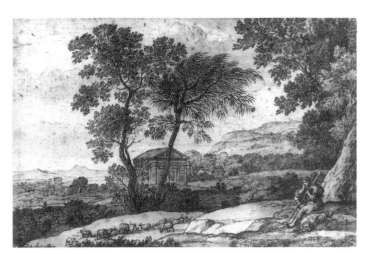

Fig. 20 *Pastoral Landscape* (No. 55).

French cleric extracted lines from the *Aeneid* and other works by Virgil to reconstruct the story of Christ and the early saints.[96] No less than other ancient classical works, therefore, the *Aeneid* was subject to numerous interpretations.

Of Claude's eight Virgilian works, six belong to the period 1672–82.[97] Of the six only one, *Landscape with Aeneas at Delos* (Plate 30), was painted for a French patron,[98] although there was a surge of interest in Virgil's works in France at this period.[99] The story of Aeneas at Delos, painted by Claude in 1672, was told in both the *Aeneid* and in Ovid's *Metamorphoses*, but it was only Ovid's brief account which told of the two trees to which Latona clung when giving birth to Apollo and Diana (Fig. 20). That Claude also consulted Virgil is suggested by the fact that only Virgil said that King Anius was crowned with laurel, and also that Claude's description on the painting of Anius as 'SACER[D]OTE [DI] APOLLO...' is close to the Italian translation of the *Aeneid* which he is known to have used in the same year.[100] It is impossible to say whether Claude's consultation of two sources was suggested by the patron, by an adviser, or self-generated. However, the architectural references to Apollo and to Rome incorporated into Claude's architecture (see No. 53), taken together with the inscription, suggest that Claude perceived his patron as someone who would be impressed by a display of learning.

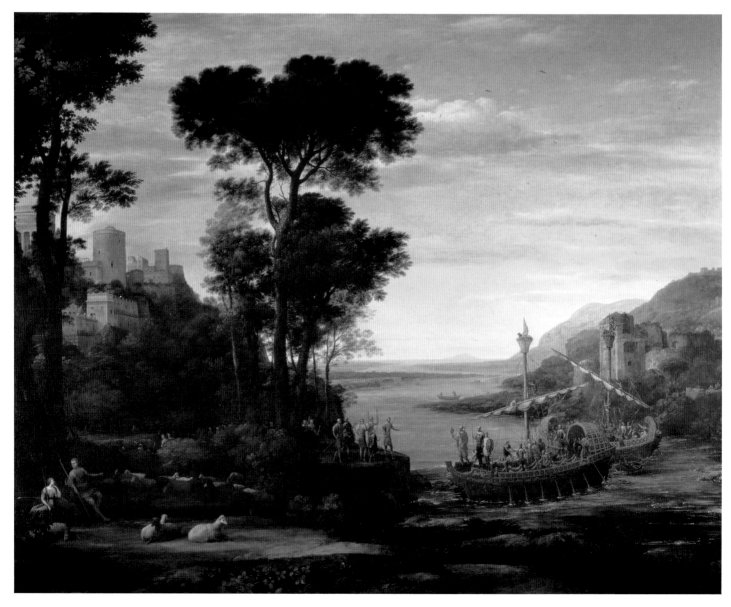

Plate 31 *Landscape with the Arrival of Aeneas before the City of Pallanteum* (No. 56).

Meanings in later pairs

Aeneas at Delos is an example of Claude's later paintings more closely following their textual sources. This transition can be further demonstrated by comparing *Landscape with the Father of Psyche sacrificing at the Temple of Apollo* (Plate 32), executed in 1662, and the painting later commissioned as its pendant, *Landscape with the Arrival of Aeneas before the City of Pallanteum* (Plate 31), executed in 1675.[101] The inscription on the first, recorded in the nineteenth century but now disappeared, was 'IL TEMPIO DI APPOLLO' (The Temple of

Apollo). The precise subject is identifiable not from the painting but from the inscription on a drawing made by Claude eight years later.[102] On the other hand the inscription on the second painting, 'Larrivo d'Anea a palant[eo] al monte evantino' (the arrival of Aeneas at Pallanteum at Mount Aventine), refers to a specific incident in the text of Virgil's *Aeneid*. The subject of the first painting is derived from the story of Cupid and Psyche as recounted in Apuleius' *Golden Ass*: Psyche's father goes to the town of Miletus to receive the oracle of Apollo, and there prays and offers sacrifices to the

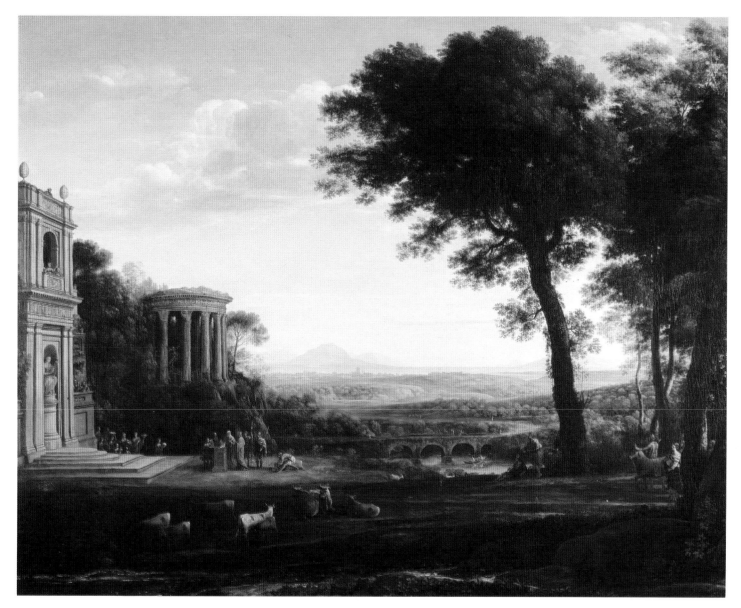

Plate 32 *Landscape with the Father of Psyche sacrificing at the Temple of Apollo* (No. 36).

god to help find a husband for his daughter. The lack of descriptive detail in Apuleius would allow licence to any artist, but Claude has located the statue of Apollo at the left of the painting in a Renaissance-style building juxtaposed with an antique temple adapted from the ancient Temple of the Sibyl at Tivoli.[103] The combination of Renaissance and antique buildings does not, however, appear in the *Arrival of Aeneas* in which Claude has attempted topographical accuracy according to Virgil's text.[104]

The subject matter of the *Father of Psyche sacrificing* and the *Arrival of Aeneas before the City of Pallanteum* has been proposed as specifically alluding to the circumstances of their respective commissioners. The *Father of Psyche sacrificing* was ordered by Angelo Albertoni (1624–1706). The *Arrival of Aeneas* was made for Albertoni's son, Gasparo (1646–1720), who married the sole heiress of Cardinal Altieri in 1667. When Altieri was elected Pope Clement X in 1670, both Gasparo Albertoni and his father took the Altieri name and the title of prince.[105] The first painting has been interpreted as alluding to Angelo Albertoni negotiating

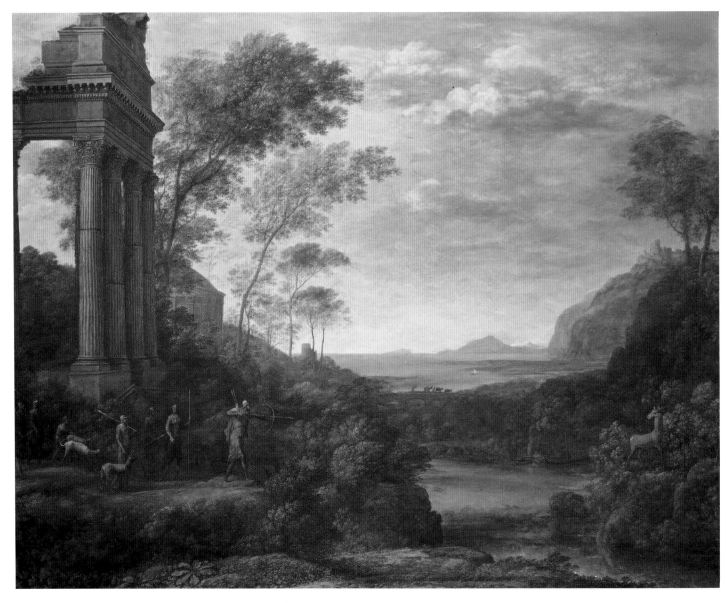

Plate 33 *Landscape with Ascanius shooting the Stag of Silvia* (No. 60).

an ambitious marriage for his son to a noble heiress and the second as alluding to the 'arrival' of the son at the pinnacle of Roman society.[106] This interpretation is problematic, however, because as regards the first painting Psyche's father was praying for the marriage of a daughter not a son, and the outcome of this prayer was the oracle's prophecy that Psyche would marry a monster. Can some alternative interpretation be elicited?

The *Arrival of Aeneas before the City of Pallanteum* was commissioned by Gasparo probably in 1671.[107] One of Claude's preparatory drawings, dated 1672, is inscribed (in translation): 'Prince Don Gasparo has told me that he desires the subject of Aeneas showing the olive branch to Pallas as a sign of peace.'[108] The Altieri, among other noble Roman families, claimed descent from Aeneas, and their family arms decorate the flags on Aeneas' ships.[109] It is, therefore, likely that the *Arrival* alludes to the Altieri princely title and to its distinguished ancestry, and more specifically to Angelo's recently acquired position as commander of the papal galleys.[110] However, even if such specific allusions to the patrons were intended, it seems unlikely that the

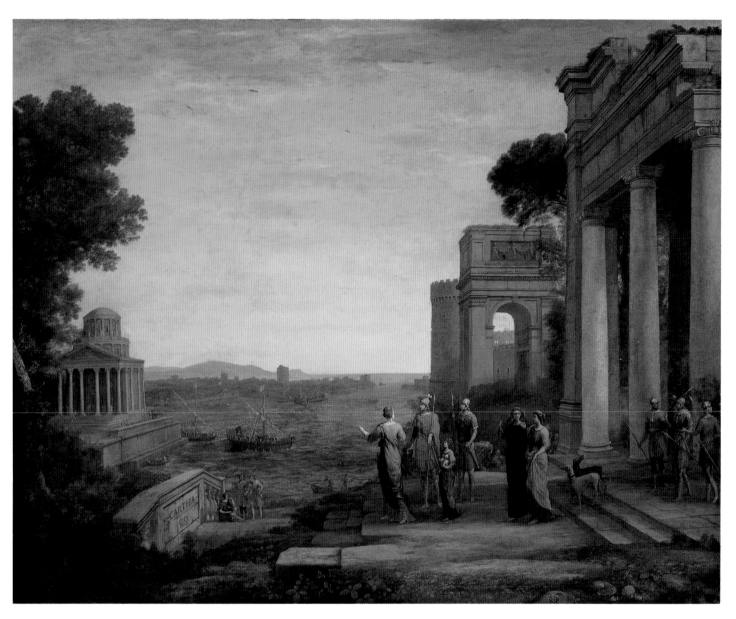

Plate 34 *View of Carthage with Dido and Aeneas* (No. 59).

seventeenth-century viewer would have left it at that. For example, one commentator on the story of Cupid and Psyche, who firmly believed that 'fables usually hide the truth under their veil', proposed a parallel between Psyche's father sacrificing and the biblical episode of Abraham's intended sacrifice of Isaac. It was, he said, obedience to God's will which saved Isaac.[111] The two paintings might then have been seen to represent submission to God's will (the *Father of Psyche sacrificing*) leading the soul to divine wisdom (the *Arrival of Aeneas*), or, more abstractly, as paintings

representing question on the one hand, represented by the oracle being consulted, and resolution on the other, represented by arrival at the ultimate destination.

Claude's last pair of paintings, *View of Carthage with Dido and Aeneas* of 1676 (Plate 34) and *Landscape with Ascanius shooting the Stag of Silvia* of 1682 (Plate 33), were painted for Lorenzo Onofrio Colonna (1637–89), Claude's most important patron in his later years. The inscriptions on the first painting, 'AENEAS. ET DIDO' and 'CARTHAGO', and on the *Liber Veritatis* drawing, 'libro 4. de virgilio f. 108(?)' (the folio number

is unclear), indicate both subject and source. Whether the precise subject shown is that of Dido and Aeneas leaving for the hunt or alludes to Aeneas' forthcoming departure from Carthage has been disputed.[112] Claude's probable intention was to illustrate in the first place a specific passage in the text, in this case Dido and Aeneas leaving Carthage to go hunting. However, he has also included references to past and future time: Dido points both towards the Temple of Juno (goddess of marital fidelity), in which she and Aeneas had met, and towards the ships in which Aeneas and his party would later leave. Aeneas' gesture seems to anticipate the conflict between love and duty that he would later experience (see page 100). Above are shown the gathering storm clouds which will force the couple to seek refuge during the forthcoming hunt with fateful consequences.

The moment is one of suspense. Although alluding to a tragic future, no illicit act has yet occurred, the couple may yet not depart for the hunt, and Aeneas may decide to leave Carthage before becoming Dido's lover. The pendant, *Landscape with Ascanius shooting the Stag of Silvia* (Plate 33), on the other hand, does show a single moment of time, as well as illustrating specific lines of Virgil's text. It may also allude more generally to the destruction of love or innocence of which the deer was symbolic.[113] Colonna's own adulteries caused his wife to leave him in 1672, but, since he became penitent only in his last moments,[114] it is unlikely that these paintings represent expressions of remorse. One possible personal allusion to Colonna himself is the prominent motif of columns in both paintings: a column , predictably, was the symbol of the Colonna family.

The contrast between on the one hand a painting showing a time just before a fateful decision is to be made, and on the other hand one showing a specific event, may have its parallel in an earlier Colonna commission given to Claude. This was for two paintings, both of unusual subjects, based on the story of Psyche and Cupid (see page 86).

The story of Psyche and Cupid appears in Apuleius' *Golden Ass*. The beautiful Psyche, a mortal, threatened with marriage to a monster, is wafted away by the West Wind. She awakes and sees a magical palace. There she encounters Cupid who becomes her lover, but makes her promise not to look upon his (divine) face. Psyche's sisters, however, overcome with jealousy, eventually persuade her that Cupid is a monster whom she should murder while he sleeps. However, a drop of burning oil from her lamp wakes him and, after berating her for breaking her promise, he abandons her. In despair she attempts to drown herself but is saved by the river, which pities her. It is this last incident which is shown by Claude in *Psyche saved from drowning herself*, 1666 (Cologne, Wallraf-Richartz-Museum), the *Liber Veritatis* drawing of which is illustrated here (Fig. 21).

The subject of its companion, *Psyche outside the Palace of Cupid* (Plates 35 and 36), painted two years earlier, has been recently much discussed.[115] The painting does not show, as used to be assumed, a melancholy Psyche after her abandonment by Cupid, because no moment of contemplative melancholy occurs at that point in the story.[116] It has been reasonably suggested that instead Psyche is shown after she has been deposited outside Cupid's palace by the West Wind, and so before her meeting with Cupid, and further that the painting referred to the patron Colonna's marriage in 1662 to Maria Mancini who, like Psyche, had come from the west (in this case from France to Rome).[117] However, a difficulty with this interpretation is that Psyche, although awake, appears not to have seen, or chooses to ignore, the palace so close at hand. A possible alternative interpretation of Claude's painting is that it shows Psyche left alone after her sisters' third and last visit to her.[118] It was during this last visit, that the sisters persuaded Psyche to murder Cupid. As Apuleius relates it: 'after they had thus inflamed the heart of their Sister...they ranne away and tooke shipping. When Psyche was left alone (saving that she seemed not be alone, being stirred by so many Furies),

Plate 35 *Landscape with Psyche outside the Palace of Cupid* (No. 38).

Fig. 21 *Landscape with Psyche saved from drowning herself* (No. 42).

she was in a tossing minde, like the waves of the sea, and although her wil was obstinate, and resisted to put in execution the counsell of her sisters, yet she was in

doubtfull and divers opinions touching her calamite. Sometimes she would, sometime she would not, sometime she is bold, sometimes she feares, sometime she mistrusteth, sometime she is moved, sometime she hateth the beast, sometime she loveth her husband, but at length night came, when as shee made preparation for her wicked intent.'[119]

It is possibly the time of indecision which Claude has shown when the solitary Psyche 'was in a tossing minde, like the waves of the sea'. It is tempting to see in the waves painted by Claude a reference to the words of Apuleius, and in the small boat with two figures in it a reference to Psyche's departing sisters. Both waves and figures in rowing boats are, however, common motifs in Claude's work and French and Italian translations of *The Golden Ass* current in the mid-seventeenth century suggest that the sisters' visit occurred inside Cupid's palace.[120] Nevertheless, one of Claude's preparatory drawings (Fig. 22) suggests that

Fig. 22 *Study for Landscape with Psyche outside the Palace of Cupid*, 1663(?). Chalk, pen, brown wash on white paper, 25.1 x 38.8 cm. Chantilly, Musée Condé.

the artist was thinking of the time after Psyche had been abandoned by her sisters.[121] Here the two figures in the boat are more prominent and are clearly rowing away from the solitary and pensive Psyche. Furthermore, although the sisters' visit and presumably their parting occurred inside the palace, Apuleius' text does not require Psyche to remain inside throughout her agony, and, even if it did, Claude seems to have been prepared to paint interior scenes outside when it suited him (see No. 54).

If indeed the painting can be interpreted as showing Psyche in a state of indecision whether to surrender to her curiosity and fear, the pair would have a parallel in the later Colonna commission, *Dido and Aeneas* and *Ascanius shooting the Stag of Silvia*. In *Psyche outside the Palace of Cupid* as in the later *Dido and Aeneas*, Claude shows a time of suspense when, as Apuleius related the story, the decision might go either way. *Psyche saved from drowning herself*, on the other hand, shows a specific moment of drama, just as in the *Ascanius*. It is also worth noting that in the seventeenth century there was still current a long tradition of allegorical interpretation of the Cupid and Psyche story. According to one such interpretation Psyche represented the Soul which discovered Desire (Cupid) egged on

Opposite: Plate 36 *Landscape with Psyche outside the Palace of Cupid*, detail (No. 38).

by the Flesh and the Spirit of Liberty (the two sisters).[122] The London and Cologne paintings could then be read respectively as the Soul on trial and the Soul saved. This would be consistent with another allegorical interpretation of the story in which Psyche was understood as the Soul seeking union with Christ (Cupid).[123] Thus the London painting can be seen as showing Psyche contemplating whether to embrace or murder the divine, and the looming, shimmering castle which dominates both the composition and Psyche can be understood to represent divinity.

Whether the paintings were intended to relate also to the specific circumstances of Colonna's marriage to Maria Mancini cannot be known. It is, however, the case that by 1666 when *Psyche saved* was executed, Colonna's wife was objecting to his philandering, so the paintings could be read together as showing the potentially disastrous consequences of a wife being over-curious.[124] This is conjecture, but whatever the intention there would have been no mutual exclusivity between personal and allegorical interpretations of the paintings. On the contrary a seventeenth-century commentary on the story of Psyche and Cupid shows how a broad interpretation could be applied to Colonna's specific circumstances: '[Apuleius] wished to picture for us by the representation of this beautiful Palace...the diverse pleasures that one finds in the world. But in an instant, also in the same Picture, the pleasant things which are inseparable from the misfortune visited on Psyche for being too curious, for which she was punished...one must never forget these words of the sage who says that whoever opens his soul to the joy of the world, at the same time opens his heart to the sadness which is inseparable from it.'[125]

In no sense, of course, was the possibility of multiple interpretation exclusive to Claude's paintings or to landscape generally. Claude's paintings were, however, particularly susceptible to it, and perhaps deliberately so. The pastoral subjects which were not based on specific texts were visual equivalents of pastoral poetry,

a genre sufficiently familiar to likely viewers of Claude's paintings that the associations between the two would have been immediately appreciated. In some cases Claude's narrative subjects, such as *Landscape with the Marriage of Isaac and Rebekah*, were directly derived from the pastorals, and so themselves had pastoral associations. In other cases Claude's treatment of the narrative carried one or more allusive sub-texts, about the passing of time for example, such as in his *Seaport with the Embarkation of Saint Ursula*, which shows both a rising sun and preparations for a journey, or motifs used as metaphor, such as the castle in *Psyche outside the Palace of Cupid*.

This is the nature of art which is called evocative. It is recognised as one thing (its nominal subject matter), but sensed as something else. Its enabling characteristic is its permissiveness. This is perhaps where Claude most differs from Poussin. The latter's approach to narrative was explicative and declamatory. Poussin's paintings seem intended to provoke a mutual interrogation between picture and spectator which would finally yield the picture's (only possible) meaning. Claude's paintings on the other hand did not so much demand a response from the spectator as leave open space into which the spectator could project his or her own imaginative reactions. *Psyche outside the Palace of Cupid* is typical in this respect – there is no correct interpretation of its meaning. All interpretations of it, not to mention its popular title, *The Enchanted Castle*, are more or less imaginative responses. Something of this quality of Claude's art was perhaps experienced by his contemporary Baldinucci, when after praising Claude's unsurpassed imitations of nature he wrote: 'one sees things from his hand which, going beyond all imagination, can by no means be described.'[126] Furthermore, it was a quality of which Claude himself was probably conscious. The curious elongated figures of his later paintings, the purpose of which has recently been debated,[127] were perhaps deliberate markers of unreality, signals to viewers of his paintings that what they saw was not a real but a poetic landscape, a fiction in which each spectator was invited to become a co-narrator.

To call Claude's art evocative or poetic may sound romantic and old-fashioned. Yet poetic is precisely what it was and in terms that his contemporaries would have understood. By permitting the same multiplicity of interpretation as was allowed to poetry, and by encouraging a plurality of associations, Claude's paintings did more than just illustrate the poets. They went to the root of the poetic function. With great subtlety and rarely equalled power Claude painted that mute poetry of which Simonides had spoken two thousand years before.

Notes

Frequently cited sources are referred to as follows in the footnotes:

MRP: Marcel Roethlisberger, *Claude Lorrain. The Paintings*, 2 vols., London 1961. Only vol. I is paginated.

MRD: Marcel Roethlisberger, *Claude Lorrain. The Drawings*, 2 vols., Berkeley and Los Angeles 1968. Only vol. I is paginated.

Kitson: Michael Kitson, *Claude Lorrain. Liber Veritatis*, London 1978.

Russell: H. Diane Russell, *Claude Lorrain, 1600–1682*, Washington 1982.

The translation of Sandrart's and Baldinucci's biographies of Claude are those made by Marcel Roethlisberger and printed in MRP.

For the source of quotations from the Bible and translations of Ovid's *Metamorphoses* and Virgil's *Aeneid*, see page 61.

Other translations, save where indicated, are by the author.

1. Sir Joshua Reynolds, *Discourses on Art*, ed. R.R. Wark, San Marino, California 1959, p. 255 (Discourse XIV, 10 Dec. 1788).
2. See in particular M. Roethlisberger, 'The Subjects of Claude Lorrain's Paintings', *Gazette des Beaux-Arts*, VIᵉ période, LV, 1960, pp. 209–24; Michael Kitson, 'The "Altieri Claudes" and Virgil', *Burlington Magazine*, CII, 1960, pp. 312–18; and Russell, pp. 81–96 and *passim*.
3. Rensselaer W. Lee, 'Ut Pictura Poesis: The Humanistic Theory of Painting', *Art Bulletin*, XXII, 1940, pp. 197–269.
4. MRP, p. 56.
5. With the exception of Innocent XI Odescalchi (1676–89) and his family.
6. For a discussion of the various possible functions of the *Liber Veritatis*, see Kitson, pp. 20–4.
7. MRP, p. 49.
8. MRP, p. 56.
9. Roger de Piles, *Abrégé de la vie des Peintres*, Paris 1715, p. 523 (first published in 1699).

10. The only painting by Claude which did not include the human figure, so far as I am aware, is *Landscape with Sheep* (1656; Vienna, Gemäldegalerie der Akademie der Bildenden Künste). Most scholarly opinion is agreed that, save in respect of some early works, Claude painted his own figures. However, Baldinucci's comment to the contrary has been given some support by the recent publication of letters written by Lord Shaftesbury from Naples in 1712 describing a painting as 'a perspective of Claude Lorrainese with above a douzen little figures of your Favourite Giordano, and of the kind in which he most excelled...' See Livio Pestilli, 'Shaftesbury "agente" d'arte: sulla provenienza vicereale di due quadri di Salvator Rosa ed uno (scomparso?) di Claude Lorraine', *Bollettino d'Arte*, 1992, pp. 131–40, at pp. 134 and 139, no. 35.

11. MRP, pp. 49 and 56.

12. P. Rosenberg, G. Jansen and J. Giltaij, *Chefs d'oeuvre de la peinture française des musées néerlandais XVII^e–XVIII^e siècles*, Dijon, Paris, Rotterdam 1992–3, pp. 33–6.

13. For these and other references to inventoried paintings by Claude, see Luigi Salerno, *Pittori di Paesaggio del Seicento a Roma*, 3 vols., Rome 1977–80, vol. 3, pp. 1121–40. See also MRP, pp. 312–13 for another example of misdescription of a Claude painting.

14. Luigi Salerno, op. cit., vol. 3, p. 1135.

15. J.J. Morper, 'Johann Friedrich Graf von Waldstein und Claude Lorrain', *Münchner Jahrbuch der bildenden Kunst*, 1961, pp. 203–17, at p. 210.

16. MRD, pp. 406–7.

17. S. Corradini, 'La Collezione del Cardinal Angelo Giori', *Antologia di Belle Arti*, I, 1977, p. 83–8. I am grateful to Rosemary MacLean for having provided the information in this paragraph of the essay, and the references on which it is based.

18. J. Garms, *Quellen aus dem Archiv Doria-Pamphilj zur Kunsttätigkeit in Rom unter Innocenz X*, Rome and Vienna 1972, p. 335.

19. See Burton B. Fredericksen, 'A pair of pendant pictures by Claude Lorrain and Salvator Rosa from the Chigi Collection', *Burlington Magazine*, 1991, pp. 543–6; and Humphrey Wine and Olaf Koester, *Fransk Guldalder. Poussin og Claude og Maleriet i det 17 århundredes Frankrig*, Copenhagen 1992 (with English translation), pp. 146–9.

20. J.A.F. Orbaan, *Documenti sul Barocco in Roma*, Rome 1920, pp. 519–20; MRP, p. 430; Russell, p. 189.

21. Ovid, *Metamorphoses*, XIV, 149.

22. MRD, no. 1077.

23. For a figure study for the *Arrival of Aeneas before the City of Pallanteum* not recorded in MRD, see An Zwollo, 'An Additional Study for Claude's Picture "The Arrival of Aeneas at Pallantium"', *Master Drawings*, VIII, 1970, pp. 272–5, and plates 26–7.

24. MRD, nos. 842 and 746 respectively.

25. Michael Kitson, 'Claude Lorrain as a figure draughtsman', in *Drawing: Masters and Methods. Raphael to Redon. Papers presented to the Ian Woodner Master Drawings Symposium at the Royal Academy of Arts, London*, ed. Diana Dethloff, London 1992, pp. 64–88.

26. I.G. Kennedy, 'Claude and Architecture', *Journal of the Warburg and Courtauld Institutes*, 35, 1972, pp. 260–83.

27. MRD, no. 660, dated 1647 is probably the earliest drawing annotated with its source at the time it was made. If so, it is exceptional for this period of Claude's life. Notes of sources on earlier drawings, MRD, nos. 526 and 554, were probably made when engravings were made after them in the 1660s, and other notes of sources belong to 1670 onwards.

28. For the possible symbolism of Claude's trees, see MRP, pp. 24–6

29. Giulio Mancini, *Considerazioni sulla Pittura*, ed. A. Marucchi, with comment and material by L. Venturi and L. Salerno, 2 vols., Rome 1956–7, vol. 1, pp. 112–13.

30. Clovis Whitfield, 'A programme for "Erminia and the Shepherds" by G.B. Agucchi', *Storia dell'arte*, 19, 1973, pp. 217–29.

31. MRP, p. 60.

32. As has been pointed out by M. Roethlisberger, see MRD, no. 645.

33. For the suggested history of the Pamphili commission and the Bouillon purchase, see MRP, pp. 280–1, and Kitson, pp. 122–3.

34. Torgil Magnuson, *Rome in the Age of Bernini*, 2 vols., Stockholm 1982–6, vol. 2, p. 6.

35. M. Roethlisberger, 'Claude Lorrain, Nouveaux dessins, tableaux et lettres', *Bulletin de la Société de l'Histoire de l'Art Français*, 1986, pp. 33–55.

36. See Russell, pp. 82–3, and the article by Creighton Gilbert cited at n. 9, 'On Subject and Non-Subject in Italian Renaissance Pictures', *Art Bulletin*, 1952, pp. 202–17.

37. (Le Père Rapin) *Rapin's De Carmine Pastorali, prefixed to Thomas Creech's translation of the Idylliums of Theocritus (1684)*, with introduction by J.E. Congleton, Ann Arbor 1947, p. 5.

38. Ibid, p. 4.

39. 'Heureuses bonnes gens d'estre ainsi loing des villes/Loing de l'ambition, loing des moeurs inutiles/Loing des traicts de la Court plein d'infidelité.' N. Le Digne, *Les Fleurettes du premier meslange*, Paris 1601, p. 35, quoted by Gilbert Delley, in *L'Assomption de la Nature dans la Lyrique française de l'Age baroque*, Berne 1969, p. 188.

40. 'Au bord tristement doux des eaux, je me retire/Et voy couler ensemble et les eaux et mes jours/Je m'y voy sec, et pasle, et si j'ayme tousjours Leur resveuse mollesse où ma peine se mire/Au plus secret des bois je conte mon martyre.' Du Perron, *Recueil de Bonfons*, Paris 1598, quoted by Gilbert Delley, op. cit., p. 75.

41. L. Freedman, *The Classical Pastoral in the Visual Arts*, New York, Berne, Frankfurt, Paris 1989, p. 110. Shakespeare's *As You Like It* is the most familiar English equivalent.

42. Bernard de Bovier de Fontenelle, *Discours sur la nature de l'eglogue*, 1688, para. 3: 59, translated into English 1695, and quoted by Annabel Patterson, in *Pastoral and Ideology. Virgil to Valéry*, Oxford 1988, p. 240.

43. I.G. Kennedy, op. cit., pp. 263–5.

44. For an example of this commonly held sentiment see G.P. Bellori's 'L'Idea del Pittore, Dello Schultore e Dell'Architetto, Scelta Delle Bellezze Naturali Superiore Alla Natura', a lecture of 1664 later published by the author as an introduction to *Le vite de' Pittori, Scultori et Architetti moderni* (Rome 1672), reproduced and translated in E. Panofsky, *Idea, A Concept in Art Theory*, New York, Evanston, San Francisco, London 1960, pp. 154–77.

45. MRP, pp. 47–8.

46. 'Ce doux Createur des beautez/Nous donnant le bon soir se cache dans les eaux/Et les ombres tendues/Advertissent le Ciel d'allumer ses flambeaux', quoted by Gilbert Delley, op. cit., p. 238.

47. See, for example, John 1: 4 'In him was life, and the life was the light of men.'

48. M. Roethlisberger, 'The Dimension of Time in the Art of Claude Lorrain', *Artibus et Historiae*, no. 20, 1989, pp. 73–92. See also Russell, p. 83, who proposes journeying as the 'single great subject which links so many of his works'. Laurent Bolard has noted that most of Claude's scenes of departure refer to some future tragedy, see his 'La Symbolique des ports chez Claude Lorrain: une révision', *Gazette des Beaux-Arts*, 1991, pp. 221–30. Ruins, however, were usually seen as historic references rather than as a cause of reverie, see Roland Mortier, *La Poétique des ruines en France*, Geneva 1974, pp. 86–90.

49. See Pamela M. Jones, 'Federico Borromeo as a Patron of Landscapes and Still Lifes: Christian Optimism in Italy ca. 1600', *Art Bulletin*, 1988, pp. 261–72; and by the same author, *Federico Borromeo and the Ambrosiana. Art Patronage and Reform in Seventeenth-Century Milan*, Cambridge 1993, p. 74.

50. J. Baudoin, *Recueil d'Emblemes divers avec des discours moraux, philosophiques et politiques*, Paris 1638, preface.

51. 'Le murmure si doux du cristal des ruiseaux; Le son harmonieux du concert des oiseaux', in Marin Le Roy de Gomberville's *Recueil de poésies chrestiennes*, Paris 1679, p. 272, quoted by Gilbert Delley, op. cit., p. 63.

52. Gilbert Delley, op. cit., pp. 180–4.

53. Pamela M. Jones 1988, op. cit., p. 267.

54. On the subject of Claude's pairs see M. Roethlisberger, 'Les pendants dans l'oeuvre de Claude Lorrain', *Gazette des Beaux-Arts*, 1958, pp. 215–18, MRP *passim*, and Russell, pp. 88–91.

55. For example, LV63 (1642) and LV69 (1643); LV136 (1655) and LV137 (1655/6); and LV175 (1669) and LV178 (1672).

56. MRP, p. 462. But see Russell, pp. 109–10, for a possible pair on canvas dated 1631. The figures in the *Judgement of Paris* are not by Claude according to Roethlisberger, see MRP, p. 461.

57. L.G. Whitbread, ed., *Fulgentius the Mythographer*, Ohio 1971, p. 64.

58. For the story of the Judgement of Paris and interpretation of it in relation to the Washington painting, see Russell, pp. 155–7. The two figures crossing the bridge in the background of No. 66 recall N. Renouard's warning to Paris in *Le Jugement de Paris*, Paris 1614: 'Le large chemin que tu prends est dangereux, il n'est parsemé de fleurs qu'à l'entrée, le reste est plein de ronces et de chardons, bornez d'horribles précipices' (The broad path which you are taking [i.e. as opposed to the narrow path of virtue] is dangerous, it is strewn with flowers only at the start, the rest is full of brambles and thistles, bounded by dreadful precipices).

59. See MRD, p. 215.

60. *De Sapienta veterum*, 1609; translated as *The Wisdom of the Ancients*, 1619, by Sir Arthur Gorges, and quoted in *Fulgentius the Mythographer*, op. cit., p. 31, n. 39.

61. MRP, pp. 343–4 and 447.

62. '...nos mythologistes, qui mettent toute leur étude à chercher un sens moral dans les pensées les plus chimériques de cet auteur...', *Ovide buffon*, 1649, quoted in H. Bardon, 'Sur l'influence d'Ovide en France au 17eme siècle', *Atti del Convegno Internazionale Ovidiano*, 2 vols., Rome 1959, vol. 2, pp. 69–83.

63. For example, Puget de la Serre, *Les Amours des Dieux*, Paris 1640, p. 95: 'Les fables cachent d'ordinaire la verité sous leur voile...Ovide a excellé en cela: car avec le crayon de ses belles pensées, il nous a despeint au naturel le plus beau de ce qui estoit caché nos yeux...' (Fables usually hide the truth under their veil...Ovid excelled in that: for with the pencil of his beautiful ideas, he has depicted realistically for us the most beautiful of what might be hidden from our eyes).

64. Quoted by Ann Moss, in *Poetry and Fable, Studies in Mythological Narrative in Sixteenth-Century France*, Cambridge 1984, p. 77.

65. Taken from Georgius Sabinus (Giorgio Sabino), *Fabularum Ovidis interpretatio*, Könisberg 1575, quoted by Ann Moss, in *Ovid in Renaissance France*, London 1982, p. 51.

66. Jennifer Montagu, 'The Painted Enigma and French Seventeenth-Century Art', *Journal of the Warburg and Courtauld Institutes*, 31, 1968, pp. 307–35.

67. For the popularity of Ovid in seventeenth-century France, see H. Bardon, op. cit., at n. 62; and W. Brewer, *Ovid's Metamorphoses in European Culture*, 3 vols., Francestown, New Hampshire 1933–59, vol. 1, pp. 29ff.; and Ann Moss 1982, op. cit., pp. 1 and 23.

68. See *Ovide Moralisé en prose*, ed. C. de Boeur, Amsterdam 1954, pp. 3–5.

69. Ibid, p. 222.

70. Bersuire's book was placed on the Index of banned books in 1559, Ann Moss 1982, op. cit., p. 27.

71. John Lyly, in *The Complete Works of John Lyly*, ed. R.W. Bond, 3 vols., 1902, vol. 1, p. 240; quoted by Colin Burrow, in 'Original Fictions: Metamorphoses in the Faerie Queene', *Ovid Renewed: Ovidian influences on literature and art from the Middle Ages to the twentieth century*, ed. C. Martindale, Cambridge 1988, pp. 99–119.

72. One popular school textbook said that the story of Narcissus was too well known to be explained: M. Le Ragois, *Instruction sur l'Histoire de France, et sur la Romaine, par demande, et par Réponses. Avec une explication des 109 Fables des Metamorphoses d'Ovide*, Paris 1684.

73. Barptolemy Aneau, *Imagination Poetique, traducte en vers François, des Latins, & Grecz, par l'auteur mesme d'iceux*, Lyon 1552.

74. Natalis Comitis (Natali Conti), *Mythologiae, sive explicationis Fabularum*, Geneva 1612, p. 1003.

75. *The Fable of Ovid treting of Narcissus, translated out of Latin into English Metre, with a moral ther unto, very pleasante to rede* (Thomas Howell), London 1560, p. 16.

76. Martin Davies, *National Gallery Catalogues, French School*, London 1957, p. 43; MRP, p. 222; Kitson, p. 99; H. Wine and O. Koester, op. cit., pp. 132–5.

77. J. Baudoin, op. cit., n. 50, pp. 216–17.

78. P. du Ryer, *Les Metamorphoses d'Ovide en Latin et François*, Brussels 1677, p. 99. (First published 1660.)

79. Pausanias, *Description of Greece*, Book IX, ch. XXXI, 8; translated W.H.S. Jones, 1965, Loeb edition, p. 311. Pausanias' account was printed in 1516 in Venice and referred to in Conti's widely read *Mythologiae*.

80. Louise Vinge has pointed out that Farra made these analogies in his *Settenario* (Venice 1594), in *The Narcissus Theme in Western European Literature up to the early Nineteenth Century*, Lund 1967, pp. 149–50.

81. 'Suspiciones in matrimonie sapé afferunt magnum

calamitatem...', Giorgio Sabino, *Fabularum P. Ovidii Metamorphosi Descriptorum Interpretatio Ethica, Physica et Historica*, 1614, p. 78.

82. N. Renouard, *Les Metamorphoses d'Ovide de nouveau traduittes en françois avec XV Discours Contenans l'explication morale des fables*, Paris 1614, p. 186, and by the same author, *Les Metamorphoses d'Ovide traduites en Prose françoise...avec XV Discours Contenans l'Explication Morale et Historique*, Paris 1619, p. 102.

83. N. Renouard, Paris 1619, op. cit., p. 101.

84. P. du Ryer, op. cit., p. 237. For a modern interpretation of Ovid's story as a conflict between hunting and lovemaking, see Gregson Davis, *The Death of Procris, 'Amor' and the Hunt in Ovid's Metamorphoses*, Rome 1983.

85. Martin Davies, op. cit., pp. 32–3, noted that such an episode did occur in Niccolò da Correggio's play *Cefalo* (1487). There is no evidence that Claude was aware of this play.

86. Russell, pp. 91 and 181.

87. See Gregson Davis, op. cit., pp. 127–9.

88. R.R. Bolgar, *The Classical Heritage and its Beneficiaries from the Carolingian Age to the End of the Renaissance*, London and New York 1954 (reprint 1964), p. 538.

89. Russell, p. 86, and Giuliano Mambelli, *Gli Annali delle Edizioni Virgiliane*, Florence 1954.

90. Don Cameron Allen, *Image and Meaning. Metaphoric Traditions in Renaissance Poetry*, Baltimore 1960 (revised 1968), p. 75. See also Russell, p. 86.

91. On Bocchius' *Symbolicorum quaestionum libri cinque*, see H. Bardon 'L'Enéide et l'Art XVIe–XVIIIe siècle', *Gazette des Beaux-Arts*, VIe période, 33 (2), pp. 77–98. Bardon points out that the *Aeneid* was the second most popular source for artists after Ovid's *Metamorphoses*.

92. Quoted in *Fulgentius the Mythographer*, op. cit., p. 109.

93. René Rapin, *Comparaison des Poëmes d'Homère et de Virgile*, Paris 1664, pp. 32–3.

94. 'Enée qui est du sang des Dieux, represente bien à mon avis, la grandeur de vostre extraction, qui tire son origine du plus glorieux Sang de l'Univers', p. iii.

95. Annabel Patterson, *Pastoral and Ideology. Virgil to Valéry*, Oxford 1988.

96. Fr. Stephane Depleurre, *Aeneis Sacra continens Acta Domini nostri Jesu Christi, et primorum martyrum qui passi sunt tempae persequationis*, Paris 1618.

97. The eight are usefully listed by Russell, p. 94, n. 29.

98. According to the *Liber Veritatis* inscription, the patron was 'monsieur Dupassy le Gout', who may have been a member of the Le Gouz family, seigneurs du Plessis, see Kitson, p. 164.

99. Noémi Hepp, 'Virgile devant la Critique Française à l'époque de Boileau', in *Critique et Création Littéraires en France au XVIIe siècle, Paris 4–6 juin 1974*, ed. du C.N.R.S., Paris 1977, pp. 39–49.

100. Michael Kitson first noted use by Claude of *L'Eneide di Virgilio del Comendatore Anibal Caro*, Rome 1623, in M. Kitson, 'The Altieri Claudes and Virgil', *Burlington Magazine*, 1960. For the reference to Anius as 'sacerdote', see p. 73 of that edition of Caro's *Eneide*, first published in Venice in 1581, see G. Mambelli, op. cit., p. 181.

101. For a full discussion of these paintings, see M. Kitson 1960, op. cit., and the relevant entries in MRP, MRD and Kitson.

102. MRD, p. 375.

103. M. Kitson, *The Art of Claude Lorrain*, London 1969, p. 28, and I.G. Kennedy, op. cit., pp. 265–6.

104. M. Kitson 1969, op. cit., p. 31, and MRD, no. 1079.

105. MRP, pp. 369–70.

106. MRP, p. 370.

107. An Zwollo, op. cit., p. 272.

108. MRD, no. 1077.

109. Kitson, p. 169. For an illustration of the Altieri arms, see Russell, p. 44.

110. Torgil Magnuson, op. cit., vol. 2, p. 278.

111. Puget de la Serre, *Les Amours des Dieux*, Paris 1640, p. 100.

112. Russell, p. 191.

113. For associations between deer and love, the lover as wounded deer and the deer as symbolic of Christ, see Don Cameron Allen, op. cit., pp. 167–78.

114. *Famiglie Celebri di Italia*, 13 vols., Milan, 1819–69, XI, 1837, Colonna di Roma, table XI.

115. Russell, pp. 177–9, H. Diane Russell, 'Claude's Psyche Pendants: London and Cologne', *Claude Lorrain 1600–1682: A Symposium, Studies in the History of Art*, vol. 14, Washington 1984, pp. 67–81; Sir Michael Levey, '"The Enchanted Castle" by Claude: Subject, Significance and Interpretation', *Burlington Magazine*, 1988, pp. 812–20.

116. As pointed out by Levey, ibid.

117. Ibid. This explanation was accepted by the author in Wine and Koester, op. cit., pp. 150–3.

118. That this may have been the moment illustrated was first noted by Leslie Parris who connected this possibility with the small boat with two figures in it at the right of the painting, in *The Loyd Collection of Paintings and Drawings*, London 1967, pp. 7 and 9, n. 3.

119. *The Most Pleasant and Delectable Tale of the Marriage of Cupid and Psyche, done into English by William Adlington*, London 1566, ed., Andrew Lang, London 1887, pp. 29–30.

120. For example, *Les Metamorphoses ou l'Asne d'Or*, Paris 1648; *L'Asino d'Oro di Lucio Apuleio*, Venice 1639.

121. MRD, no. 930.

122. This was the interpretation of the Latin grammarian Fulgentius, who lived not earlier than the sixth century AD. Fulgentius' interpretation appeared in translation in, for example, *Commentaires sur la Metamorphose de l'Asne d'or de l'Apulée*, Paris 1648, p. 74.

123. Russell 1984, op. cit., p. 76.

124. Russell 1984, op. cit., p. 78.

125. Puget de la Serre, op. cit., pp. 102–3.

126. MRP, p. 56.

127. Marcel Roethlisberger, 'Das Enigma Überlängter Figuren in Claude Lorrains Spätwerk', *Nicolas Poussin, Claude Lorraine, Zu den Bildern im Städel*, Frankfurt 1988, pp. 92–100. The arguments in that essay were summarised in English by Richard Verdi in a pertinent review of the exhibition in *Burlington Magazine*, 1988, pp. 393–5. Roethlisberger's conclusions have been disputed by Michael Kitson in 'Claude Lorrain as a figure draughtsman', op. cit., at n. 25.

Catalogue

The catalogue has been divided into five sections acording to subject. In the first section works have been arranged in the order in which the author believes they were made. Subsequently, paintings have generally been catalogued chronologically within each section, and drawings have been catalogued in chronological order after the painting to which they are here related.

Dimensions are given in centimetres, height before width. All drawings are on white paper, unless otherwise indicated.

Inscriptions on the reverse of drawings have not been given. For these reference may be made to Marcel Roethlisberger, *Claude Lorrain. The Drawings*, 2 vols., Berkeley and Los Angeles 1968 (MRD), and to Michael Kitson, *Claude Lorrain: Liber Veritatis*, London 1978 (Kitson). The number in brackets accompanying each entry refers to the relevant number in these works or in Roethlisberger's catalogue of Claude's paintings (MRP).

The initials 'I.V.' or 'I.V.F.' in Claude's signatures stand for 'in urbe' (in the city) or 'in urbe fecit' (made in the city). The city is, of course, Rome, and the initials are usually followed by 'Romae' (at Rome). The initial 'G' in Claude's signature stands for 'Gellée', which was his surname. Translations of the inscriptions are those of the author.

Quotations from the Bible are from the King James' Authorised Version. Those from Virgil's *Aeneid* are from H.R. Fairclough's translation in the Loeb edition, 1969. Those from Ovid's *Metamorphoses* are from F.J. Miller's translation in the Loeb edition, 1966. For bibliographic abbreviations, see the bibliographic note on page 56.

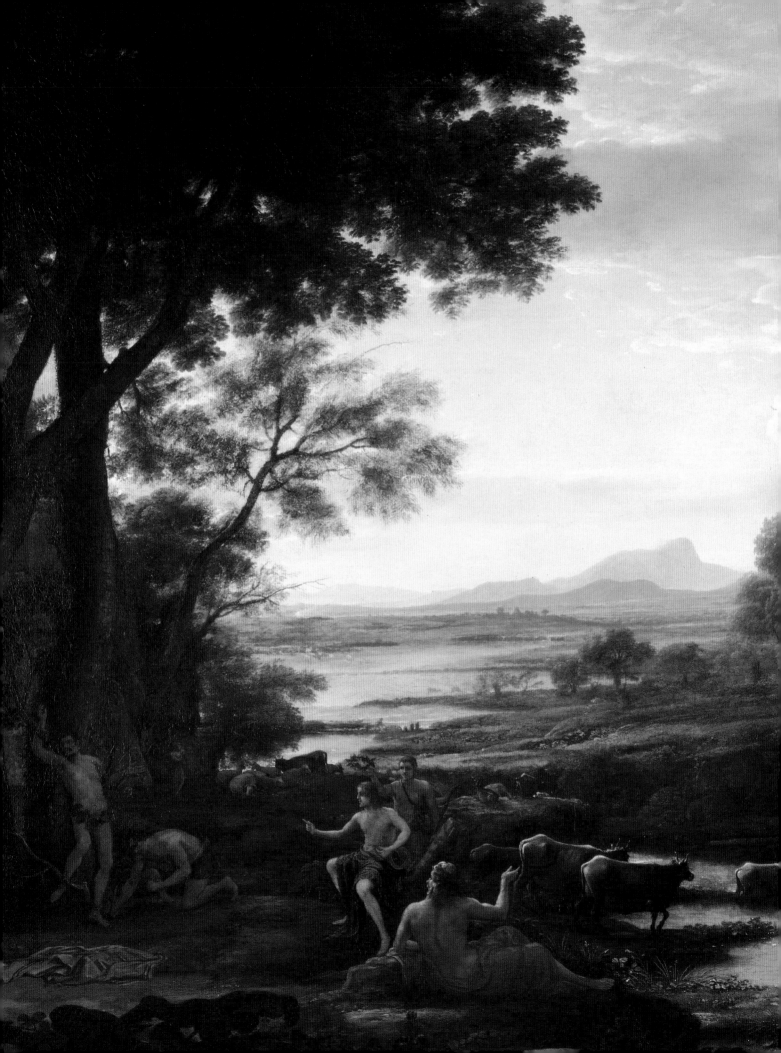

Painter of Nature

When Claude's career as an independent painter in Rome began about 1626–7, landscape painting was well established, and in a state of flux. Netherlandish artists had represented landscape as an object of curiosity, and often of fantastic aspect. From around 1600, however, Bolognese artists working in Rome, such as Annibale Carracci (see Fig. 16) and Domenichino (see Fig. 8), whose main activities were in large-scale figure painting, painted a more serene landscape to serve as a frame for dignified human action. Such landscape was more restrained in form and colour, and more balanced in composition, than that of the earlier Netherlandish painters, and it became the model for landscapists working in Italy, including Claude, for the rest of the century.

Before the mid-1630s few of Claude's landscapes depicted a subject identifiable from any literary text. His early landscapes were principally of three types, all showing human activities. These were harbour or seaport scenes, like No. 13; seacoast views; and inland landscapes, which, like No. 9, often included scenes reminiscent of the pastoral poetry of the ancient Roman poet Virgil. Paintings of or including actual views, such as No. 4, were rare.

The building blocks for Claude's paintings were his drawn studies from nature made during sketching expeditions along the coast and in the Roman Campagna (the countryside around Rome). These ranged from panoramic views like No. 12 to careful studies of individual objects such as trees (No. 10). Consequently, even though most of Claude's painted landscapes were imaginary in that they did not represent an actual place, they were made up of elements of reality.

Opposite: Plate 37 *Landscape with the Flaying of Marsyas*, detail (No. 71)

1

An Artist sketching a Statue

Pen and ink, 12.8 × 9.3 cm
The Royal Collection, no. 13092
(MRD 24)

The draughtsman is shown on a trestle table drawing a statue which is just discernible between the columns of a building. Another statue in front of the columns is sketched in with a few summary strokes. Of more interest to Claude is the study of the lights and darks of the trestle supporting the artist. The drawing probably pre-dates by a year or two Claude's *View of Rome* of 1632 (No. 4) in which is depicted a statue of Apollo on a pedestal.

3

Study of an Antique Statue

Pen, brown wash,
20 × 9.5 cm
London, British Museum,
no. Oo. 6–1 (MRD 82)

Claude made few known studies after antique sculpture. This one was possibly drawn in the early 1630s. It is of a life-size antique statue in the Palazzo dei Conservatori, Rome, which had been restored as a Muse, and was placed in 1639 on its present base inscribed 'URANIA', the Muse of Astronomy. Drawing from antique sculpture was a conventional way for artists to practise drawing the human figure (given the expense of live models). This weak study shows Claude's lack of interest, or

talent, in this area, a characteristic remarked upon by his contemporaries.

2

Coast View

Pen, brown wash,
18.2 × 26.5 cm
Cambridge, Fitzwilliam
Museum, no. 2921 (MRD 47)
This drawing was probably
preparatory for a painting
executed by Claude in 1630
(whereabouts unknown).
Claude used the formula of
temple columns before a screen
of trees at the right of *A View of
Rome* (No. 4). Landscape
elements in one painting often
reappear in others.

4

A View of Rome

Signed and dated:
CLAVDE.I.V/ROMAE 1632
Oil on canvas, 59.5 × 84 cm
London, National Gallery,
NG 1319 (MRP 214)
The left-hand side of the
painting is a view, possibly from
the top of Claude's home in Via
Margutta, of the sixteenth-
century church of S. Trinità de'
Monti in Rome, which still looks
much as shown here. In the
shadow of the imagined pagan
temple at the right a scene of
prostitution is shown. By way of
contrast the church, intended as
a truthful view, is bathed in
light. (Plate 2)

5

Coast View

Signed: Claudio ivf/Roma
Pen, brown wash, traces of
black chalk, pale green splashes
in the sky, 20 × 26.5 cm
London, British Museum, Liber
Veritatis 2 (MRD 76; Kitson 2)
Executed as a record of a
painting of about 1633/4 (San
Marino, California, Huntington
Library and Art Gallery). The
formula of figures on the
foreground shore framed by
architecture on one side and
natural elements on the other
was used in other seaport
scenes, including *Seaport with
the Embarkation of Saint Ursula*
(No. 15).

6

Landscape with Ruins

Pen, brown and grey wash,
some heightening, 21.5 × 28 cm
Derbyshire, Chatsworth,
Devonshire Collection, no. 875
(MRD 58)
Datable to the early 1630s.
Although the individual
elements differ, the overall
composition of the landscape is
close to that of *Landscape with
the Judgement of Paris* of 1633
(No. 66).

7
Landscape
Pen and grey ink and grey wash,
14.2 × 19.9 cm
Oxford, Ashmolean Museum,
no. 415 (MRD 78)
Buildings by the water's edge
similar to those shown in this
drawing (datable about 1635)
occur in *Landscape with the
Marriage of Isaac and Rebekah*
of 1648 (No. 21). The landscape
corresponds to that in an
etching by Claude (Mannocci
no. 13) and, in reverse, to that in
a painting of about 1635 (New
York, private collection).

8
*Trees and Rocks by a
Cascade*
Chalk, brown wash and
heightening on buff paper,
38.8 × 25.2 cm
London, British Museum,
no. Oo. 7–209 (MRD 92)
In this study after nature, dated
1635 on the reverse, the
relationship of the various
elements is close to that of the
trees, rocks and water at the
left-hand side of Claude's
*Landscape with Narcissus and
Echo* of 1644 (No. 67).

9

*Landscape with a
Goatherd and Goats*

Oil on canvas, 52 × 41 cm
London, National Gallery, NG 58
(MRP 15)
Painted about 1636/7. This work
is not based on any known text,
but is a visual equivalent to
pastoral poetry, for example
that in the *Eclogues*, a series of
poems composed by Virgil
between 42 and 37 BC. The
poems describe a countryside of
shady groves and murmuring
streams peopled by contented
rustics whose main concerns
are those of love. The painting
possibly shows the park of the
Villa Madama in Rome, a
property of the Medici family.
(Plate 4)

10

*Study of Trees in the
Vigna Madama*

Inscribed: Claudio fecit/facto a
Vigne madama
Chalk, pen, brown and grey
wash, 33 × 22.4 cm
London, British Museum,
no. Oo. 7–224 (MRD 295)
This detailed study was made in
about 1638 at Vigna Madama,
the gardens of Villa Madama at
Monte Mario to the north-west
of Rome. The composition is
related to *Landscape with a
Goatherd and Goats* (No. 9).
(Plate 17)

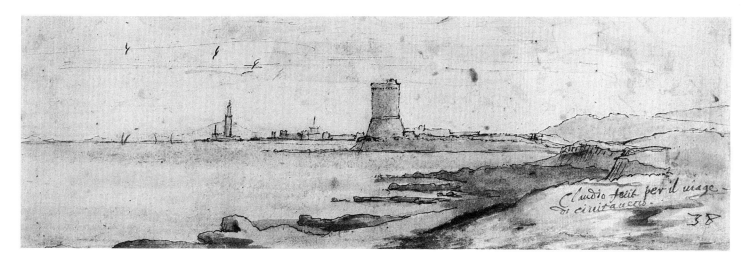

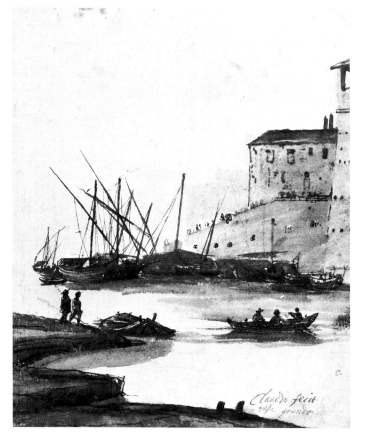

11 (left)
Ripa Grande in Rome
Inscribed: Claudio fecit/ripa
grande
Pen, brown and grey wash,
25 × 21.4 cm
London, British Museum,
no. Ff. 2–156 (MRD 280)
Claude's surviving studies of
boats are few. This one of about
1638 is inscribed as being made
at the port of Ripa Grande, one
of the ports on the Tiber serving
Rome. A comparison between
the buildings and boats in this
drawing from the life and those
in his *Seaport* of 1639(?) (No.
13) shows how they were
imaginatively elaborated and
ennobled by Claude in his
paintings.

12 (above)
View of Civitavecchia
Inscribed: Claudio fecit per il
viage-/di civitavecio
Pen, red and grey wash,
10.3 × 32.2 cm
London, British Museum,
no. Ff. 2–157 (MRD 310)
Claude drew a number of views
of Civitavecchia, a port some
seventy kilometres north-west
of Rome. Elaborations of the
lighthouse and the fort appear
in his painted port scenes. This
one, according to the inscription
made on a journey to Civita-
vecchia, dates to around 1638.

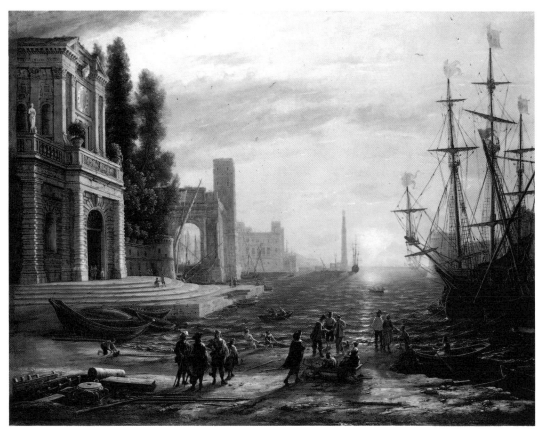

13
A Seaport
Signed and dated:
CLAVDIO.G.I.V 1639(?)
Oil on canvas, 99 × 129.5 cm
London, National Gallery, NG 5
(MRP 43)
Painted for Angelo Giori (1586–1662), a member of Pope Urban VIII's entourage who was made a cardinal in 1643. As in many of Claude's seaports, architecture is used to help create an effect of depth. The palace front at the left has been adapted from a gateway built about 1570 which led to the Farnese Gardens from the Forum. Behind it is the antique Arch of Titus. Mixing ancient and modern architecture was typical of Claude's practice in the first half of his career. The figures are non-specific and in contemporary dress, unlike those in Claude's later seaport scenes. (Plate 5)

14
Figures on a Tree Trunk
Chalk and brown wash,
21.3 × 31.8 cm
London, British Museum,
no. Oo. 7–181 (MRD 290v)
In this remarkable study, in which the seated figure is drawing, Claude shows himself more interested in the effects of light than in the rendering of human form, here shown in a cursory way. To judge from surviving drawings, Claude made scarcely any academic figure studies. This drawing is datable perhaps to the late 1630s. A similar group of artist and companion appears at the right of a painting executed in 1648 (London, private collection) and recorded in *Liber Veritatis* 115. (Plate 19)

Religious Subjects

During Claude's lifetime the Bible continued to be the most frequently used written source for painters. In Rome the Latin Vulgate version adopted by the Roman Catholic Church would have been consulted. Among biblical subjects popular with landscape painters were the Flight into Egypt (Matthew 2: 14) and its derivation, the Rest on the Flight into Egypt, for which there was no biblical account but many apocryphal sources. Claude painted these subjects several times throughout his career. Other biblical subjects to which he frequently returned were episodes from the Old Testament stories of Jacob and Rachel and of Hagar. The common thread of these stories was that of journeying, but not every biblical journey appealed to Claude. He did not paint, for example, the crossing of the Red Sea, or the conversion of Saint Paul on the road to Damascus, perhaps because of his aversion to excessively animated subjects. Like other artists Claude also painted episodes from the lives of the saints taken from *The Golden Legend* of Jacobus de Voragine (*c.*1230–98) (see No. 15). This exceptionally popular book had been translated and printed in French, Italian and English by 1483 and appeared in numerous later editions.

The Martyrdom of Saint Ursula

The best-known version of the story of Saint Ursula appears in Jacobus de Voragine's *Golden Legend*, written about 1275. Ursula, daughter of a king of Britain or Brittany (the account is unclear), agreed to marry her suitor, the only son of the king of England, if he was baptised and if she was granted a period of three years before the wedding to make a pilgrimage to Rome. She specified that she and her party of ten young noblewomen should each have a retinue of a thousand virgins, hence the celebrated eleven thousand virgins of the story. In Rome, to which Saint Ursula came via Cologne and Basel, she was enthusiastically received by Pope Ciriacus, who renounced the papacy in order to accompany her on the return journey, having seen in a vision that the travellers would be martyred. The mass martyrdom took place at Cologne during a siege of invading Huns. Most of the party were beheaded, but Saint Ursula, after refusing to marry the Hun leader, was shot with an arrow.

15 (top)
Seaport with the Embarkation of Saint Ursula
Signed and dated:
CLAVDIO.I.V.F. ROMAE 1641
Inscription (doubted):
EMBARQUE.../ORS...
Oil on canvas, 113 × 149 cm
London, National Gallery, NG 30
(MRP 54)
The painting was executed in 1641 for Fausto Poli (1581–1653), who held important posts in the household of Pope Urban VIII Barberini. In 1643, like another of Claude's patrons, Angelo Giori (see No. 13), he

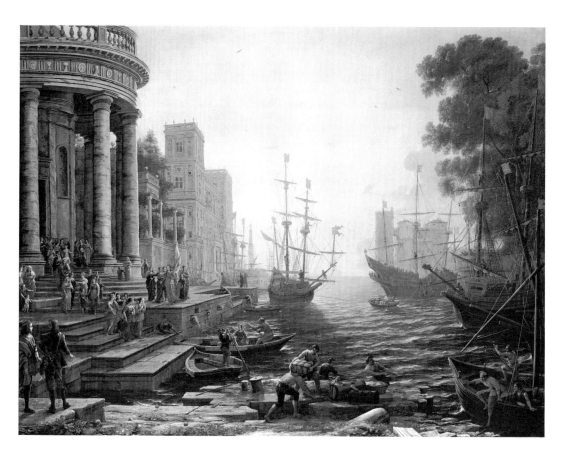

was made a cardinal. After Poli's death No. 15 was inherited by Cardinal Francesco Barberini. Its pair, *Landscape with Saint George* (see Fig. 9), was inherited by Francesco's brother, Cardinal Antonio Barberini.

The building in the left foreground is based on the Tempietto di San Pietro in Montorio, Rome, built on the site of Saint Peter's martyrdom. This and its shape – round was the favoured shape for commemorative chapels to martyrs – make it an appropriate setting for Saint Ursula and her companions on their journey from Rome to martyrdom. The building beyond it is reminiscent of the Palazzo Cancellaria, Rome, where Cardinal Francesco Barberini, Pope Urban VIII's nephew, was then vice-chancellor. Surviving drawings (Nos. 16 and 17) indicate that it was a late thought. (Plate 20)

16 (above)
Seaport
Chalk, pen, dark wash,
23.1 × 33.2 cm
London, British Museum,
no. Oo. 6–97 (MRD 401v)
Drawn about 1640. Claude was concerned here with planning the architectural content of No. 15. At this stage he had not adopted a round temple at the

left, and the space at the right was filled by buildings not ships. The almost complete absence of figures is not unusual in Claude's preliminary compositional studies.

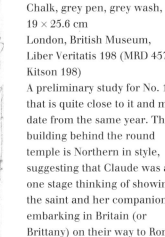

17

Seaport with the Embarkation of Saint Ursula

Chalk, grey pen, grey wash, 19 × 25.6 cm
London, British Museum, Liber Veritatis 198 (MRD 457; Kitson 198)

A preliminary study for No. 15 that is quite close to it and may date from the same year. The building behind the round temple is Northern in style, suggesting that Claude was at one stage thinking of showing the saint and her companions embarking in Britain (or Brittany) on their way to Rome, rather than from Rome as in the painting. The expanse of sea at the right of the drawing would be inconsistent with an embarkation at Cologne, which has only a river harbour.

18

Saint Ursula and her Companions

Pen, brown wash, 26.5 × 41 cm
London, British Museum, no. 1866.7.14.60 (MRD 459)

In this study Claude has integrated the group of Saint Ursula and some of her companions with the architecture of the left-hand side of the composition. The solution is close to that of the painting, although in the latter a flight of steps separates Saint Ursula from the temple building and the figures of a mother and child have been added at the top of them.

Hagar and the Angel

Hagar, an Egyptian servant, who was expecting a child by her master, Abraham, was banished from his house by his childless wife, Sarah. An angel appeared to Hagar beside a spring in the desert and ordered her to return to her mistress, saying: 'I will multiply thy seed exceedingly.' The angel also spoke to her of her unborn child, and told her he should be named Ishmael ('God hears'), because the Lord 'hath heard thy affliction', and that Ishmael would be against every man, and every man's hand would be against him (Genesis 16: 7–15). In Galatians 4: 21–31 Paul interpreted the episode allegorically: Hagar represented the old covenant given on Mount Sinai, and Sarah the new covenant instituted by Christ. The Pauline interpretation was adopted by the Catholic Church.

19
Landscape with Hagar and the Angel

Signed and dated: [C]LAVD 1646
Oil on canvas, mounted on wood, 53 × 44 cm
London, National Gallery, NG 61 (MRP 106)

This is the first of five paintings by Claude featuring episodes from the story of Hagar. The name of the patron is unknown, although an inscription on the *Liber Veritatis* drawing suggests that he lived in Paris. According to the Bible the appearance of the angel to Hagar after her banishment by Sarah takes place by a spring of water in the desert, but Claude has chosen a verdant setting reminiscent of the countryside around Rome, and the spring has been transformed into a river. The composition is close to that of the *Landscape with Tobias laying hold of the Fish* (London, National Gallery) by Domenichino, whose work influenced Claude during the 1640s. (Plate 10)

20
Landscape with Hagar, Ishmael, and the Angel

Pen, grey brown wash, some heightening, 17.3 × 23.8 cm
London, British Museum, no. Oo. 7–155 (MRD 800)

In this drawing of the mid-1650s the tiny figure of Ishmael, Hagar's son, appears beside her, indicating that a later episode is represented, that of the angel's appearance to Hagar with the reassurance that God would watch over her child (Genesis 21: 15–18). Again the location, according to the Bible, was a desert but the inclusion of a round temple, similar to the one at Tivoli, suggests that Claude was more concerned to use familiar motifs than to imagine a desert.

The Marriage of Isaac and Rebekah

Abraham, Isaac's father, sent a servant, Eliezer, to his homeland to choose a bride for his son, then forty years old. Eliezer met the young Rebekah at a well, where she drew water for him and his camels to drink (Genesis 24).

21
Landscape with the Marriage of Isaac and Rebekah ('The Mill')

Signed and dated:
CLAVDIO.G.L. (perhaps over GILLE)/I.N.V. ROMAE 1648/.F
Inscribed: MARI(age)/DISAC/ AVEC/REBECA
Oil on canvas, 149 × 197 cm
London, National Gallery, NG 12 (MRP 113)

No. 21 was painted in 1648 for Cardinal Camillo Pamphili (1622–65), nephew of Pope Innocent X. However, Pamphili was disgraced when he renounced his cardinalate in order to marry, and never took possession of this work. Instead, both it and its pendant (No. 26) were sold to the Duc de Bouillon (1605–52), a French general in the papal army. Claude painted a version of No. 21 for Camillo Pamphili soon afterwards (Rome, Doria-Pamphili Gallery).

The painting's title derives from the artist's inscription: MARI[age]/DISAC/AVEC/ REBECA. The Bible does not mention any festivities to celebrate the marriage of Isaac with Rebekah. From the Middle Ages the Roman Church saw their wedding as symbolic of Christ's union with the Church. (Plate 13)

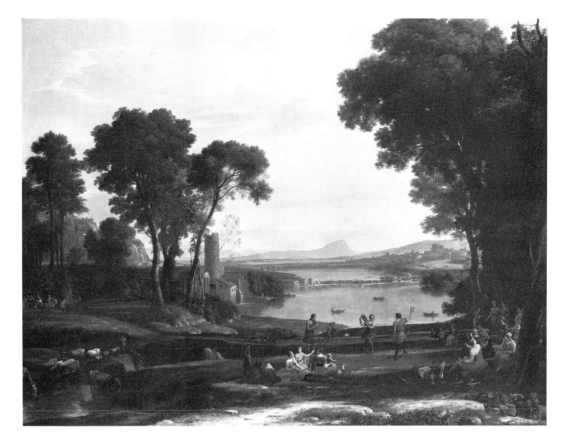

22
Landscape with Saint John the Baptist and Angels

Pen, brown-grey wash, 19.9 × 28.8 cm
London, British Museum, no. Oo. 6–129 (MRD 647)

This drawing of around 1647 shows a landscape composition like that of No. 21, suggesting that for Claude a similar landscape background could be used for different subjects. For another example of this practice, this time from towards the end of Claude's career, see No. 34.

23
Landscape Study

Chalk underdrawing, pen, brown wash, 19 × 26.5 cm London, British Museum, no. Oo. 7–156 (MRD 648) This drawing is a study for the composition of the painting *Landscape with the Marriage of Isaac and Rebekah*. A small, lightly sketched man in the centre indicates scale, but otherwise figure, and therefore narrative, are irrelevant. Another drawing dated 1647 (Bayonne, Musée Bonnat) is even closer to the painting in composition but shows a group of huntsmen in antique dress, indicating the interchange-ability of subject matter in Claude's landscapes. Claude inscribed the back of the Bayonne drawing: '... disine et pancé du taublau du prince panfille mais le figure est un autre sujet...' (drawn and conceived from Prince Pamphili's painting but the figure is another subject).

24
Rural Dance

Black chalk, slight red chalk, brown and grey wash, 16.4 × 22.2 cm Australia, Private Collection (MRD 651) Claude has used the girl with the tambourine from this drawing for one of the central figures of the painting, but like the following drawing (No. 25) it may not have been made with the painting in mind.

25
Figure Group with Dancing Girl

Chalk and grey wash,
18.7 × 26.9 cm
Paris, Musée du Louvre,
RF 4595 (MRD 652)
The group at the right of the
drawing bears some
resemblance to that at the right
of the painting (No. 21). From
the mid-1640s Claude's
drawings indicate a greater
interest in figures and their
grouping.

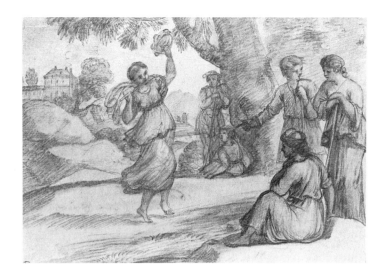

The Embarkation of the Queen of Sheba

According to 1 Kings 10: 1–2, the
Queen of Sheba resolved to visit
King Solomon in Jerusalem
after she had heard tell of his
great wisdom. The Bible
recounts how she set forth with
a large retinue and many
luxurious gifts for her host, but
offers no further details of the
manner in which she travelled.

26
Seaport with the Embarkation of the Queen of Sheba

Signed and dated: CLAVDE GIL:
I.V.FAICT.POVR.SON.ALTESSE.
LE.DVC.DE./BVILLON.
A ROMA.1648
Inscribed: LA REINE DE SABA
VA/TROV(ver) SALOMON
Oil on canvas, 148.5 × 194 cm
London, National Gallery, NG 14
(MRP 114)

No. 26, like its pair, *Landscape
with the Marriage of Isaac and
Rebekah* (No. 21), was an
imaginative elaboration of the
biblical story. The Queen of
Sheba's visit was believed to
prefigure the journey of the
Three Kings to pay homage to
the infant Christ or,
alternatively, to represent the

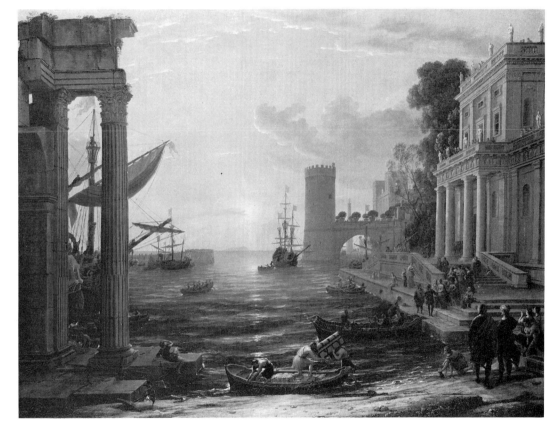

Gentile Church approaching to
hear the word of Christ. So
interpreted, Claude's painting
would have had a secondary
meaning similar to that of its
pair. No. 26 probably depicts a
sunrise, an appropriate time to
set off on a journey, while the
pastoral figures of No. 21 are
shown in the lengthening
shadows of the evening, the

time when Isaac and Rebekah
are said to have met (Genesis
24: 63). (Plate 14)

David at the Cave of Adullam

King David, unable to enter Bethlehem because Philistines occupied it and the valley of Rephaim below, was forced to remain at the cave of Adullam. He expressed longing for a drink of water from a well by the city gate and three of his bravest warriors broke through enemy lines to bring him some. When David realised how his best soldiers had risked their lives for his frivolous desire, he was unable to drink the water for shame and offered it instead to God (2 Samuel 23: 13–17).

The story contains elements of the temptation of Christ, but, like the visit of the Queen of Sheba to Solomon, the three soldiers presenting a gift to their king were usually interpreted as a prefigurement of the Adoration of the Magi.

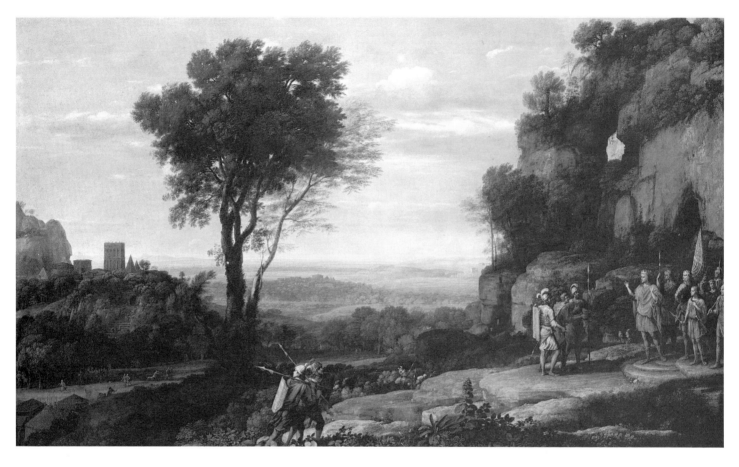

27

Landscape with David at the Cave of Adullam

Signed and dated: CLAVDIO Gellee/IVF. ROMAE 1658
Oil on canvas, 112 × 185 cm
London, National Gallery, NG 6 (MRP 145)

No. 27 was painted in 1658 for Prince Agostino Chigi, nephew of Pope Alexander VII. In an inventory of the prince's paintings in 1658 this work was paired with one by Salvator Rosa, *Mercury, Argus and Io* (see Fig. 3), which was the same size and in an identical ornate frame.

The subject was unusual in painting, but the biblical episode of a military commander refusing a personal benefit may have seemed suitable for Prince Agostino, who was Captain of the Papal Guard. It was perhaps intentionally contrasted with the subject of Rosa's picture, one of many stories concerned with the lustful and deceitful behaviour of the pagan gods.

Claude's landscape includes many of the elements described in the Bible: the cave, the Philistine encampment in the valley, and at the left the city of Bethlehem. Six years later Claude used the composition (in reverse) for *Landscape with Moses and the Burning Bush* (Mertoun, Roxburghshire, Duke of Sutherland Collection). (Plate 7)

The Adoration of the Golden Calf

Moses spent forty days and nights on Mount Sinai receiving the Ten Commandments. In his absence the Israelites grew restless and requested Aaron to make them an image for worship. A golden calf, fashioned from the women's jewellery, was raised up for adoration with much celebration. The Lord was greatly angered by their actions and intended to destroy the Israelites, but Moses persuaded him to be merciful. Moses then left the mountain and went down to his people where he found them dancing around the golden calf. Overcome by anger, he broke the tablets on which the commandments had been engraved and destroyed the graven image (Exodus 32: 1–20).

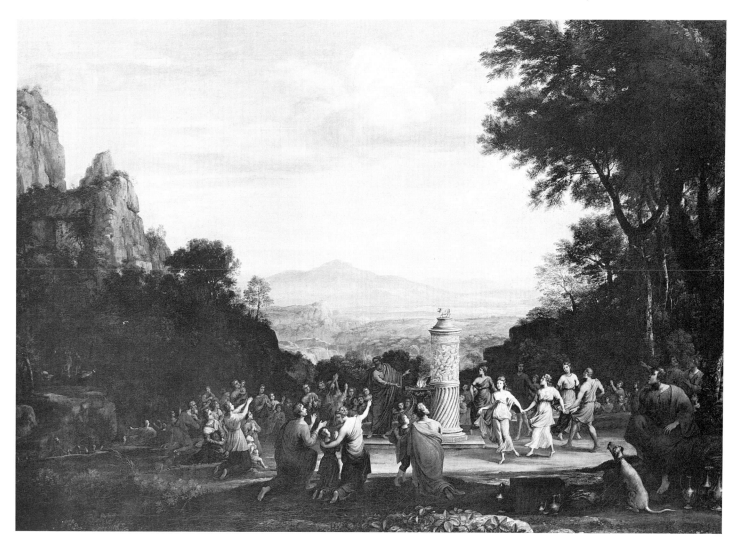

28
Landscape with the Adoration of the Golden Calf
Signed and dated: CLAVDE GELLE F I ROMA 1660
Oil on canvas, 114.5 × 158.3 cm
Manchester City Art Gallery (MRP 148)
This painting of 1660 is a smaller version of Claude's painting of 1653 (Karlsruhe, Staatliche Kunsthalle – see No. 29). The patron, who was probably French, has not been identified. No pendant is known for the Manchester painting, which differs little in composition from the earlier one. Some of the figure groups are virtual replicas of those in the Karlsruhe painting.
(Plate 11)

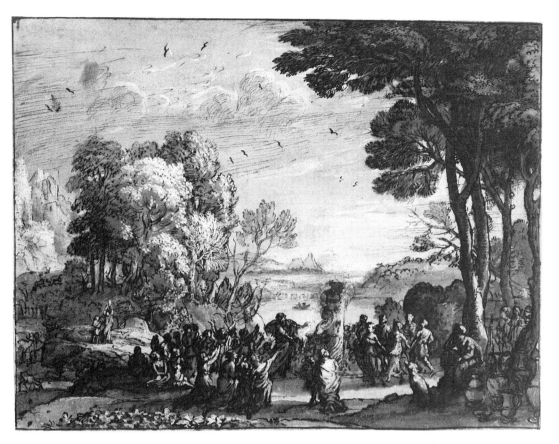

29

Adoration of the Golden Calf

Pen, brown and grey-brown wash and heightening on blue paper, 19.4 × 25.3 cm
London, British Museum, Liber Veritatis 129 (MRD 729; Kitson 129)

No. 29 is Claude's record of *Landscape with the Adoration of the Golden Calf* (1653; Karlsruhe, Staatliche Kunsthalle). The painting was executed for the Roman nobleman Carlo Cardelli (1626–62) as the pendant to *Landscape with Jacob, Laban and his Daughters* (see Fig. 5) of which No. 32 is the record. The subjects may have been chosen for their contrasting allusions: to Jacob's faithfulness in his bargains with Laban, and to the Israelites' faithlessness to God.

In No. 29 Claude has depicted a calm lake in the middle distance, possibly a reference to the water upon which the ground-down idol was strewn (Exodus 32: 20). In the later painting (No. 28) the terrain corresponds more closely to the mountain and wilderness referred to elsewhere in the biblical text (Exodus 19: 1–2).

30

Figure Study

Chalk and grey wash on paper tinted yellow, 35.3 × 46.3 cm
London, British Museum, no. Oo. 6–96 (MRD 728)

This detailed figure study of the right-hand group of Israelites was drawn about 1652–3 in preparation for the Karlsruhe painting. It was probably consulted for the repetition (No. 28) as the figures are almost identical. However, in both paintings the golden calf faces left and Claude added an altar next to the column.

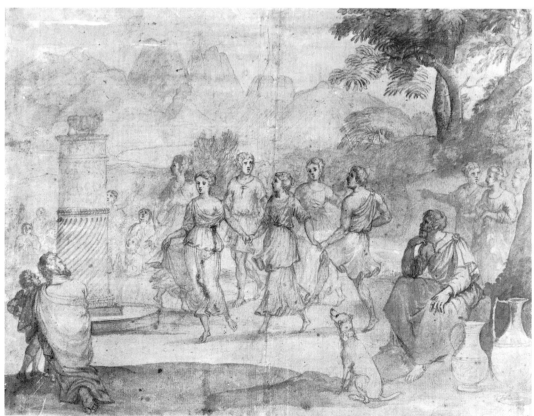

Jacob, Laban and his Daughters

Travelling in search of his uncle, Laban, Jacob met Laban's younger daughter, Rachel, who was tending her father's flock, and was captivated by her. The news was brought to Laban that his nephew had arrived and he gave Jacob a home and work, guarding his sheep. After a month Laban asked Jacob what reward he wanted for his labours. Jacob declared he would work for seven years if he might then marry Rachel. Laban agreed, but when the time was up he substituted his elder daughter, Leah, as Jacob's wife. When Jacob complained of being cheated, Laban said that if Jacob would complete the nuptial week with Leah, he could marry Rachel also in return for a further seven years' service (Genesis 29: 10–27).

Like Martha and Mary of the New Testament (Luke 10: 38-42), Leah and Rachel were seen as personifying respectively the active and the contemplative types of the human personality, and Jacob's choice of Rachel was seen as prefiguring Christ's approval of Mary.

31
Landscape with Jacob, Laban and his Daughters

Signed and dated: CLADIO IVF.ROMAE. 1676
Oil on canvas, 72 × 94.5 cm
London, Dulwich Picture Gallery, no. 205 (MRP 188)
No. 31, dated 1676, was made for Franz Mayer von Regensburg, a counsellor of the Bavarian Elector and a collector of paintings. Claude has designed the landscape composition of this painting to give the figures a prominence that is not apparent in an earlier version of the subject (see No. 32). The relationship of the figures to each other is similar in both paintings and it is likely that Rachel, the younger daughter, has been placed at Laban's left. (Plate 9)

32
Landscape with Jacob, Laban and his Daughters

Pen, brown ink, grey and some brown wash, 19.5 × 25.5 cm
London, British Museum, Liber Veritatis 134 (MRD 755; Kitson 134)
This drawing of 1655 is the record made by Claude of the painting (see Fig. 5) executed in that or the previous year for Carlo Cardelli, and the pair to *Landscape with the Adoration of the Golden Calf* (Karlsruhe, Staatliche Kunsthalle) (see No. 29). No. 32 has some compositional affinity, in reverse, to *Landscape with Apollo and the Muses* (No. 72).

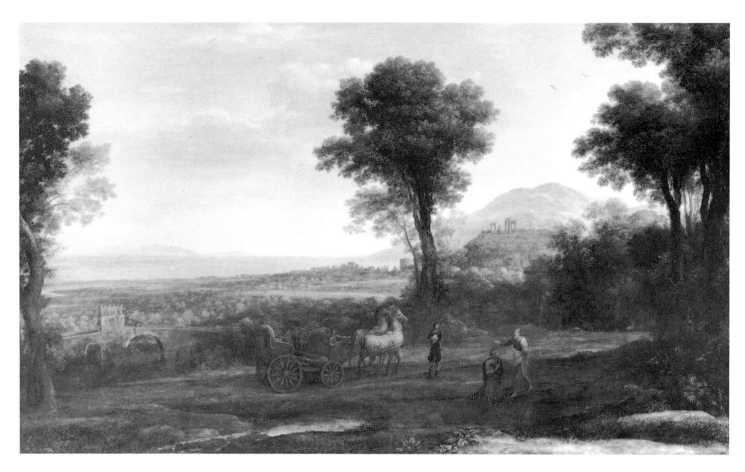

Saint Philip baptising the Eunuch

Saint Philip, one of the seven deacons of the early Church, was charged with preaching the word of God. An angel appeared to him and bade him travel the desert road between Jerusalem and Gaza. There Philip met a eunuch, who was treasurer to Candace, Queen of Ethiopia. Instructed by the angel to follow the Ethiopian's carriage, Philip discovered that he was reading the book of Isaiah. The eunuch was not able to understand the prophet's words and invited Philip to explain them to him. As they travelled Philip 'preached unto him Jesus', and when they drew near to some water the eunuch asked if he could be baptised. Philip replied that this could be done if he believed in Christ with all his heart. The eunuch was baptised and went on his way rejoicing (Acts 8: 26–40).

33
Landscape with Saint Philip baptising the Eunuch

Signed and dated: CLAVDE INV.ROMA 1678
Inscribed: S Filippo battesta lenucco della Regina
Oil on canvas, 84.5 × 140.5 cm
Cardiff, National Museum of Wales, no. NMWA4 (MRP 191)
No. 33 was painted in 1678 for Cardinal Fabrizio Spada (1643–1717). The subject matter may allude to the patron's conversion of Calvinists while he was Papal Nuncio in Turin, but, like its pair, *Landscape with Christ appearing to Saint Mary Magdalene* (1681; Frankfurt, Städelsches Kunstinstitut), it also contains a more general allusion to the revelation of the divine. (Plate 6)

34

Landscape with (?)Aeneas and the Cumaean Sibyl

Signed and dated:
CLAVDIO.IVF./ROMAE 1677
Pen, brown wash and some
heightening, 22.5 × 37.7 cm
London, British Museum,
no. 0o.7–147 (MRD 1106)
The subject is unclear. Both the
landscape and the motif of the
carriage bear obvious
similarities to No. 33. It has
been suggested that when the
drawing was made the subject
had not yet been decided, the
carriage alluding to the story of
Philip, the figures to that of
Aeneas (MRD, p. 407).

35

Landscape with Saint Philip baptising the Eunuch

Signed and dated: CLAVDIO
I.V./ROMA 1677
Inscribed: (by a later hand)
EVNVCO di CANDACE
Pen, brown wash,
20.5 × 29.2 cm
France, Private Collection
(MRD 1107)
No. 35 is a study for the figures
in No. 33. The group of Philip
and the eunuch is closer to the
subsidiary figures than in the
painting. Between drawing and
painting the position of the
subsidiary figures was also
changed.

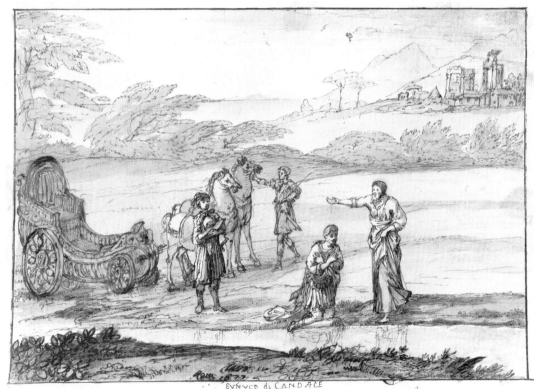

Fables and Legends

Most of Claude's paintings based on profane literary texts were derived from Ovid or Virgil, but he also painted subjects taken from other authors, including Apuleius, Tasso, Nonnus and Justinus.

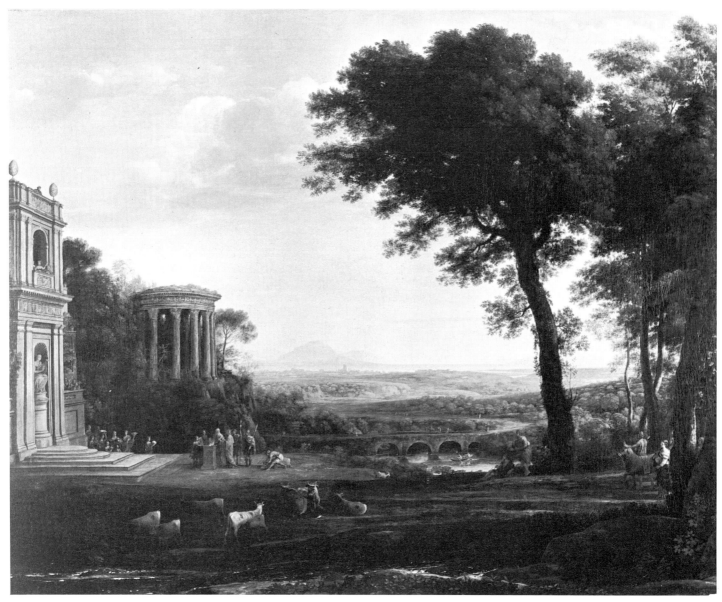

36

Apuleius

Apuleius was born about AD 130 in North Africa and was educated in Carthage and Athens. His major work is *The Golden Ass*, which related mythological incidents as satirical commentary on contemporary society. *The Golden Ass* is best known for the story of Cupid and Psyche, a source of inspiration for numerous writers and artists. It had been translated into French, Italian and English by the mid-sixteenth century. The interpretation of the story as an allegory of the soul seeking perfection was current during Claude's lifetime.

36 (opposite)
Landscape with the Father of Psyche sacrificing at the Temple of Apollo
Signed and dated: CLAUDIO G[EL]LEE FECIT ROMA 166[2?]
Oil on canvas, 174 × 220 cm
Cambridge, Anglesey Abbey, National Trust (MRP 157)
No. 36 was painted in 1662 for Angelo Paluzzi degli Albertoni (1624–1706), a member of the Roman nobility, and was Claude's first painting based on Apuleius' story of Cupid and Psyche. In 1667 Don Angelo's son, Gasparo, married the niece and heiress of Cardinal Emilio Altieri, and took the Altieri name and the rank of prince. It has been suggested that the subject of the painting was chosen as an allusion to Don Angelo's dynastic ambitions (MRP, p. 370). But it may perhaps have been intended as an example of human, and in particular princely, submission to the divine. (For the pendant see No. 56.) (Plate 32)

The Father of Psyche sacrificing at the Temple of Apollo

A king had three daughters, of whom the youngest, Psyche, was very beautiful. People came from far and wide to witness such beauty for themselves and worshipped her as though she were a goddess. This aroused the jealousy of Venus, whose temples were being neglected because of the new enthusiasm for Psyche. She urged her son, Cupid, to take revenge on the mortal by causing her to fall in love with the ugliest person imaginable. Meanwhile, Psyche's father, concerned that no suitor had come forward to claim the hand of his youngest daughter, went to consult the oracle of Apollo at Miletus. He offered prayers and sacrifices in the hope that the god would grant his daughter a suitable spouse. Instead, he received the unhappy news that Psyche must be prepared for marriage with a creature of darkness, feared by the gods themselves. Despite her family's grief, Psyche accepted the oracle's words as her destiny: she had usurped the position of Venus and this was her punishment. She urged her parents to abandon her to her fate.

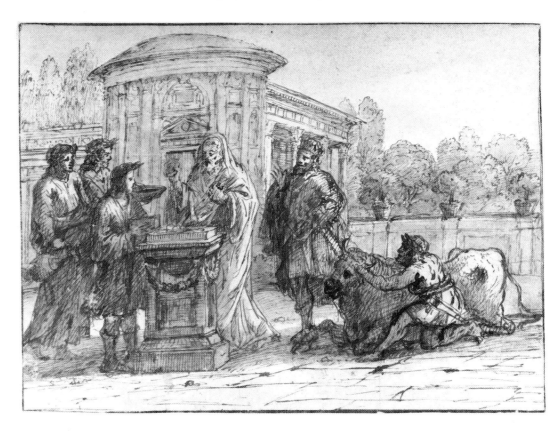

37
Study for the Father of Psyche sacrificing to Apollo
Pen, brown wash,
18.2 × 26 cm
Oxford, Ashmolean Museum, no. P.451a (MRD 882)

The figures and architecture in this study are close, but not identical, to those in the final painting (No. 36). In particular, the size of the figures relative to the architecture was reduced in the painting, and the architecture of the temple changed.

Psyche outside the Palace of Cupid

Abandoned on a mountain top Psyche awaited the fate prophesied for her by the oracle (see above). However, instead of the prophecy being fulfilled, she was transported by the gentle West Wind to Cupid's domain. Psyche's first view of Cupid's imposing castle was from the valley where the West Wind had carried her. She awoke to see a towering edifice so magnificently wrought with precious metals that no human hand could have fashioned it. Her curiosity emboldened her to enter the castle. There spirit voices greeted her and tended

to her every need. Each night she was visited by Cupid who forbade her to look at him. However, Psyche was eventually persuaded by her jealous sisters that Cupid was a monster whom she should behead. Taking a lamp to him as he slept, she discovered her mistake, but a drop of hot oil from the lamp awoke him. He vowed never to return to her because of the trust she had betrayed. Psyche, beside herself with grief, threw herself into a river in an attempt to end her life, but the river saved her by casting her body on to the bank, where she was

found by Pan and Syrinx. Pan urged her to stop grieving and instead live her life in such a way that Cupid would see she had repented of her action. After a series of trials Cupid and Psyche were reunited (Apuleius, *The Golden Ass*, V, 1–3).

The most frequently depicted episode of the Cupid and Psyche story was the climactic moment of Psyche looking on Cupid with her lamp. This occurred inside the palace, but as a landscapist Claude has shown in No. 38 and its pendant episodes which took place outside the palace before and after this moment.

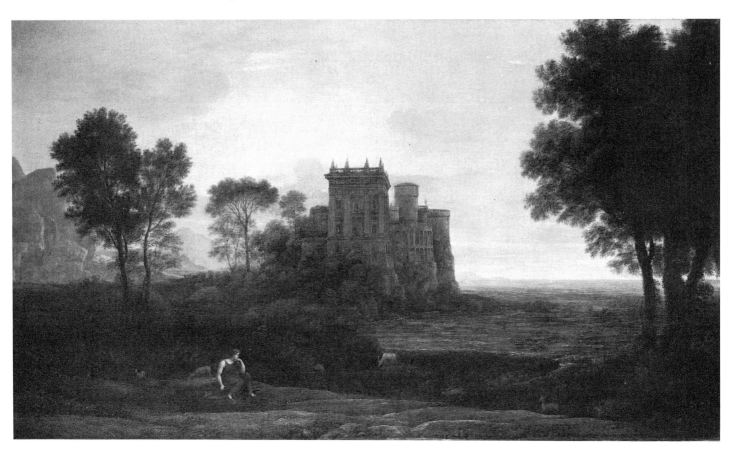

38
Landscape with Psyche outside the Palace of Cupid ('The Enchanted Castle')
Oil on canvas, 87 × 151 cm
London, National Gallery,
NG 6471 (MRP 162)

Claude painted No. 38 in 1664 for Prince Lorenzo Onofrio Colonna (1637–89), one of his most important patrons (see also Nos. 46, 59 and 60). It is unclear which part of Apuleius' story Claude has depicted, but the painting may show Psyche

in torment after her sisters' advice to kill Cupid. Colonna probably specified the subject of this painting and its pendant, *Landscape with Psyche saved from drowning herself* (Cologne, Wallraf-Richartz-Museum). No. 38 acquired its title 'The

Enchanted Castle' from the title of an engraving made after it in 1782. (Plate 35)

39

Landscape Study

Pen, brown wash,
12.4 × 18.7 cm
London, British Museum,
no. 1895.9.15.914 (MRD 500)
The drawing has been dated to
the early 1640s. Although the
building at the left is probably a
mill, not a palace, Claude
adopted a similar compositional
formula for the right-hand part
of one of the preparatory
drawings (No. 41) for the
painting.

40

*Study of Psyche in a
Landscape*

Inscribed: Claud 1663;
Chalk, brown wash,
15.4 × 21 cm
Private Collection (MRD 929)
The figure connects this
drawing to the painting (No. 38),
although in the latter her pose is
reversed and she no longer sits
under a group of trees. The
landscape composition is
broadly similar.

41
Landscape Study

Inscribed illegibly, and dated:
1663 Roma
Pen, brown wash, traces of
black chalk, diagonals in red
chalk on two pieces of paper
stuck together, 18.2 × 34.5 cm
Karlsruhe, Staatliche
Kunsthalle, no. 1983–10
(MRD 931)
In this drawing Psyche is again
shown seated under some trees
and facing left. The right-hand
side of the drawing now
includes Cupid's palace, the
architecture of which was
elaborated in the painting
(No. 38).

42
Landscape with Psyche saved from drowning herself

Pen, brown ink and grey-brown
wash on blue paper,
19.7 × 25.5 cm
London, British Museum,
Liber Veritatis 167 (MRD 957;
Kitson 167)
This is the record of the
painting (Cologne, Wallraf-
Richartz-Museum) made in
1666 as a pendant to No. 38.
The river which saved Psyche
has been personified as a
winged putto. On the bank is the
god Pan teaching Syrinx to play
the flute. It is not clear whether
the buildings in the background
are intended to represent
Cupid's palace.

Torquato Tasso (1544–95)

Tasso completed his epic poem *Gerusalemme Liberata* in 1575. In 1580 part of the *Gerusalemme* was published in Venice under the title of *Il Goffredo*, and the following year it appeared in full in a variety of editions (none of which carried Tasso's authorisation). The *Gerusalemme* quickly became one of Europe's most popular books. It was published in numerous editions and by 1600 had been translated into English, French, Spanish and Latin. Its stories were popular subjects in Italian and French seventeenth-century painting.

The poem concerns the conflicts between Christians and Saracens during the first Crusade. Although Tasso has employed heroic elements modelled on Homer's *Iliad* and Virgil's *Aeneid*, one of the principal features of his work is its romantic character. Tancred, a Christian knight, falls in love with Clorinda, a Saracen, and is also loved by Erminia, the daughter of a Saracen king. Rinaldo, a Christian prince, loves Armida, a beautiful witch, sent by Satan (invoked by the Saracens) to kill him.

The romantic interludes provide an element of contrast in the poem. Not only do the love scenes counterbalance the battle scenes but their setting in the tranquil countryside provides a refuge from the fierceness of the fighting that takes place in the city of Jerusalem. The contrasting locations are employed by Tasso to create a distinction between the duty of the Christian soldier to uphold the faith, and the pursuit of private interests, in this case love that crosses the barriers of faith.

Erminia and the Shepherd

In *Gerusalemme Liberata*, Erminia, a Saracen, falls in love with a Christian knight, Tancred. She fears he has been wounded and sets off to find him, disguised in armour belonging to the amazonian Saracen warrior Clorinda.

She comes across a peaceful grove set among shady trees and a murmuring stream. A shepherd's song drifts across the stillness and she sees an old man making baskets and listening to the singing of his three children. Her sudden appearance in armour startles them but, once reassured, the shepherd tells her about the rewards of his quiet, pastoral life. Impressed by his argument, Erminia decides to stay. Tasso introduces this scene, which was frequently depicted by seventeenth-century painters, as a respite from the episodes of fighting (*Gerusalemme Liberata*, VII, 5ff.).

43
Landscape with Erminia and the Shepherd

Oil on canvas, 92.5 × 137 cm
Norfolk, Holkham Hall, Viscount Coke (MRP 166)
Painted in 1666 for Prince Paolo Francesco Falconieri (1626–96), a Roman nobleman of Florentine origin. This work, and its pendant of the following year, *Coast View with the Embarkation of Carlo and Ubaldo* (Toronto, Art Gallery of Ontario), are the only pendants by Claude based on Tasso's poem, although Claude was to explore another episode from the poem in drawings around 1669 (MRD, pp. 369–71). Since these drawings can be related to a painting of *Aeneas and the Cumaean Sibyl* (1673, whereabouts unknown) also executed for Falconieri, it seems likely that Claude painted the two subjects from Tasso at this patron's specific request.

The composition of No. 43 is similar, in reverse, to the version of *Landscape with Cephalus and Procris reunited by Diana* (Earl of Plymouth Collection) painted by Claude two years previously. It is not known whether Claude knew Domenichino's version of *Erminia and the Shepherd* (Paris, Louvre). If he did, Claude's marginalisation of the figures within a dominant landscape may represent Erminia's seclusion from the world. (Plate 22)

44
Landscape Study

Inscribed: CLAUDIO INV FEC
Pen, brown and brown-grey
wash, black chalk and some
heightening, 23.5 × 39.3 cm
Derbyshire, Chatsworth,
Devonshire Collection, no. 945
(MRD 950)
Both the landscape composition
and the position of the figures in
this drawing of about 1665
resemble those of No. 43, but
the subject is not Erminia and
the Shepherd. Diana and
Callisto has been suggested.

45
Landscape with Erminia and the Shepherd

Signed and dated:
CLAVDIO.I.V.F./ROMA 1677.
Chalk, pen, brown wash and
heightening, 14 × 23.4 cm
London, British Museum,
no. Oo. 8–263 (MRD 1100)
In 1677 Claude returned to the
subject of Erminia and the
Shepherd with a series of three
drawings, of which this is one.
The artist may have been
working out ideas for a new
commission which never came
to fruition. The fall of the land in
this drawing seems too steep for
the merely murmuring stream
described by Tasso.

Nonnus

Nonnus was a Christian Greek poet who lived in the fifth century AD. The *Dionysiaca*, an epic poem, was his major work. It consisted of forty-eight books on the pagan deities, but particularly Dionysus, the god of wine, also known as Bacchus. It first appeared in print in Greek in 1569. In 1605 a Latin translation was published.

Bacchus at the Palace of Staphylus

In this episode from the *Dionysiaca* (XVIII, 334–9) Bacchus had been lavishly entertained by King Staphylus, an Assyrian king, and his son Botrys, at their magnificent palace, constructed from precious metals and decorated with jewels. The day after the feast Bacchus departed on a mission of war but in the evening when he returned with his retinue he found that Staphylus had died and the palace was in mourning. Bacchus assuaged the grief of the king's family with wine and urged them to become part of his company. The episode is an allegory of drunkenness in which the principal characters have been given names representing elements of wine and its effects: the aged servant, Pithos (a wine jar); the son, Botrys (grapes); the king's wife, Methe (drunkenness); the king, Staphylus (a bunch of grapes).

46

Landscape with Bacchus at the Palace of Staphylus

Pen, brown ink and wash, 19.5 × 25.5 cm
London, British Museum, Liber Veritatis 178 (MRD 1036; Kitson 178)

No. 46 is the record Claude made of a work painted in 1672 (Rome, Pallavicini Collection,) for Lorenzo Onofrio Colonna (1637–89), Duke of Paliano and Grand Constable of Naples. Colonna was the most important patron of Claude's later years, commissioning nine or ten paintings from him between 1663 and 1682, including Nos. 38, 59 and 60. The episode from Nonnus involving a magnificent palace – that of King Staphylus – may have appealed to Colonna, for whom Claude had painted another magnificent palace – that of Cupid (No. 38) – eight years previously. Its pendant,

Landscape with the Nymph Egeria mourning over Numa (Naples, Museo di Capodimonte), painted in 1669, comes from a more familiar source, namely Ovid's *Metamorphoses*.

Bacchus is shown at the extreme left mounting the palace steps, accompanied by a woman and a boy identified as Staphylus' widow, Methe, and their son, Botrys (MRP, p. 418). Below them is Bacchus' chariot, and facing them at the top of the stairs, but faintly drawn, is Pithos announcing that his master, Staphylus, is dead. At the right of the drawing a bull is being brought for sacrifice at the funeral ceremonies (Kitson, p. 163).

No. 46 and its pendant are about different responses to death. Whereas Methe indulged in drink, the nymph Egeria, mourning her husband Numa, was so disconsolate that she

melted away in tears until Diana out of pity turned her into a spring (Ovid, *Metamorphoses*, XV, 482–96, 547–51).

The composition is close to that of the *Landscape with the Father of Psyche sacrificing to Apollo* (No. 36) painted ten years previously, but the architecture of the palace is similar (in reverse) to that in the *Embarkation of the Queen of Sheba* (No. 26) made twenty-four years previously – an example of the use made by Claude of his earlier drawings.

Justinus

Justinus was a historian who lived no later than the beginning of the fifth century. He was the author or the *Historiae Philippicae*, an anthology of extracts from the *Universal History of Trogus Pompeius*, probably written shortly after 20 BC, which charted the history of the Macedonian monarchy, five of whose kings were called Philip.

Justinus' work was first printed in Venice in 1470, and a number of critical editions appeared during the sixteenth century. It was translated into Italian in 1526 and into French in 1538.

View of Delphi with a Procession

The town of Delphi was built on the slopes of Mount Parnassus, in northern Greece, to serve the oracle of the god Apollo. The site was described by Justinus as follows: 'The temple of Apollo is located on Mount Parnassus, at the summit of a steep rock... And the temple and the city are not defended by walls but by crags of rock, formed by nature not man, so that it is uncertain whether the natural strength of the site or the majesty of the god contributes most to their magnificence... Among the rocks, almost half way up the mountain, is a small plain, in which there is a deep hole, this is the opening of the oracle... Consequently, many rich gifts brought by kings and people alike can be seen in this place; the wealth of the votive offerings being proof of the gratitude of the suplicants and the responses of the gods' (Justinus, *Historiae Philippicae*, XXIV, 6).

47
View of Delphi with a Procession

Signed and dated: Claudio IVF./Roma. 1672/ROMA
Inscribed: il tempio di Apollo in delfo sopra l'monte parnaso/cavata da giustino historico (the temple of Apollo in Delphi on Mount Parnassus taken from Justinus the historian)
Pen, grey wash and some heightening, 25.6 × 32.9 cm
The Royal Collection, no. 13079 (MRD 1057)
No. 47 is not a record of a finished painting, but a detailed preliminary drawing for the painting *View of Delphi with a Procession* (Chicago, Art Institute), of 1673, executed for Cardinal Camillo Massimi, a learned collector. The subject and literary source are indicated by the inscription. Claude

carefully followed Justinus' text in both drawing and painting, the pendant of which was *Perseus and the Origin of Coral* (No. 79). Like the *View of Delphi* this was another rare subject, in this case from Ovid's *Metamorphoses*. No connection between the themes of the two paintings has been identified and they were not hung as a pair (see pages 15–17).

The unusual subject of this drawing and of No. 79 suggest that sophisticated patrons looked for unusual episodes in ancient sources which would suit Claude's talents.

Virgil

Virgil (Publius Vergilius Maro; 70–19 BC) was born near Mantua. His epic poem, the *Aeneid*, was his last work.

The subject of the *Aeneid* is the adventures of the Trojan hero Aeneas, after the fall of Troy. It relates how Aeneas overcame various trials on his journey towards Italy where he settled with his Trojan companions. It is therefore a sequel to Homer's *Iliad* which relates the war between the Greeks and Trojans, and a parallel to Homer's account in the *Odyssey* of the adventures of the Greek hero Ulysses.

Aeneas and his companions were the legendary forbears of the Romans. Aeneas as the son of Venus also provided a direct link between the dynasty of the founders of the city of Rome and the ancient gods. Members of several seventeenth-century noble Roman families claimed descent from him.

The events of the *Aeneid* were interpreted in a moral or allegorical manner. For example, a parallel was drawn between the obstacles of Aeneas' journey and the road to virtue, with his arrival in Italy being seen as the attainment of moral fulfilment (see pages 96 and 98). The *Aeneid* was available in numerous editions and translations by the mid-seventeenth century, but from inscriptions which he made on some *Liber Veritatis* drawings Claude is known to have consulted the Italian translation by Annibale Caro in the edition published in Rome in 1623.

50

The Landing of Aeneas

The subject of No. 48 is unknown, but is most likely to be one of the landings of Aeneas, of which a number are recounted by Virgil (including *Aeneid*, V, 32–42; VI, 1–12; VII, 25–36) and several by Ovid (*Metamorphoses*, XIII, 630–1; XIV, 77, 83, 156–7, 447–8). The evocative atmosphere of No. 48 does not fit any of these passages, although one of the preparatory drawings for it (No. 50) is close to the description in the *Aeneid*, Book VI, where Aeneas lands at Cumae. However, the sentiment of No. 48 would be best matched by the passage in Book VII immediately following Aeneas' landing: 'Who were the kings, what was the tide of events, how stood ancient Latium, when first that stranger host beached its barques on Ausonia's shore...?' (*Aeneid*, VII, 37–9). No. 48 cannot, however, be certainly related to the *Aeneid*, and its pendant No. 52 is not based on any known text.

50 (previous page)
Study for the Coast Scene with the Landing of Aeneas
Pen, brown, grey and some pink wash, white heightening, 18.6 × 25.8 cm
Paris, Ecole Nationale Supérieure des Beaux-Arts, no. 937 (MRD 690)
In this drawing the principal figures are shown as having landed. Claude may have had in mind Aeneas' landing at Cumae when the hero 'seeks the heights, where Apollo sits enthroned [in his temple] and a vast cavern hard by, hidden haunt of the dread Sibyl...' (*Aeneid*, VI, 9–10).

48
Coast Scene with the Landing of Aeneas
Signed and dated: CLAVDIO IVF ROMA 1650
Oil on canvas, 102 × 135 cm
Private Collection (MRP 122)
No. 48 was painted for a patron in Paris in 1650, six years after its pendant No. 52. The composition of the two paintings is contrasted, one being a landscape, the other a coast view. (Plate 26)

49 (above)
Landing at a Classical Seaport
Signed and dated: Claudio iv F/Roma 1643
Pen and brown ink, traces of black chalk, with grey, brown and pink wash on buff paper, 24.5 × 42.9 cm
The Netherlands, Private Collection (MRD 525)
The two ships at the left and the figures in the boat being rowed ashore are nearly identical to those in No. 48. The setting is clearly different. The calculated measurements of the faint chalk lines suggest that the drawing was a final model for a painting, which seems not to have been executed, and the subject of which is unidentified. (Plate 27)

51

Study for Coast Scene with the Landing of Aeneas

Chalk, pen, brown wash, some heightening on reddish tinted paper, 19.2 × 26.7 cm
London, British Museum, no. 0o.7–160 (MRD 689)
This study, although not as calculated as No. 50, is not necessarily earlier. The small tree-topped island is similar to that in the painting. Aeneas and his companions are walking away from the heights – which is perhaps a freer interpretation of the text.

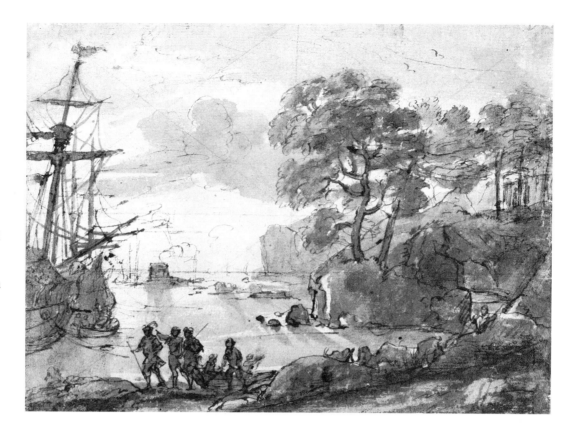

52

Pastoral Landscape with the Arch of Titus

Indistinctly dated: 1644
Oil on canvas, 102 × 135 cm
Private Collection (MRP 82)
This imaginary pastoral scene is the pendant of No. 48, but for reasons outlined above (see pages 40–2) it is difficult to make an interpretative connection between the two paintings. Prominent at the right of this imaginary pastoral scene of 1644 is the ruined Arch of Titus. Titus was Emperor of Rome from AD 79 to AD 81. Other ruins associated with his reign are shown in imagined locations: the superimposed arches reminiscent of the Colosseum, and in the centre an aqueduct, perhaps one of a number he had repaired. Both the Arch of Titus and the Colosseum are found in several of Claude's paintings. (Plate 25)

Aeneas at Delos

After fleeing the besieged and burning Troy, Aeneas put to sea with his father, Anchises, and his son, Ascanius. They chanced upon an island, a safe haven, and there cast anchor. The island was Delos, sacred to the god Apollo.

Aeneas and his family were greeted by King Anius, ruler of the island, who showed them the landmarks of his city, including Apollo's temple, of which Anius was the priest. Anius invited them into the temple where they offered prayers and sacrifices to the god for 'an enduring home...a race, and a city that shall abide'. Apollo told the Trojans to return to 'the land which bore you first from your parent stock...There the house of Aeneas shall lord it over all lands, even his children's children and their race that shall be born of them.' Initially, the Trojans interpreted Apollo's cryptic instruction as meaning that they should go to Crete, but once there they encountered plague and drought. Only following further prayer was it revealed to Aeneas that their proper destination was Italy (Virgil, *Aeneid*, III, 73ff., and Ovid, *Metamorphoses*, VI, 335; XIII, 630ff.).

53
Landscape with Aeneas at Delos
Signed and dated:
.CLAVDE.GILLE.INV.FE.
ROMAE 1672
Inscribed: ANIVS ROY.
SACER[D]OTE [DI] APOLLO.
-ANCHISE-ENEA
Oil on canvas, 99.7 × 134 cm
London, National Gallery,
NG 1018 (MRP 179)
No. 53 was painted in 1672 for a patron who was probably French and possibly a member of the Le Gouz family, seigneurs du Plessis. No pendant is known. It is the first of the six works based on Virgil painted by Claude in the final ten years of his career. However, in the case of this painting, Claude also consulted Ovid's *Metamorphoses* because it is Ovid and not Virgil who relates that Anius pointed out the sacred trees, olive and palm. Apollo's priest, Anius (dressed in white at the left of the main group of figures), is showing Anchises, Aeneas and Ascanius the city, its shrine and the two sacred trees. These were the trees to which Latona had clung when giving birth to Apollo and his twin sister, Diana. A relief on the roof balustrade of Anius' home at the right of the painting shows Apollo and Diana killing the giant Tityus for having tried to rape Latona. The oracular prophecy of Apollo that Aeneas and his companions would find a permanent home in Italy is alluded to by the temple in the background – its architecture approximates to that of the Pantheon in Rome. The golden eagles at the corners of the pediment may allude both to Jupiter, Apollo's father, and to the Roman Empire. (Plate 30)

54
Coast View with Mercury and Aglauros

Pen, brown wash,
19.7 × 26.5 cm
London, British Museum,
Liber Veritatis 70 (MRD 526;
Kitson 70)

There is a marked similarity in composition between this drawing, the *Liber Veritatis* record of a painting made in 1643, and No. 53.

The subject matter of the drawing is taken from Ovid's *Metamorphoses*, II, 748–51: the greedy Aglauros demands gold from Mercury to speak favourably of him to her sister Herse. The episode occurred inside the sisters' house, but as a landscapist Claude has ignored this and moved the scene out of doors. He shows Aglauros, Herse and Mercury together, an encounter not related by Ovid. Nearly thirty years later Claude adapted the composition to make an appropriate setting for the story of Aeneas on Delos – yet another example of Claude re-using elements of earlier compositions (see No. 46). A comparison between Nos. 53 and 54 shows Claude's greater concern in his later years to be faithful to his text.

The present drawing would have been relatively fresh in the artist's mind when he was working on *Aeneas at Delos*, since in 1667–8 he had made two near copies of the drawing in preparation for an etching of 1668 by Dominique Barrière (*c*.1610–78). The painting of *Mercury and Aglauros* (Rome, Pallavicini Collection), of which No. 54 is the record, was made for Giulio Rospigliosi (1600–69), who was to become Pope Clement IX in 1667.

On the reverse of No. 54 Claude transcribed almost word

for word, and acknowledged, Horologgi's notes on the subject of Mercury and Aglauros in Anguillara's Italian translation of the *Metamorphoses*: 'Aglauro che dimanda a mercurio gran/soma de denari per lasciar goder lamore/della sorella chiamata.herse/favola cavata nell'annotasione, del secondo libri di ovidio.' (Aglauros who asks Mercury for a large sum of money to let him enjoy the love of her sister called Herse. Story extract in the notes from the second book of Ovid.)

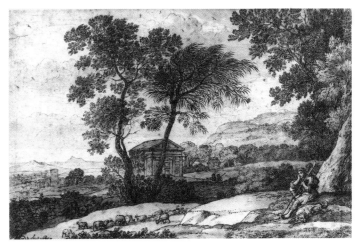

55
Pastoral Landscape

Inscribed: Claudio fecit 1670
Chalk, pen, brown and grey
wash with some heightening,
25.6 × 39.2 cm
Norfolk, Holkham Hall, Viscount
Coke (MRD 1039)

The central motif of the two trees, one of which is a palm, was used in No. 53, although it is not clear if Claude was here considering the subject of Aeneas at Delos.

The Landing of Aeneas at Pallanteum

After seven years of wandering following the fall of Troy, Aeneas and his companions reached the shore of Latium, the region around Rome. This was partial fulfilment of the prophecy of Apollo at Delos (see above). The god of the river Tiber told Aeneas that he would guide him and his party safely up river to Pallanteum. There they would meet the Arcadians, who would unite with the Trojans against the hostile tribes to found the city of Alba, precursor of Rome.

Aeneas set off along the Tiber with two galleys of soldiers and after days and nights of journeying saw from afar the roofs and walls of the city of Pallanteum. By chance, the Arcadian king Evander was with his nobles in a grove outside the walls offering a sacrifice to Hercules, and observed the arrival of the ships. His son, Pallas, went to meet the Trojans and, seeing the olive branch borne by Aeneas, welcomed them. Evander, who had known Anchises, the father of Aeneas, gladly agreed to join in the Trojans' endeavour and offered them hospitality (Virgil, *Aeneid*, VIII, 26ff.).

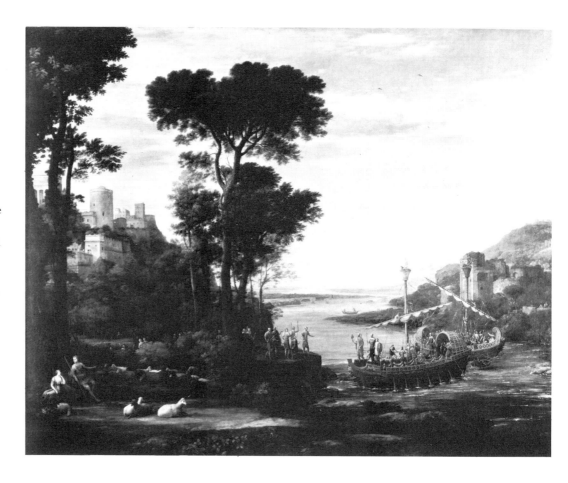

56

Landscape with the Arrival of Aeneas before the City of Pallanteum

Inscribed, signed and dated: Larrivo d'Anea a palant(eo) al monte evantino/Claudio.Gille inv.fecit ROMAE. 1675
Oil on canvas, 175 × 224 cm
Cambridge, Anglesey Abbey, National Trust (MRP 185)
Claude started work on No. 56 by 1671, but it was not finished until 1675. Prince Gasparo Altieri must therefore have commissioned it as a pendant to No. 36 soon after Cardinal Altieri had been elected Pope Clement X in 1670. Claude's inscription on a preparatory drawing (MRD 1077; not illustrated here) states that Gasparo requested the subject of Aeneas showing the olive branch to Pallas as a sign of peace. Gasparo may have wanted to

have Aeneas represented as an allusion to his own princely status. The Altieri family claimed descent from Aeneas and their arms are painted on the flag of Aeneas' ship.

As the central action of Aeneas showing the olive branch to Pallas and the inscriptions on No. 57 indicate, Claude must have read Virgil's text carefully, but he did not follow it in every particular. For example, the Tiber is not heavily wooded on both banks, as Virgil's words suggest, and Claude has depicted Aeneas at his ship's prow rather than speaking 'from the high stern' (*Aeneid*, VIII, 115). Nevertheless, unlike Claude's earlier rendering of a landing of Aeneas (No. 48), the text on which this painting was based can be precisely identified.
(Plate 31)

57

Study for the Landscape with the Arrival of Aeneas before the City of Pallanteum

Signed and dated, bottom left:
Roma 1675 Claudio fecit
Inscribed at left: cittadella... Re
Evandra..[m]onte Evantine; and
at right (partly obscured):
...ruine de la...ianicolo;
saturno...
Pencil, pen and brown ink and
brown wash, white bodycolour,
17.7 × 25.2 cm
London, Courtauld Institute
Galleries, no. 9273 (MRD 1079)
The inscriptions refer to the
citadel of King Evander; Rome's
Aventine Hill, at the left of the
drawing; and to the ruined hill
towns of Janiculum and
Saturnia, at the right, which,
according to Virgil, Evander
showed Aeneas during their
tour of Pallanteum (*Aeneid*,
XVIII, 357-8).

58

Figure Study

Inscribed Claudio, IVF. Roma.
1675
Chalk, pen, brown wash,
18.5 × 25.4 cm
London, British Museum,
no. Oo.8–269 (MRD 1083)
The drawing shows two galleys
powered by oars in accordance
with Virgil's text (*Aeneid*, VIII,
79 and 108). Aeneas, holding an
olive branch, is on the stern of
one with Achates. The armour
worn by the figures was
simplified in the painting.

 Virgil's text required the
boat's prow to point landwards
but Aeneas to be at its stern.
This would seem to be Aeneas'
position to judge from the
projecting rudder, but since
rowers would usually have their
backs to the prow, Claude
seems in this drawing to have
been considering placing
Aeneas there as he ultimately

did in No. 56. He presumably
felt that proximity between
Aeneas and Pallas was more
important in rendering the
story's drama than precisely
following the text.

Dido and Aeneas

Venus, disguised as a huntress, appeared to her son, Aeneas, on the coast of Libya, and directed him to the city of Carthage, founded by Dido. Fearful for her son's safety in the face of the Greeks, who were championed by Juno, Venus besought Cupid to unite Aeneas and Dido in love so that the Carthaginians would side with the Trojans.

Cupid, in the guise of Ascanius, Aeneas' son, inflamed Dido with an obsessive love for the Trojan leader that caused her to forget her vow of fidelity to her late husband. When Juno perceived that Venus was gaining the upper hand she joined forces with her, persuading Venus that the consummation of the couple's love would serve both their interests. Thus, the next day, after setting out from Carthage on a hunting trip with a large retinue, Dido and Aeneas became isolated from the party during a storm and were forced to shelter in a cave, where they made love (*Aeneid*, IV, 1–175). Subsequently Aeneas, instructed by Mercury on Jupiter's bidding, and persuaded that he should have regard for the future of his son Ascanius, abandoned Dido and continued his voyage to Italy.

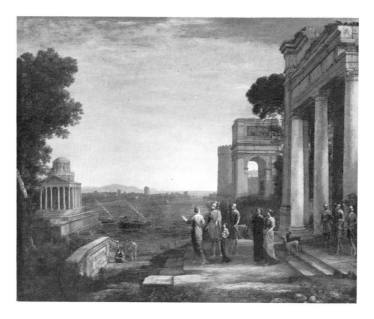

59
View of Carthage with Dido and Aeneas

Inscribed lower centre: AENEAS. ET DIDO. CLAVDIO. I.V.F. ROMA 1676; and on the parapet lower left: CARTHAGO; and apparently CLAVDIO 1675 ROMA on the bale of goods below the arch.
Oil on canvas, 120 × 149.2 cm
Hamburg, Kunsthalle, acc-no. 783 (MRP 186)

Nos. 59 and 60 were painted as pendants for Lorenzo Onofrio Colonna (see Nos. 38 and 46) in 1676 and 1682 respectively. The former was Claude's last seaport and the latter his last painting. The episodes in both paintings were probably chosen by the patron, and it can be inferred from Claude's letters to Colonna regarding other paintings that Colonna was consulted on the details (see Roethlisberger 1988).

The subject of No. 59 is problematic. On the *Liber Veritatis* drawing Claude inscribed a reference to his source: libro 4 de virgilio f.108(?) (book 4 of Virgil folio 108 (?)). Unfortunately the folio reference is unclear, but folio 108 of the edition of the *Aeneid* which Claude was using would correspond to *Aeneid*, IV, 130–50 (Kitson, p. 169). This passage relates how just after dawn Dido and Aeneas met outside the gates of Carthage to go hunting; Virgil describes Dido as accompanied by horsemen and as having a 'prancing steed ... brilliant in purple and gold'. Claude has not included these details, and harbour steps seem an odd place from which to depart for the hunt. Nevertheless, other motifs from Virgil's description of the scene have been incorporated, 'the broad-pointed hunting spears... the keen scented hounds... [Dido's] tresses knotted into gold', and no other passage in the *Aeneid* corresponds more closely to the painting.

The primary incident in the painting is that of the departure for the hunt, but two questions then arise: first, why, and at what, is Dido pointing, since this gesture is not mentioned by Virgil; second, why is the episode given a harbour setting? It has been suggested that Dido is pointing at the harbour rather than at the temple (Russell, p. 191). However, in two related drawings (MRD 1087 and 1088)

Dido is pointing at both, and this may therefore have been Claude's (imperfectly realised) intention. If so, the gesture would allude to both past and future events: the temple of Juno in which Dido and Aeneas had first met (*Aeneid*, I, 446ff.) and the ships by which Aeneas would later depart Carthage to the suicidal despair of Dido. The need to include both the temple and the ships explains the harbour setting.

The temple of Juno, however, is itself allusive since Juno was worshipped as protectress of marriage, a state which Dido was to claim, and Aeneas to deny, by virtue of their consummated passion (*Aeneid*, IV, 316, 338–9). Dido's gesture towards the temple and the ships therefore also anticipates her plea when she discovers that Aeneas intends to leave: 'Can neither our love keep thee, nor the pledge once given...' (*Aeneid*, IV, 307); and her accusation: '...his lost fleet I rescued, his crews I saved from death' (*Aeneid*, IV, 375). The somewhat bewildered gesture of Aeneas in turn anticipates the conflict between his desire to stay with Dido and his duty to go to Italy. 'There is my love, there my country!' (*Aeneid*, IV, 347). Indeed, Aeneas stands between Dido – representing his love – and Ascanius, his son and heir – representing his duty. Claude therefore presents the departure for the hunt not as a picturesque event but as a turning point in the devlopment of a tragedy. The architecture, so much more severe than in earlier seaport scenes, seems to reinforce the painting's tragic import.
(Plate 34)

Landscape with Ascanius shooting the Stag of Silvia

Aeneas and his party of Trojans had settled in Latium, but Alecto, one of the Furies, wanted to provoke hostilities between the Trojans and the Latini. While Ascanius, Aeneas' son, was out hunting, she caused his hounds to pick up the scent of a stag which belonged to Tyrrheus, the keeper of the royal herds. It was a magnificent animal, with large antlers, that had been nurtured by Tyrrheus' sons since its birth. Their sister, Silvia, doted upon it, washing the animal herself and making garlands of flowers to adorn its antlers, and although it roamed the woods by day, she had trained it to return home at night.

The hounds caught up with the stag on a river bank and Ascanius, anxious for glory, fired his arrow, wounding the stag and causing it to flee to safety in great pain. When Silvia saw the stag's suffering she sought help from her neighbours who armed themselves and went in search of the Trojans. Fierce fighting ensued, fulfilling the Fury's evil desire (*Aeneid*, VII, 475–510).

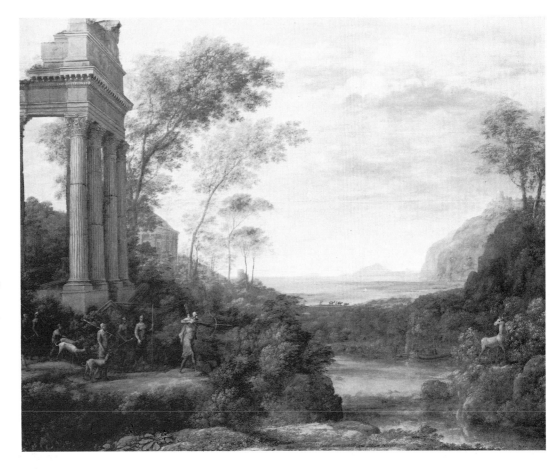

60
Landscape with Ascanius shooting the Stag of Silvia

Signed and dated: CLAVDIO. I.V.F. A ROMAE 1682
Inscribed: come Ascanio.saettà il Cervo di Silvia figliuola di Tirro Lib 7 Vig. And further signed below: CLAVDIO ROM
Oil on canvas, 120 × 150 cm
Oxford, Ashmolean Museum, no. A. 376 (MRP 222)
The inscription 'How Ascanius shot the Stag of Silvia daughter of Tyrrheus Book 7 Virgil' identifies the subject. In both this painting and its pendant, No. 59, a woman loses, or is soon to lose, something dear to her with tragic consequences.

Indeed, the paintings can be seen as concerned with the destruction of love, in one case by Aeneas' abandonment of Dido, and in the other by the killing of the stag, beloved of Silvia. The episode in No. 60 is all the more poignant when paired with No. 59. In the former Aeneas destroyed Dido's love for him out of a sense of duty to his son, Ascanius; in the present painting Aeneas' enterprise is put at risk by the consequences of Ascanius' self-centred deed. The pairing of the two works is made explicit both by the architecture, the columns on the right of *Dido and Aeneas* being 'answered' by those on the left of *Ascanius*, and by the huntsmen and dogs emerging from right and left respectively.

The Colonna arms included an unfluted column, as in No. 59, with a Corinthian capital, as in No. 60. Claude's use of this architectural motif to allude to his patron combines unity of theme with variety of expression, just as with the main subject matter of the two paintings.

Elongated figures are characteristic of Claude's late paintings. By challenging the viewer's sense of reality, they help to emphasise the poetic nature of the landscape, as do the feathery trees and silvery-blue tonality in No. 60.
(Plate 33)

61

Study for Coast View with Aeneas hunting

Inscribed: CLAVDIO G/F.IV. Rom/.1669.

Chalk, grey and brown wash, pen, heightening, 24.1 × 35.6 cm

London, British Museum, no. Oo. 8–256 (MRD 991)

A study for a painting (now in Brussels, Musées royaux des Beaux-Arts) executed in 1672 for Prince Falconieri (see No. 43). The episode is from Book I of the *Aeneid*: Aeneas hunts deer for his hungry soldiers following their landing in Libya. The composition has similarities both to No. 60 and to another drawing of 1669 (Berlin, Kupferstichkabinett; MRD 987) showing not Aeneas hunting, but another hunt, possibly that of Ascanius.

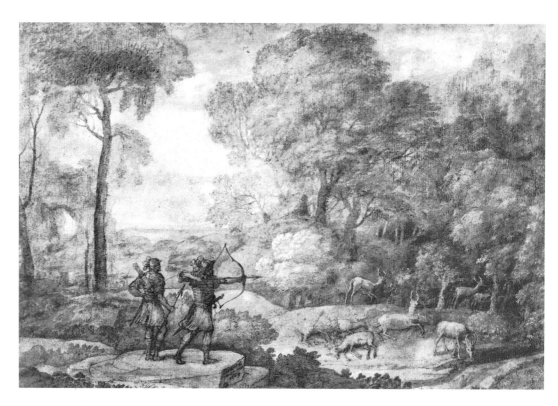

62

Venus and Aeneas

Inscribed: Enea. accompagnato. d'Acato. rincontra Venus in habito di./diCaciatrice. lib.1°./Eneide. di Virgilio

Possibly dated: Ro..16..

Pen and brown and orange-brown ink, grey-brown and grey wash, and heightening, 24.5 × 31.8 cm

Derbyshire, Chatsworth, Devonshire Collection, no. 940 (MRD 1126)

Many of the compositional elements of this drawing of about 1678 reappear in No. 60, for example the columns at the left and the high ground at the right separated from the principal figures by a steep valley. As inscribed, the episode is from Book I of the *Aeneid*: Venus appears to Aeneas and Achates dressed as a huntress. The figure on the right is Achates, Aeneas' follower, grasping two spears, tipped with broad steel as Virgil relates (*Aeneid*, I, 312–13).

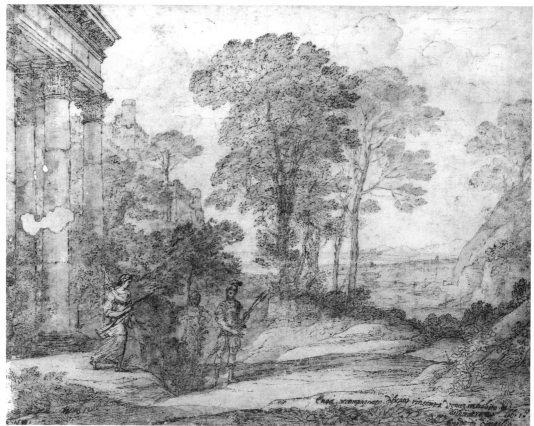

63
Ascanius hunting

Inscribed: libro settimo di Virgilio foglio. 16./Come Ascanio saetto il Cervo.de/.de Silvia. Figliuola di. Tirro./Claudio I.V.F./Roma 1671678

Pen and orange-brown ink, grey wash, traces of heightening, 25.3 × 32.8 cm

Derbyshire, Chatsworth, Devonshire Collection, no. 943 (MRD 1127)

The figures, their relationship to each other and to the stag appear in this drawing of 1678 nearly as in the painting, but Ascanius and the stag are not yet separated by a river and the temple at the left has still to be introduced. The reference to 'foglio. 16' in the inscription shows that Claude was using the 1623 edition of Caro's translation of the *Aeneid*.

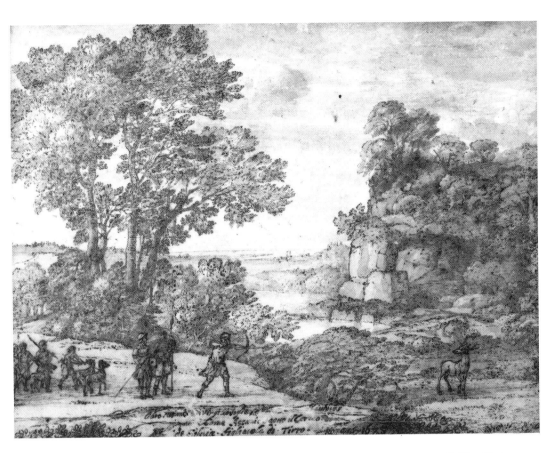

64
Ascanius hunting

Inscribed: libro. 7 di/Vigilio[sic]/Claud IV 1682/Come Ascanio saettà il Cervo. di silvia figliola. di Tirro/Roma 168-/CLAVDIO/I.V.F.

Pen, brown wash, some heightening, 24.8 × 31.5 cm

Oxford, Ashmolean Museum, no. P.402 (MRD 1128)

In this preparatory drawing the figures are larger than in No. 63, but there are fewer of them. Not referrered to in Virgil's text is the ruined temple which Claude has introduced perhaps as a reference to the patron's name, Colonna, which means column. Between drawing and painting the temple's architecture was altered, the figures were reduced in size in relation to the overall picture space but also elongated, and the void between the two halves of the composition was widened.

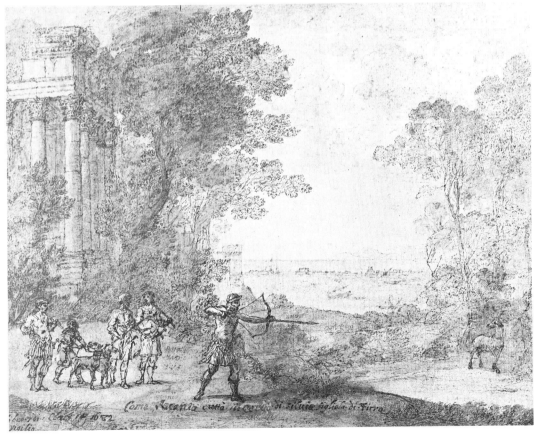

Ovid

The *Metamorphoses* is the best-known work by the Roman poet Ovid (Publius Ovidius Naso; 43 BC–AD 17). In its fifteen books, Ovid told the numerous stories of classical mythology. It was largely completed by AD 8 when the author was banished from Rome to an outpost of the empire on the Black Sea; on learning of his imminent exile Ovid burned the poem but copies in the possession of his friends survived.

The *Metamorphoses* has been widely read since the Middle Ages, a particularly popular variant then being the Moralised Ovid, which provided a Christian interpretation of the text with a biblical counterpart for each mythological character.

Numerous editions and translations of the *Metamorphoses* were produced following its first appearance in print in 1471. Notes to the text were a common addition made by publishers. One annotated example that ran to many editions after its publication in 1554 was the Italian translation by Giovanni Andrea Anguillara with notes by Horologgi. Claude is known to have referred to an edition of this translation (see No. 54). Other works by Ovid, such as the *Heroides*, a youthful work of love poems, and the *Fasti*, a poem based on the Roman calendar, were also widely available in printed translation by the mid-seventeenth century.

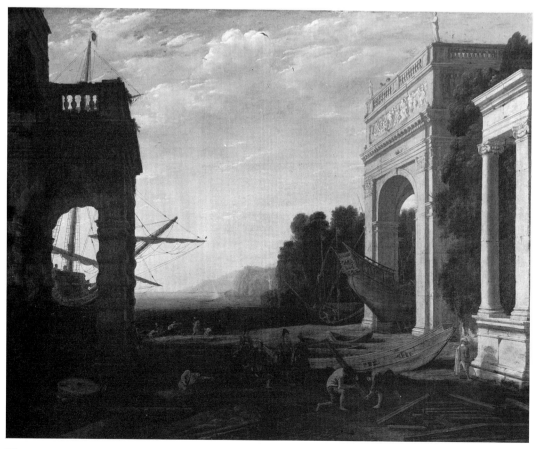

65

Judgement of Paris

When Eris, the goddess of discord, was not invited to the wedding of Peleus and the sea-nymph Thetis, she shattered the harmony of the proceedings by leaving a golden apple inscribed 'to the fairest'. A dispute ensued among the goddesses over who should be given the apple, and Jupiter decreed that Mercury should transport Venus, Juno and Minerva to Mount Ida, where the handsome shepherd prince Paris should choose the winner.

To sway his judgement, Juno promised Paris great rewards and Minerva promised him power and military glory, but he chose Venus as the fairest because she vowed he would be the lover of the beautiful Helen, daughter of Jupiter and Leda. When Paris realised the prophecy by taking Helen away from her husband, the Greeks' fury at his deed led to war and the destruction of Troy, a disaster that had been foretold at his birth.

This story is related by Ovid in *Heroides*, XVI, 55ff., and by Servius in his commentary on Virgil's *Aeneid*, I, 27. It also appears in Lucian's *Deorum Dialogi*, XX, Hyginus' *Fabulae*, XCII, and is referred to in Homer's *Iliad*, XXIV, 25, 29, and Pausanias' *Description of Greece*, V, 19, 55, with a varying amount of detail. It is likely that Claude's interpretation is indebted to a pictorial tradition itself derived from an amalgam of these sources. The Judgement of Paris is not part of the *Metamorphoses* but was often incorporated into editions of Ovid's poem. The story was frequently interpreted as signifying the choice of vice rather than virtue.

65 (opposite)
Coast View
Inscribed: CLAVDIO...LE INV..RO; and (by a later hand) CLAVDIO GELLÈ INV. ROMAE.1633
Oil on canvas, 97 × 122 cm
Selkirk, Bowhill, Duke of Buccleuch (MRP 202)
The *Landscape with the Judgement of Paris* (No. 66) and its pendant, No. 65, have similarly balanced compositions, but one is a coast view in morning light (No. 65), and the other a landscape in afternoon light (No. 66). (Plate 23)

66 (below)
Landscape with the Judgement of Paris
Inscribed (retouched): CLAVDIO.IELLE INV. 1633
Oil on canvas, 97 × 122 cm
Selkirk, Bowhill, Duke of Buccleuch (MRP 201)
Although the *Coast View* (No. 65) contains references to the antique in the architecture, it is in essence a genre scene, unlike its pendant, the *Judgement of Paris*, which illustrates a fateful moment in the affairs of gods and men. Venus is shown with Cupid, Juno with her attribute, a peacock, while Minerva kneels. Facing them is Paris holding the apple, and standing beside him is Mercury. The ruined temple may have been intended to allude to the forthcoming strife between the Greeks and Trojans consequent upon Paris' choice. On the basis of style it has been suggested that the main figures in the *Judgement of Paris* may be the work of another artist (MRP, p. 461). (Plate 24)

Landscape with Narcissus and Echo

When Narcissus was born to the beautiful nymph Liriope, the wise Tiresias warned that the child must never come to know himself or his life would be cut short. By the time he reached the age of sixteen many of his companions fell in love with him, but the handsome Narcissus shunned their attentions. One nymph, Echo, loved him deeply, but could not express her love as the jealous goddess Juno had deprived her of the power of speech, and she could only utter the last phrase spoken by others.

She attempted to communicate her feelings to Narcissus but her curious repetitions startled him and he spurned her. Her grief was overwhelming; it consumed her body until only her voice remained, forlornly repeating the words it heard. One of Narcissus' companions, who had been spurned like Echo, invoked the heavens praying that Narcissus might fall in love with himself and thus be unrequited.

The goddess Nemesis heard the youth's plea and when Narcissus, weary from the hunt, stooped to drink from a pool of water, she caused him to be smitten by his own reflection. He was unable to tear himself away from his watery likeness and rather than leave his new-found love, preferred to die by the water's edge. Echo felt pity when she saw his life slipping away and the other nymphs joined her in her grief. The nymphs prepared a funeral pyre, but when they went to collect his body it had gone. In its place was a flower with white petals and a yellow centre that ever since has borne his name (Ovid, *Metamorphoses*, III, 345–510).

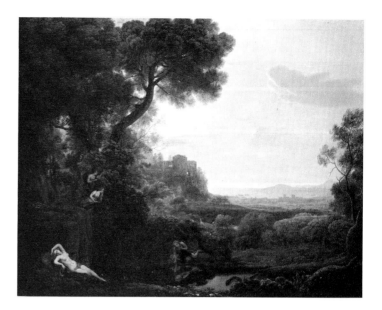

67
Landscape with Narcissus and Echo

Signed and dated: CLAVDE GILLEE...1644
Oil on canvas, 94.5 × 118 cm
London, National Gallery, NG 19 (MRP 77)

No. 67 is Claude's only known painting of this frequently depicted subject, and one of only two paintings recorded by him as having been made for an English patron (*Liber Veritatis* 77 and 78); the other is *Landscape with a Temple of Bacchus* (Ottawa, National Gallery of Canada). The paintings are of similar size, but not necessarily made as pendants, nor even for the same patron.

The lower of the two nymphs in the trees is probably Echo. The other nymphs may be among those whom Narcissus had scorned although they did not appear at this stage of Ovid's story. The water-nymph in the foreground was originally painted draped, according to the *Liber Veritatis* drawing and a print made after the painting in 1743. Traces of the original drapery can still be seen. This nymph may have been intended as Narcissus' dead sister whom he had loved, according to Pausanias' version of the tale (see page 44), but here she appears asleep rather than dead. (Plate 28)

68
Landscape Study with Narcissus

Pen, brown wash, 11.5 × 17.7 cm
London, British Museum, no. Oo. 6–68 (MRD 548)

This preliminary study for No. 67 suggests that Claude may have been thinking of Ovid's words: '... as hoar frost melts before the warm morning sun, so does [Narcissus], wasted with love, pine away...' (*Metamorphoses*, III, 488–90). However, he may have decided finally to use Ovid's description of the woodland pool – in a 'coppice that would never suffer the sun to warm the spot' (*Metamorphoses*, III, 412) – and have modified his conception of the painting accordingly.

Cephalus and Procris

The goddess Aurora lured Cephalus away from his wife, Procris, but when he could speak only of the pleasures of his marriage, she became jealous and cast doubts in his mind about his wife's fidelity.

Cephalus resolved to test his wife and with the goddess's help was transformed into a stranger. So disguised, he made his way home and there encountered Procris, lonely, and anxious for her husband's return. He tried many times to court her favour, finally causing her to hesitate when he offered a great fortune in return for her love. In anger, he revealed his identity and Procris fled with shame.

She roamed the countryside as one of Diana's huntresses, spurning the company of men, saddened as she was by the trickery of her husband. But Cephalus was lonely and begged his wife's forgiveness. Procris returned to him and brought gifts that Diana had given her, a hound and a spear. The ensuing happiness of Cephalus and Procris was, however, undone by Procris' unfounded suspicions of her husband's infidelity: while she watched him hidden by bushes, he mistakenly killed her with the spear.

The story was told in *Metamorphoses*, VII, 693–758, although Ovid does not mention Diana being present at the reunion of Cephalus with Procris as depicted by Claude. A similar scene does form the ending to the play, *Cefalo*, by Niccolò da Correggio, first produced in 1487 and printed in several editions. However, in *Cefalo* the remorseful Cephalus is brought to Diana and her company of nymphs by the nymph Galatea. Neither the nymphs nor Galatea appear in any of Claude's versions of the subject.

69
Landscape with Cephalus and Procris reunited by Diana

Signed and dated: CLG. I.V. ROMA 1645
Oil on canvas, 101.6 × 132.1 cm
London, National Gallery, NG 2 (MRP 91)

Besides the National Gallery version (No. 69), painted in 1645 for an unknown patron in Paris, Claude made several other versions of the story of Cephalus and Procris reunited by Diana: before 1638 for the Marchese Vincenzo Giustiniani (1564–1637), one of Rome's leading art collectors (formerly Berlin, Staatliche Museen, destroyed 1945); in 1645 in upright format for Prince Camillo Pamphili (1622–65) (Rome, Galleria Doria-Pamphili); and in 1664 for the Abbé Louis d'Anglure, sieur de Bourlemont (1627–97), a French diplomat in Rome (England, private collection).

The figures in the Pamphili painting are virtually identical in reverse to those in No. 69, and close to those of the other versions. In the 1664 version the figures are more centrally placed and the landscape elements appear to frame them, whereas in No. 69 they seem to be placed where space happens to be available. The stags of the later version are more appropriate to the theme of hunting than the cattle shown in the present painting.

A commonly painted episode from the story was the death of Procris. Claude painted the subject once around 1646/7 (whereabouts unknown, copy in the National Gallery, NG 55).

The various versions of Cephalus and Procris reunited by Diana suggest, however, his preference for less dramatic scenes and his willingness to adjust a story to his talents (see also No. 54). (Plate 29)

70 (bottom)
Pastoral Landscape

Pen, brown wash, 19.5 × 26.3 cm
London, British Museum, Liber Veritatis 75 (MRD 534; Kitson 75)

This is the record of a painting (unknown; possibly that of Lord Jersey destroyed by fire) of 1643/4 for a patron living in Antwerp. There is no known direct literary source for the painting, but both the composition of the landscape and the placement of the figures and cattle within it are close to No. 69.

Landscape with the Flaying of Marsyas

Marsyas, a satyr, discovered a flute that had been discarded by Minerva, and played the instrument, not knowing that the goddess had caused it to be cursed. Proud of his new-found ability, the satyr challenged Apollo to a contest, pitting his skill on the flute against Apollo's playing of the lyre.

Apollo was declared the victor by the Muses and Marsyas was made to suffer a dreadful punishment. He was tied to a tree and flayed alive, the skin stripped from his body to expose his muscles and veins. The country people and the fauns and satyrs were desolated by such cruelty and wept profusely. The earth gathered up their tears and transformed them into a stream bearing the name of Marsyas (Ovid, *Metamorphoses*, VI, 382–400; see also Hyginus, *Fabulae*, CLXV).

The subject was frequently painted and variously interpreted as a reminder of their vulnerability to those who would fearlessly compete with God (Francesco Turchi 1637); and as an example to ignorant poets not to be presumptuous (Renouard 1619, and Du Ryer 1660).

71

Landscape with the Flaying of Marsyas

Oil on canvas, 120.5 × 158 cm
Norfolk, Holkham Hall, Viscount Coke (MRP 95)

Claude depicted this subject twice, once around 1639/40 (Moscow, Pushkin Museum) for a Monsieur Perochel (1574–1659), a counsellor in Paris and Sèvres, and in the present painting of around 1645/6 for an unknown, probably French, patron. The composition was reversed in the later painting, and the reclining river god added, alluding perhaps to the forthcoming metamorphosis of the people's tears. Apollo is shown being crowned the victor, while Marsyas, tied to a tree, is about to be flayed by a Scythian slave. The country people at the left shrink in anticipation of his impending torture. Scenes of violence were unusual in Claude's work. The cruelty in the present painting is contrasted with the peaceful surroundings in which it takes place. (Plate 16)

Apollo and the Muses

Two mountains were sacred to Apollo and the Muses, Mount Helicon (some forty kilometres west of Thebes), and Mount Parnassus, which is above the town of Delphi. It was on the former that the Muses were believed to dwell, although there was a temple for their worship at both sites. Numerous ancient authors, including Ovid, wrote of Apollo, the god of music and poetry, and of the nine Muses of poetic and creative inspiration. The first to name all nine was the Greek poet Hesiod in his poem *Theogonia*, written probably in the eighth century BC.

The nine Muses were believed by most ancient writers, including Hesiod, to be the offspring of Zeus, the greatest of the gods, and Mnemosyne, daughter of Uranus, first ruler of the world, who had lain together for nine nights. Each maiden represented a different type of creative inspiration and as described in Cesare Ripa's *Iconologia* (Rome 1593) was recognisable by an attribute that was representative of her art.

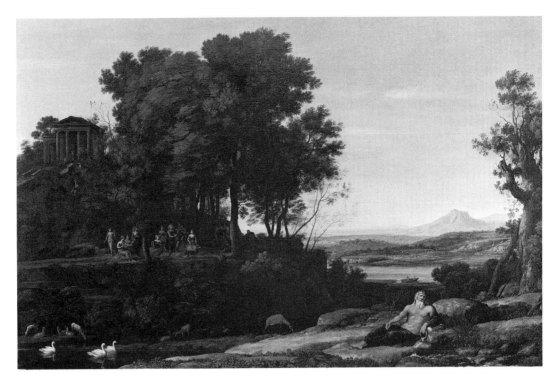

72
Landscape with Apollo and the Muses

Signed and dated: CLAVDIO IV ROMA 1652
Oil on canvas, 186 × 290 cm
Edinburgh, National Gallery of Scotland, no. 2240 (MRP 126)
The patron of No. 72 was Camillo Astalli (1619–63), whom Pope Innocent X created Cardinal Pamphili in 1650 following the disgrace in 1647 of the former Cardinal Camillo Pamphili (see Nos. 21 and 26).

In view of the absence from the painting of the winged horse Pegasus who caused the Hippocrene fountain to spring forth from Mount Helicon (Ovid, *Metamorphoses*, V, 256–7), Claude probably intended to show Mount Parnassus, the other place most often associated with the Muses. There is a general resemblance in the arrangement of Claude's figures with those in Marcantonio Raimondi's print after Raphael's *Parnassus* (Rome, Stanza della Segnatura).

The swans are attributes of Apollo, who is seen playing a lyre. The figure in the foreground is a river god. The Muses in the painting can be identified by reference to Claude's drawing of them executed over twenty years later (see No. 75). (Plate 18)

73
Landscape

Pen, brown wash and
heightening, 17.3 × 23.4 cm
London, British Museum,
no. Oo 7–204 (MRD 713)
This landscape study of around
1650 was not necessarily made
with *Apollo and the Muses* (No.
72) in mind. In the painting
Claude has introduced an area
of flat ground between the
heights and the valley floor.

74
Pastoral Landscape

Pen, brown wash,
19.5 × 29.5 cm
Paris, Musée du Louvre,
no. RF 4,585 (MRD 717)
Possibly executed a little after
completion of No. 72. The
platform of land on the far bank
of the river is here too small to
accommodate Apollo and the
Muses. The drawing represents
an intermediate point between
the composition of No. 72 and
that of *Landscape with Mercury
and Battus* of 1663 (No. 77).

75 (above)
Apollo and the Muses
Inscribed: CLAVDIO.
I.V.F./ROMA 1674; and below
the cartouche of Clio:
claudio/Fecit; and within the
cartouches, see below.
Pen, brown wash and
heightening on three sheets,
20.3 × 57.4 cm
London, Agnew's (MRD 1070)
This drawing, dated 1674,
virtually repeats the figures of
Apollo and the Muses in the
Edinburgh painting (No.72).
The inscriptions in the
cartouches are notes taken from
Cesare Ripa's *Iconologia*, by
then published in several
editions. The existence of four
other drawings on the subject of
Parnassus, all dated 1674,
suggests that this drawing was
made with a painting in mind.

The cartouches read:
(i) Terpsicore la/cetara in
mano/ghirlanda/di pene di vary
colore/in atto di/Ballare
(Terpsichore [Muse of dancing
and song], lyre in hand, garland
of feathers of different colours,
in the act of dancing)
(ii) Talia/ghirlanda di/vari foiri
[sic] un/maschera in/mano et
allegre (Thalia [Muse of comedy
and pastoral poetry], garland of
different flowers, a mask in

hand and cheerful)
(iii) Pollinnia/volume/in
mano/polinnia/acconciatura/in
testa di/perle et gioie (Poly-
hymnia [Muse of heroic hymns],
book in hand, Polyhymnia head-
dress of pearls and jewels)
(iv) Urania/una ghirlanda/di
lucenti stelle/un globo in mano
(Urania [Muse of astronomy], a
garland of shining stars, a globe
in hand)
(v) Calliope un/cerchio d'oro
cinta/la fronte in mano/un libri
in mano (Calliope [Muse of epic
poetry], a circle of gold around
the forehead, a book in hand)
(vi) Melpomene ricca et/vaga
acconciatura di/Capo con
corone in/mano et scettri
(Melpomene [Muse of tragedy],
costly and beautiful head-dress,
with crown in hand and
sceptres)
(vii) Apollo
(viii) Euterpe ghirlanda/di varie
flory in/mano diversi
strumenta/da fiato (Euterpe
[Muse of music and lyric
poetry], garland of different
flowers, various wind
instruments in hand)
(ix) ERato cinte le tempie/con
corona di mirto/con la mano
terra/una lira et il /plectro
(Erato [Muse of lyric and love
poetry], the temples surrounded

with crown of myrtle, the hand
holding a lyre and plectrum)
(x) Clio/ghirlanda di/lauro et
con la/mano uno/tromba (Clio
[Muse of history], garland of
laurel, and [in her] hand a
trumpet)

76
Parnassus
Inscribed: ROMAE 1681.
CLAVDIO. IVF
Chalk, pen and ink, brown and
grey wash with heightening on
blue paper and touches of blue
wash, 19 × 25 cm
London, British Museum,
Liber Veritatis 193 (MRD 1114;
Kitson 193)

The record of the painting
(Boston, Museum of Fine Arts)
executed (as an inscription on
the reverse indicates) for
Lorenzo Onofrio Colonna (see
Nos. 38, 46, 59, 60) in 1680. As
compared with No. 72, the
figures are on the right-hand
side of the image and closer to
the viewer. Although the scene
at first appears to be Apollo and
the Muses on Mount Parnassus,
the inclusion at the extreme
right of the winged horse
Pegasus sugggests that it may be
Mount Helicon (Rosenberg 1982,
p. 282).

Mercury and Battus

Mercury stole some cattle from Apollo, whose mind was on love instead of the animals in his care. There was only one witness to the theft, an old man called Battus who had been watching some mares grazing nearby. Mercury feared Battus would reveal his crime so he offered him a heifer to keep silent. The old man agreed, professing that a stone would sooner talk than he.

Mercury left but returned in disguise and asked the man if he had seen some cattle, offering this time one cow and one bull in return for information. Battus was immediately tempted and disclosed the location of the herd. Mercury turned him into a stone, so that he was never able to speak again (Ovid, *Metamorphoses*, II, 676–707).

In the seventeenth century the story was commonly interpreted as a warning against lying and perjury, although one commentator saw it also as a warning to beware promises from strangers (Du Ryer 1660).

77
Landscape with Mercury and Battus
Oil on canvas, 74 × 100 cm
Derbyshire, Chatsworth, Devonshire Collection
(MRP 159)
No. 77 was painted in 1663, probably for the same Antwerp patron who may have commissioned as its pendant *Landscape with Apollo and Mercury* (1660; London, Wallace Collection), a painting of the immediately preceding episode of Ovid's story. The composition of No. 77 is ultimately derived from that of the Edinburgh *Apollo and the Muses* (No. 72). The gestures of the figures suggest that Claude has shown the moment when Mercury offers Battus a heifer and Battus promises his silence. Ovid described the episode as taking place in a glade near rich pasture, which would have appealed to Claude.

78
Landscape with Mercury and Battus
Inscribed: claudio/IVF Roma 166
Chalk, pen and brown ink, brown and grey wash, heightened, 24.8 × 36.4 cm
Paris, Musée du Louvre, no. RF 4,590 (MRD 891)
It is not clear whether this drawing was preparatory to No. 77. The group of three cows in the centre is similar in both works, but the figures of Mercury and Battus have been slightly changed. The drawing may, like the painting, show Mercury promising Battus a heifer for his silence, or the slightly later episode of Mercury accusing Battus of treachery.

Perseus and the Origin of Coral

When Perseus succeeded in slaying the snake-haired gorgon Medusa, sight of whom turned men to stone, he cut off her frightening head, and laid it on a bed of leaves and seaweed. On contact with the severed head the fresh pieces of seaweed absorbed the creature's blood and began to harden into coral. The nymphs of the sea found that this transformation took place on other pieces of seaweed (Ovid, *Metamorphoses*, IV, 740–9).

79

Coast View with Perseus and the Origin of Coral

Oil on canvas, 100 × 127 cm
Norfolk, Holkham Hall, Viscount Coke (MRP 184)
No. 79 was painted in 1674 for Cardinal Camillo Massimi (1620–76) as a pendant to the *View of Delphi with a Procession* (1673; Chicago, Art Institute) – two rarely depicted subjects. Massimi's interest in the story of Perseus and the Origin of Coral is shown by his also owning a drawing of this subject by Poussin (The Royal Collection). Claude's inscription on a preparatory drawing (New York, Metropolitan Museum of Art, Lehman Collection) suggests that the concept of the painting originated with Massimi.

In the inventory taken in 1677 after Massimi's death, No. 79 was described as a 'landscape ... with the fable of

Perseus with the rising of the sun', but it may have been intended as a moonlit scene.

Perseus is shown washing his hands in water as related by Ovid (*Metamorphoses*, IV, 740), while the nymphs surround the gorgon's head, marvelling at the transformation taking place. Also in the painting is the winged horse Pegasus, which sprang from the blood of Medusa's severed head (*Metamorphoses*, IV, 785–6). Pegasus is tied to a palm tree in accordance with the Anguillara translation of Ovid but not Ovid himself. The palm was a token of victory, and Pegasus of fame. In the *Mythologiae* of Natali Conti, first published in 1551, Perseus is said to represent prudence and the reason of the soul, in contrast to Medusa who is likened to a harlot and represents pleasure and desire (edition of Geneva 1612, pp.

807–8). Claude's painting may therefore have been seen as symbolising the victory of reason over desire, leading to renown. (Plate 8)

80

Studies of Sea Nymphs

Signed (?): Claudio fecit Roma
1671
Chalk, pen, brown wash,
heightening on paper tinted
blue-grey, 17.6 × 26 cm
Norfolk, Holkham Hall, Viscount
Coke (MRD 1067)
Studies (some in duplicate) for
the five nymphs shown around
the gorgon's head in No. 79. The
bluish tint of the paper supports
the suggestion that the scene
was intended to be moonlit.

81

Studies of Sea Nymphs

Inscribed: testa de lamedusa
Claudio fecit 1672
Chalk, pen, brown wash,
15.5 × 22 cm
London, British Museum,
no. 0o. 8–260 (MRD 1068)
Ovid does not mention that the
nymphs held Medusa's severed
head, and this motif does not
appear in the final painting.

Biography

Claude Gellée was born in the village of Chamagne near Nancy in the then independent Duchy of Lorraine, probably in 1604/5. In about 1617, after the death of his parents, he travelled with a relative to Rome where he worked as a pastry-cook before entering the studio of the landscape and decorative painter Agostino Tassi (c.1580–1644). Around 1620 he worked in Naples for Goffredo Wals (c.1595–1638), the German painter of small landscapes. He had returned to Rome by 1623. Two years later Claude went to Lorraine for a year to assist the court painter Claude Deruet (c.1588–1660) in the ceiling decoration of the Carmelite church at Nancy, his task being to paint illusionistic architecture. By 1627 he was back in Rome, this time to settle. He never married but had one child, a daughter, Agnese (born 1653), who survived him. Claude died in 1682 and was buried in the church of Trinità de' Monti, which appears in his *View of Rome* (No. 4), painted fifty years previously.

After he had returned to Rome from Nancy, Claude went on sketching expeditions in the Roman countryside with Poussin, among others, and Joachim von Sandrart (1606–88). Sandrart, who wrote his biography, related how Claude 'tried by every means to penetrate nature, lying in the fields before the break of day and until night in order to learn to represent very exactly the red morning sky, sunrise and sunset and the evening hours.' The first work Claude signed and dated was made in 1629. Four years later he became a member of the Accademia di S. Luca, the artists' guild in Rome. Thereafter his career as an independent landscape artist flourished and by 1636, or perhaps a little earlier, he felt obliged to record his compositions in his *Liber Veritatis* – as a safeguard against forgery, according to his other contemporary biographer, Filippo Baldinucci (1624?–96). From then on most of his paintings were recorded in the *Liber Veritatis* (now in the British Museum in London), the date and name of the patron being inscribed on the back of many of these drawn copies. By 1640 Claude was the most commercially successful landscape painter in Europe, and he remained so for the rest of his life. He was able to command high prices and his patrons included Philip IV of Spain, Pope Urban VIII, ambassadors and cardinals.

Select Bibliography

ADLINGTON, William, *The Most Pleasant and Delectable Tale of the Marriage of Cupid and Psyche, done into English by William Adlington* (London 1566), [ed. Andrew Lang], London 1887.

ALLEN, Don Cameron, *Image and Meaning, Metaphoric Traditions in Renaissance Poetry*, Baltimore 1960 (revised 1968).

ANEAU, Barptolemy, *Imagination Poetique, traduicte en vers François, des Latins, & Grecz, par l'auteur mesme d'iceux*, Lyon 1552.

L'Asino d'Oro di Lucio Apuleio, translated by Pompeo Vizani, Venice 1639.

Ausgewählte Werke der Staatlichen Kunsthalle Karlsruhe, 3 vols., Karlsruhe 1988, vol. 2. *100 Zeichnungen und Drucke aus dem Kupferstichkabinett*.

BALDINUCCI, Filippo, *Notizie de' Professori del Disegno*, 14 vols., Milan 1811–12. (The life of Claude is in vol. 13.)

BARDON, H., 'L'Enéide et l'Art XVI^e–XVIII^e siècle', *Gazette des Beaux-Arts*, 33(2), 1950, pp. 77–98.

BARDON, H., 'Sur l'influence d'Ovide en France au 17eme siècle', *Atti del Convegno Internazionale Ovidiano*, 2 vols., Rome 1959, vol. 2, pp. 69–83.

BARRELL, John, 'The public prospect and the private view: the politics of taste in eighteenth-century Britain', in *Reading Landscape. Country-city-capital*, ed. S. Pugh, Manchester and New York 1990.

BAUDOIN, Jean, *Recueil d'Emblemes divers avec des discours moraux, philosophiques et politiques*, Paris 1638.

BAUEREISEN, H., 'Claude Lorrain als Figurenmaler', *Intuition und Darstellung*, ed. F. Büttner and C. Lenz, Munich 1985, pp. 159–64.

BOBER, P.P., and RUBINSTEIN, R.O., *Renaissance Artists and Antique Sculpture*, Oxford 1986.

BJURSTRÖM, P., *Claude Lorrain. Sketchbook*, Stockholm 1984.

BOEUR, C. de, ed., *Ovide Moralisé en prose*, Amsterdam 1954.

BOLARD, Laurent, 'La symbolique des ports chez Claude Lorrain; une révision', *Gazette des Beaux-Arts*, 1991, pp. 221–30.

BOLGAR, R.R., *The Classical Heritage and its Beneficiaries from the Carolingian Age to the End of the Renaissance*, London and New York 1954 (1964 reprint).

BOYER, L.L., 'The Origin of Coral by Claude Lorrain', *Metropolitan Museum of Art Bulletin*, vol. 26, 1968, pp. 370–9.

BREWER, W., *Ovid's Metamorphoses in European Culture*, 3 vols., Francestown, New Hampshire, 1933–57.

BURROW, Colin, 'Original Fictions: Metamorphoses in the Faerie Queene', in *Ovid Renewed: Ovidian Influences on Literature and Art from the Middle Ages to the Twentieth Century*, ed. C. Martindale, Cambridge 1988, pp. 99–119.

BUZZONI, Andrea, et al., *Torquato Tasso tra letteratura musica teatro e arti figurative*, Bologna 1985.

CARFRITZ, Robert C., *see* WASHINGTON 1988.

CARO, Anibal, ed., *L'Eneide di Virgilio*, Rome 1623.

CARTARI, Vincenzo, *Les Images des Dieux*, translated by Antoine du Verdier, Lyon 1623.

COMITIS, Natalis, *Mythologiae, sive explicationis Fabularum*, Geneva 1612.

CORRADINI, S., 'La Collezione del Cardinal Angelo Giori', *Antologia di Belle Arti*, I, 1977, pp. 83–8.

CORREGGIO, Niccolò da, *Opere*, ed. A.T. Benvenuti, Bari 1969.

DAVIES, Martin, *National Gallery Catalogues, French School*, London 1957.

DAVIS, Gregson, *The Death of Procris, 'Amor' and the Hunt in Ovid's Metamorphoses*, Rome 1983.

DELLEY, Gilbert, *L'Assomption de la Nature dans la Lyrique française de l'Age baroque*, Berne 1969.

DEPLEURRE, Fr Stephane, *Aeneis Sacra continens Acta Domini nostri Jesu Christi et primorum martyrum qui passi sunt tempae persequationis*, Paris 1618.

DU RYER, Pierre, transl., *Les Metamorphoses d'Ovide en Latin et François*, Brussels 1677 (first edition, 1660).

Famiglie Celebri di Italia, 13 vols., Milan 1819–69.

FREDERICKSEN, Burton B., 'A pair of pendant pictures by Claude Lorrain and Salvator Rosa from the Chigi Collection', *Burlington Magazine*, 1991, pp. 543–6.

FREEDMAN, L., *The Classical Pastoral in the Visual Arts*, New York, Berne, Frankfurt, Paris 1989.

GARMS, J., *Quellen aus dem Archiv Doria-Pamphilj zur Kunsttätigkeit in Rom unter Innocenz X*, Rome and Vienna 1972.

GHISALBERTI, F., 'L'"Ovidius Moralizatus" di Pierre Bersuire', Studj Romanzi, XXIII (1933), pp. 5–136.

GILBERT, Creighton, 'On Subject and Non-Subject in Italian Renaissance Pictures', *Art Bulletin*, 1952, pp. 202–17.

GRATET-DUPLESSIS, Georges, *Essai bibliographique sur les différents éditions des oeuvres d'Ovide, ornées de planches publiées aux XV^e et XVI^e siècles*, Paris 1889.

HEPP, Noémi, 'Virgile devant la Critique Française à l'époque de Boileau', *Critique et Création Littéraires en France au XVII^e siècle, Paris 4–6 juin 1974*, ed. du C.N.R.S., Paris 1977, pp. 39–49.

(HOWELL, Thomas) *The Fable of Ovid treting of Narcissus, translated out of Latin into English Metre, with a moral ther unto, very pleasante to rede*, London 1560.

HUNT, J.D., *The Pastoral Landscape. Studies in the History of Art 36*, National Gallery of Art, Washington DC, Hanover and London 1992.

HYGINUS, *Mythographi Latini*, ed. Thomas Muncker, Amsterdam 1681.

JONES, Pamela M., 'Federico Borromeo as a Patron of Landscapes and Still Life: Christian Optimism in Italy ca 1600', *Art Bulletin*, 1988, pp. 261–72.

JONES, Pamela M., *Federico Borromeo and the Ambrosiana, Art Patronage and Reform in Seventeenth-Century Milan*, Cambridge 1993.

KENNEDY, I.G., 'Claude Lorrain and Topography', *Apollo*, XC, 1969, pp. 304–9.

KENNEDY, I.G., 'Claude and Architecture', *Journal of the Warburg and Courtauld Institutes*, 35, 1972, pp. 260–83.

KITSON, Michael, 'The "Altieri Claudes" and Virgil', *Burlington Magazine*, CII, 1960, pp. 312–18.

KITSON, Michael, 'The Place of Drawings in the Art of Claude Lorrain', *Studies in Western Art*, Acts of the Twentieth International Congress of the History of Art, III, Princeton 1963.

KITSON, Michael, 'Claude and Carthage', *Apollo*, 77, 1963, pp. 226–7.

KITSON, Michael, 1969, *see* LONDON 1969.

KITSON, Michael, *Claude Lorrain: Liber Veritatis*, London 1978.

KITSON, Michael, 'The Seventeenth Century: Claude to Francisque Millet', and passim in *Claude to Corot: The Development of Landscape Painting in France*, Colnaghi, New York 1990.

KITSON, Michael, 'Claude Lorrain as a Figure Draughtsman', *Drawing: Masters and Methods. Raphael to Redon. Papers presented to the Ian Woodner Master Drawings Symposium at the Royal Academy of Arts, London*, ed. Diana Dethloff, London 1992, pp. 64–88.

LANGDON, Helen, *Claude Lorrain*, Oxford 1988.

LEE, Rensselaer W., 'Ut pictura poesis: The humanistic theory of painting', *Art Bulletin*, XXII (1940), pp. 197–269.

LE RAGOIS, M., *Instruction sur l'Histoire de France, et sur la Romaine, par demande, et par Réponses. Avec une explication des 109 Fables des Metamorphoses d'Ovide*, Paris 1684.

LEVEY, Sir Michael, 'A Claude Signature and Date revealed after Cleaning', *Burlington Magazine*, CIV, 1962, p. 390.

LEVEY, Sir Michael, '"The Enchanted Castle" by Claude: subject, significance and interpretation', *Burlington Magazine*, 1988, pp. 812–20.

LLEWELLYN, Nigel, 'Illustrating Ovid' in *Ovid Renewed: Ovidian Influences on Literature and Art from the Middle Ages to the Twentieth Century*, ed. C. Martindale, Cambridge 1988, pp. 151–66.

MAGNUSON, Torgil, *Rome in the Age of Bernini*, 2 vols., Stockholm 1982–6.

MAMBELLI, Guiliano, *Gli Annali delle Edizioni Virgiliane*, Florence 1954.

MANCINI, Guilio, *Considerazioni sulla Pittura*, ed. A. Marucchi with comment and additional material by L. Venturi and L. Salerno, 2 vols., Rome 1956–7.

MANNOCCI, L., *The Etchings of Claude Lorrain*, New Haven and London 1988.

MAROLLES, Michel de, *Les Oeuvres de Virgile traduites en prose*, Paris 1655.

MATTOR, S., 'En Marge du De Lumine. Splendeur et mélancolie chez Marsile Ficin', *Lumière et Cosmos, Courants occultes de la philosophie de la Nature*, Paris 1981, pp. 33–75.

MENESTRIER, C.F., *La Philosophie des Images*, Paris 1682.

Le Metamorfosi di Ovidio ridotte da Giovanni Andrea dell'Anguillara e con gli argomenti di M. Francesco Turchi, Venice 1637.

Les Metamorphoses ou l'Asne d'or de L. Apulée, Philosophe Platonicien, Paris 1648.

La Mythologie au XVIIᵉ Siècle. 11ᵉ Colloque du Centre Méridional de Rencontres sur le XVIIᵉ siècle, Marseilles 1982.

MONTAGU, Jennifer, 'The Painted Enigma and French Seventeenth-Century Art', *Journal of the Warburg and Courtauld Institutes*, 1968, pp. 307–35.

MORPER, J.J., 'Johann Friedrich Graf von Waldstein und Claude Lorrain', *Münchner Jahrbuch der bildenden Kunst*, 1961, pp. 203–17.

MORTIER, Roland, *La Poétique des ruines en France*, Geneva 1974.

MOSS, Ann, *Ovid in Renaissance France*, London 1982.

MOSS, Ann, *Poetry and Fable. Studies in Mythological Narrative in Sixteenth-Century France*, Cambridge 1984.

ORBAAN, J.A.F., *Documenti sul Barocco in Roma*, Rome 1920.

OVID (Publius Ovidius Naso), *Metamorphoses*, translated into English by F.J. Miller, London and Cambridge, Mass., 1966 (first published 1916).

PANOFSKY, E., *Idea, A Concept in Art Theory*, New York, Evanston, San Francisco, London 1960.

(PARRIS, Leslie) *The Loyd Collection of Paintings and Drawings*, London 1967.

PATTERSON, Annabel, *Pastoral and Ideology, Virgil to Valéry*, Oxford 1988.

PAUSANIAS, *Description of Greece*, translated into English by W.H.S. Jones, 5 vols., London and Cambridge, Mass., 1965–9.

PESTILLI, Livio, 'Shaftesbury "Agente" d'arte: sulla provenienza vicereale di due quadri di Salvator Rosa ed uno (scomparso?) di Claude Lorrain', *Bollettino d'Arte*, 71 (1992), pp. 131–40.

PHILOSTRATUS, *Les Images*, translated by Blaise de Vigenère, Paris 1614, Garland edn., New York and London 1976.

PILES, Roger de, *Abrégé de la vie des Peintres*, Paris 1715 (first published 1699).

PUGET DE LA SERRE, *Les Amours des Déesses*, Paris 1626–7.

PUGET DE LA SERRE, *Les Amours des Dieux*, Paris 1640.

(RAPIN, le Père) *Rapin's De Carmine Pastorali*, prefixed to *Thomas Creech's translation of the Idylliums of Theocritus* (1684), with introduction by J.E. Congleton, Ann Arbor 1947.

RAPIN, René, *Comparaison des Poëmes d'Homère et de Virgile*, Paris 1664.

REAU, Louis, *Iconographie de l'Art Chrétien*, 3 vols., Paris 1957–74.

RENOUARD, N., *Le Jugement de Paris*, Paris 1614.

RENOUARD, N., *Les Metamorphoses d'Ovide de nouveau traduittes en françois avec XV Discours Contenans l'explication morale des fables*, Paris 1614.

RENOUARD, N., *Les Metamorphoses d'Ovide traduites en Prose françoise...avec XV Discours Contenans l'Explication Morale et Historique*, Paris 1619.

REYNOLDS, Sir Joshua, *Discourses on Art*, ed. R.R. Wark, San Marino, CA, 1959.

ROETHLISBERGER, M, 'Les pendants dans l'oeuvre de Claude Lorrain', *Gazette des Beaux-Arts*, 1958, pp. 215–18.

ROETHLISBERGER, M., 'The Subjects of Claude Lorrain's Paintings', *Gazette des Beaux-Arts*, 6th period, IV, 1960, pp. 209–24.

ROETHLISBERGER, M., *Claude Lorrain, The Paintings*, 2 vols., London 1961.

ROETHLISBERGER, M., 'Les Dessins de Claude Lorrain à Sujet Rares', *Gazette des Beaux-Arts*, LIX, 1962, pp. 153–64.

ROETHLISBERGER, M., *Claude Lorrain, The Drawings*, 2 vols., Berkeley and Los Angeles 1968.

ROETHLISBERGER, M., *The Claude Lorrain Album in the Norton Simon, Inc. Museum of Art*, Los Angeles 1971.

ROETHLISBERGER, M., and CECCHI, D., *L'Opera completa di Claude Lorrain*, Milan 1975.

ROETHLISBERGER, M., 'Claude Lorrain: Some New Perspectives', *Studies in the History of Art 14, Claude Lorrain 1600–1682: A Symposium*, Washington DC 1984, pp. 47–65.

ROETHLISBERGER, M., 'Claude Lorrain, Nouveaux dessins, tableaux et lettres', *Bulletin de la Société de l'Histoire de l'Art Français*, 1986, pp. 33–55.

ROETHLISBERGER, M., 'Das Enigma Überlängter Figuren in Claude Lorrains Spätwerk', *Nicolas Poussin, Claude Lorrain. Zu den Bildern im Städel*, Frankfurt 1988.

ROETHLISBERGER, M., 'The Dimension of Time in the Art of Claude Lorrain', *Artibus et Historiae*, no. 20 (1989), pp. 73–92.

ROSENBERG, P., JANSEN, G., and GILTAIJ, J., *Chefs d'oeuvre de la peinture française des musées néerlandais XVIIe–XVIIIe siècles*, Dijon, Paris, Rotterdam 1992–3.

RUSSELL, H. Diane, 1982, *see* WASHINGTON 1982.

RUSSELL, H. Diane, 'Claude's Psyche Pendants: London and Cologne', *Claude Lorrain 1600–1682: A Symposium. Studies in the History of Art*, vol. 14, Washington DC 1984, pp. 67–81.

SABINO, Giorgio, *Fabularum P. Ovidii Metamorphosi Descriptorum Interpretatio Ethica, Physica et Historica*, 1614

SALERNO, Luigi, *Pittori di Paesaggio del Seicento a Roma*, 3 vols., Rome 1977–80.

SANDRART, Joachim von, *Academie der Bau-, Bild- und Mahlerey-Künste von 1675*, ed. A.R. Peltzer, Munich 1925.

SEZNEC, Jean, *The Survival of the Pagan Gods*, Princeton 1972.

TERVARENT, Guy de, *Attributs et Symboles dans l'Art Profane, 1450–1660*, Geneva 1959.

TURCHI, Francesco, *see Le Metamorfosi*.

VERDI, Richard, 'Poussin and Claude at Frankfurt', *Burlington Magazine*, 1988, pp. 393–5.

VINGE, Louise, *The Narcissus Theme in Western European Literature up to the early Nineteenth Century*, Lund 1967.

VIVIAN, Frances, 'Poussin and Claude seen from the Archivio Barberini', *Burlington Magazine*, vol. III, 1969, pp. 719–26.

WHITBREAD, L. G., ed., *Fulgentius the Mythographer*, Ohio 1971.

WHITFIELD, Clovis, 'A Programme for "Erminia and the Shepherds" by G.B. Agucchi', *Storia dell'Arte*, vol. 19, 1973, pp. 217–29.

WILSON, Michael, *see* LONDON 1982.

WINE, Humphrey, and KOESTER, Olaf, *see* COPENHAGEN 1992.

ZWOLLO, An, 'An Additional Study for Claude's Picture "The Arrival of Aeneas at Pallanteum"', *Master Drawings*, VIII, 1970, pp. 272–5.

Exhibition catalogues

AMSTERDAM 1991
Meeting of Masterpieces. Jan Both–Claude Lorrain, Rijksmuseum, Amsterdam 1991.

BOLOGNA 1962
L'Ideale Classico del Seicento in Italia e la Pittura di Paesaggio, Palazzo dell'Archiginnasio, Bologna 1962.

COPENHAGEN 1992
Wine, Humphrey, and Koester, Olaf, *Fransk Guldalder, Poussin og Claude og maleriet i det 17 århundredes Frankrig*, Copenhagen 1992 (with English translation).

FRANKFURT 1988 *Nicolas Poussin. Claude Lorrain. Zu den Bilden im Städel*, Städelschen Kunstinstitut, Frankfurt am Main 1988.

LONDON 1969
Kitson, Michael, *The Art of Claude Lorrain*, Hayward Gallery, London 1969.

LONDON 1982
Wilson, Michael, *Claude. The Enchanted Castle*, National Gallery, London 1982.

LONDON 1982
Claude Lorrain (1600–1682) An Exhibition of Paintings and Drawings, partly from Private Collections, to mark the Artist's Tercentenary, Thos. Agnew & Sons Ltd., London 1982.

LONDON 1983
Mantegna to Cézanne: Master Drawings from the Courtauld Institute, Courtauld Institute Galleries, London 1983.

LONDON 1984
Art, Commerce, Scholarship. A Window onto the Art World – Colnaghi 1760 to 1984, Colnaghi, London 1984.

MUNICH 1983
Im Licht von Claude Lorrain, Haus der Kunst, Munich 1983.

PARIS 1982
La peinture française du XVIIe siècle dans les collections américaines, Paris, New York, Chicago 1982.

ROME 1982
Claude Lorrain e i pittori lorenesi in Italia nel XVII secolo, Accademia di Francia a Roma, Rome 1982.

WASHINGTON 1982
Russell, H. Diane, *Claude Lorrain 1600–1682*, National Gallery of Art, Washington DC, Grand Palais, Paris 1982–3.

WASHINGTON 1985
Collection for a King: Old Master Paintings from the Dulwich Picture Gallery, National Gallery of Art, Washington DC, Los Angeles County Museum of Art, 1985–6.

WASHINGTON 1985
The Treasure Houses of Britain: Five Hundred Years of Private Patronage and Art Collecting, National Gallery of Art, Washington DC 1985–6.

WASHINGTON 1988
Cafritz, Robert C., Gowing, Lawrence, and Rosand, David, *Places of delight – the Pastoral Landscape*, The Philips Collection in association with the National Gallery of Art, Washington DC 1988.

Lenders to the Exhibition

Lent by Her Majesty The Queen (Nos. 1, 47)

Agnew's (No. 75)

Anglesey Abbey, Fairhaven Collection
(The National Trust) (Nos. 36, 56)

The Visitors of the Ashmolean Museum,
Oxford (Nos. 7, 37, 60, 64)

Ecole nationale supérieure des Beaux-Arts,
Paris (No. 50)

The Trustees of the British Museum (Nos. 3,
5, 8, 10, 11, 12, 14, 16, 17, 18, 20, 22, 23, 29,
30, 32, 34, 39, 42, 45, 46, 51, 54, 58, 61, 68, 70,
73, 76, 81)

The Duke of Buccleuch, KT, Bowhill, Selkirk
(Nos. 65, 66)

By kind permission of Viscount Coke and the
Trustees of the Holkham Estate (Nos. 43, 55,
71, 79, 80)

Courtauld Institute Galleries, London,
Princes Gate Collection (No. 57)

The Duke of Devonshire and the Chatsworth
Settlement Trustees (Nos. 6, 44, 62, 63, 77)

Dulwich Picture Gallery (No. 31)

Lent by the Syndics of the Fitzwilliam
Museum, Cambridge (No. 2)

Hamburg Kunsthalle (No. 59)

Staatliche Kunsthalle Karlsruhe (No. 41)

Musée du Louvre, Paris, département des
Arts Graphiques (Nos. 25, 74, 78)

Manchester City Art Gallery (No. 28)

Private Collection (No. 40)

Private Collection (Nos. 48, 52)

Private Collection, Australia (No. 24)

Private Collection, France (No. 35)

Private Collection, Netherlands (No. 49)

National Galleries of Scotland (No. 72)

National Museum of Wales, Cardiff (No. 33)

Picture Credits

The Royal Collection © 1993 Her Majesty The Queen: Nos. 1, 47

Australia, Private Collection. Photograph Agnew's: No. 24

Cambridge, Fitzwilliam Museum: No. 2

Cardiff, National Museum of Wales: No. 33; Plates 6, 15

Chantilly, Musée Condé. Photograph Giraudon: Fig. 22

Chatsworth, Devonshire Collection. Reproduced by permission of the Chatsworth Settlement Trustees. Photographs Courtauld Institute of Art: Nos. 6, 44, 62, 63, 77; Fig. 14

Dresden, Gemäldegalerie Alte Meister: Fig. 1

Edinburgh, National Gallery of Scotland: No. 72; Plate 18

France, Private Collection. Photograph Agnew's: No. 35

Hamburg, Kunsthalle. Photographs © Elke Walford: No. 59; Plate 34

Hartford, Wadsworth Atheneum. The Ella Gallup Sumner and Mary Catlin Sumner Collection Fund: Fig. 9

Holkham, Viscount Coke and the Trustees of the Holkham Estate. Black-and-white photographs Courtauld Institute of Art: Nos. 43, 55, 71, 79, 80; Plates 8, 16, 22, 37; Fig. 20

Karlsruhe, Staalich Kunsthalle: No. 41

London, Agnew's: No. 75

London, British Library: Fig.19

London, The Trustees of the British Museum: Nos. 3, 5, 8, 10, 11, 12, 14, 16, 17, 18, 20, 22, 23, 29, 30, 32, 34, 39, 42, 45, 46, 51, 54, 58, 61, 68, 70, 73, 76, 81; Plates 17, 19; Figs. 2, 21

London, Courtauld Institute Galleries, Princes Gate Collection 215: No. 57

London, By permission of the Governors of Dulwich Picture Gallery: No. 31; Plate 9

London, National Trust Photographic Library: Nos. 36, 56; Plates 1, 31, 32 (Anglesey Abbey); Fig. 5 (Petworth House)

© Manchester City Art Galleries: No. 28; Plate 11

Missouri, Kansas City, Nelson-Atkins Museum of Art (Purchase: Nelson Trust) 32-192/1: Fig. 3

Munich, Alte Pinakothek: Fig. 7

Netherlands, Private Collection: No. 49; Plate 27

Oxford, Ashmolean Museum: Nos. 7, 37, 60, 64; Plates 3, 33

Paris, Ecole nationale supérieure des Beaux-Arts: No. 50

Paris, Musée du Louvre. Clichés des Musées Nationaux, Paris, © photos RMN: Nos. 25, 74, 78; Fig. 13

Private Collection: No. 40

Private Collection. Photograph National Gallery of Ireland: Fig. 6

Private Collection. Black-and-white photographs Courtauld Institute of Art: Nos. 48, 52; Plates 25, 26

Rome, Galleria Doria-Pamphili: Figs. 12, 16

St Petersburg, Hermitage: Fig. 4

Selkirk, Bowhill, The Duke of Buccleuch, KT. Colour photographs Ron Ballantyne: Nos. 65, 66; Plates 23, 24

© 1993 National Gallery of Art, Washington. Ailsa Mellon Bruce Fund: Fig. 18

By kind permission of His Grace The Duke of Wesminster DL: Fig. 11